The King's Drawings

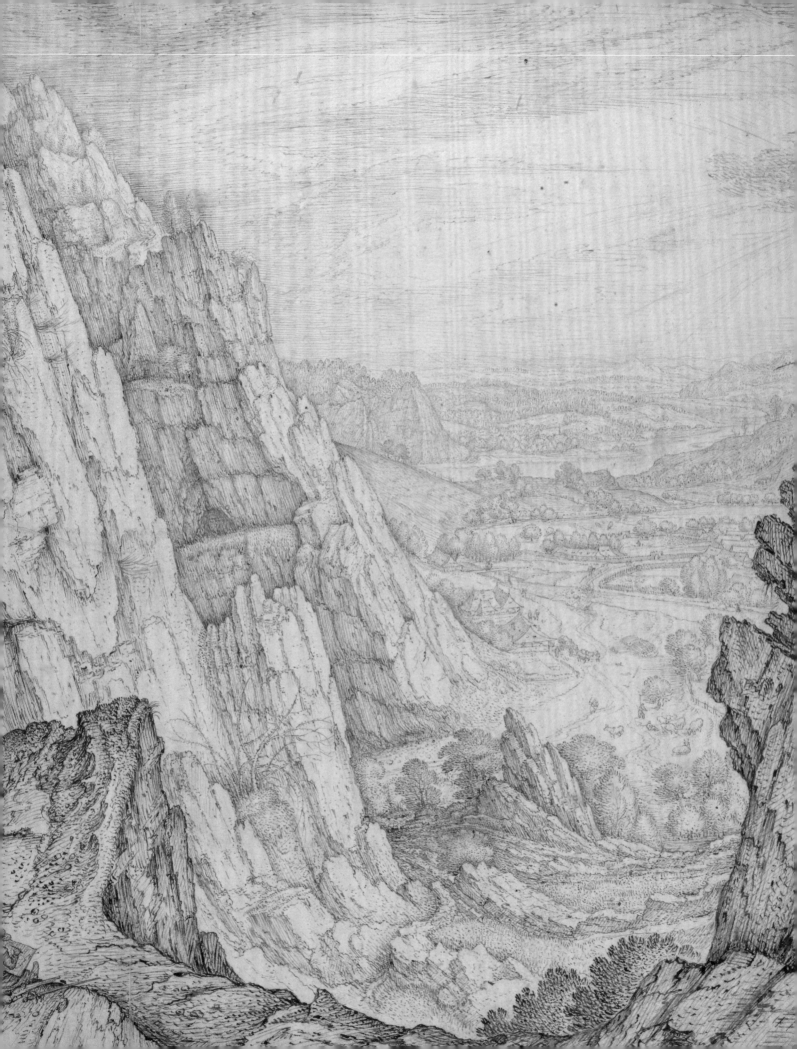

Catherine Loisel

Varena Forcione

WITH THE ASSISTANCE OF *George A. Wanklyn*

The King's Drawings

from the Musée du Louvre

HIGH MUSEUM OF ART

LOUVRE ATLANTA A collaborative project of the Musée du Louvre, Paris, and the High Museum of Art, Atlanta

LEAD PATRON

Anne Cox Chambers

PRESENTING PARTNER

LEAD CORPORATE PARTNERS

ADDITIONAL SUPPORT

Forward Arts Foundation

Frances B. Bunzl

Tull Charitable Foundation

PLANNING PARTNER

The Rich Foundation

This exhibition is supported by an indemnity from the Federal Council on the Arts and the Humanities.

Contents

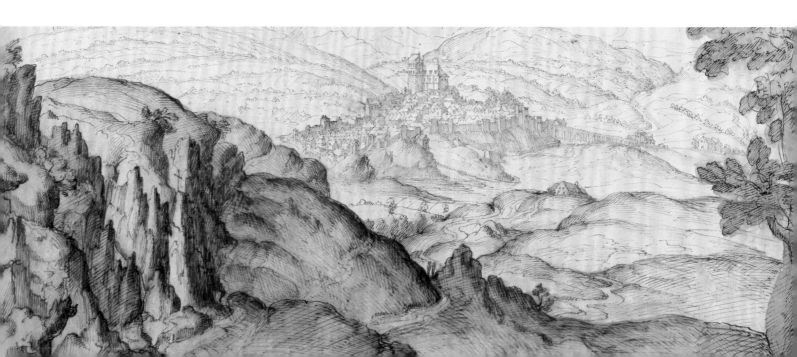

Directors' Foreword and Acknowledgments

The *Cabinet des dessins* (drawings collection) of the Musée du Louvre contains over 135,000 individual drawings. It is one of the oldest and largest collections of Old Master drawings in the world. Visitors to the Louvre can view selected parts of the collection through special exhibitions of drawings that appear routinely in galleries devoted to drawings. Scholars can also view the collection in the drawings study room.

The study and appreciation of Old Master drawings generally require intimate viewing conditions because of the subtlety of technique and the relatively small scale of most works. However, close study of Old Master drawings is repaid with a deeper understanding of the artistic process. Many drawings represent the artist's first thoughts as he or she attempted to solve a specific artistic problem. Beginning in the Renaissance, drawing was considered the basis of the art-making process. Giorgio Vasari, the artist and chronicler of the lives of the Renaissance masters, promoted artists such as Michelangelo and Raphael because he believed that they had achieved an unparalleled mastery of line. In fact, Vasari himself collected drawings by his contemporaries, which he lovingly placed on elaborate mounts decorated with pen-and-ink motifs. Some of these drawings eventually found their way into the French royal collections and can be seen in this exhibition in their original "Vasari mounts."

The first exhibition of drawings at the Louvre occurred when the Louvre opened to astonished crowds in 1793, four years after the start of the French Revolution. Like the rest of the Louvre's collections, the installation of drawings followed a scientific approach, grouping works by national schools and chronological development. The drawings shown were those assembled primarily under the reigns of Kings Louis XIV, Louis XV, and Louis XVI by their official court painters and advisors. *The King's Drawings from the Musée du Louvre,* the first exhibition of its kind both in France and the United States, tells the story of the individuals who shaped the king's collection of drawings, which forms the basis of the Louvre's outstanding drawings collection today.

Like the High Museum itself, the collecting of drawings in the Southeast is a relatively new phenomenon. In the fall of 2005, the High opened a major expansion designed by the acclaimed Italian architect Renzo Piano. One of the key features of the expanded Museum is a new Works on Paper Center with a gallery devoted to the exhibition of works on paper. The Uhry Works on Paper Study Room allows for the ongoing collecting, study, and appreciation of prints, drawings, and photographs in the High's collections.

This exhibition was the brainchild of Catherine Loisel, Chief Curator of Graphic Arts at the Musée du Louvre. She was assisted by Varena Forcione, Curatorial Research Associate. They worked with David Brenneman, Chief Curator and Frances B. Bunzl Family Curator of European Art at the High, and Olivier Meslay, Curator in the department of paintings of the Louvre—the managing curators of the *Louvre Atlanta* project. Other key colleagues at the High Museum of Art include Jody Cohen, Project Manager; Philip Verre, Deputy Director; Rhonda Matheison, Director of Finance and Operations; Susan Clark, Director of Marketing and Communications; Pat Rodewald, Chair of Education; Laurie Hicks, Exhibition Coordinator; Cassandra Champion, Manager of Public Relations; Julia Forbes, Head of Museum Interpretation; Marshall Adams, Head of School Programs; Virginia Shearer, Associate Chair of Education; Mary Shivers O'Gara, Programming Manager; Kelly Morris, Manager of Publications; Heather Medlock, Assistant Editor; Jim Waters, Head Designer; Angela Jaeger, Head of Graphics; Frances Francis, Registrar; Amy Simon, Associate Registrar; Linda McNay, Director of Advancement; Michele Egan, Senior Development Manager; Jennifer de Castro, Louvre Atlanta Sponsor Manager; Toni Pentecouteau, Assistant to the Director; and Sarah Myers, Assistant to the Chief Curator. Elisa Glazer worked with great inspiration to assemble an impressive group of corporate, foundation, and individual patrons.

At the Musée du Louvre, we wish to acknowledge Didier Selles, Chief Executive Director; Aline Sylla-Walbaum, Director of Cultural Development and Assistant General Administrator; Christophe Monin, Deputy Director of Cultural Development; Sophie Kammerer, International Development Manager; Sue Devine, Executive Director, American Friends of the Louvre; Myriam Herlet, Project Coordinator; Aggy Lerolle, Chief of Communications; François Vaysse, Head of the Service of Educational and Cultural Activities; Catherine Guillou, Director of Visitor Services and Education; Beatrice Abbo, former Assistant Director of Public Services; and Violaine Bouvet-Lanselle, Chief of Publications.

The authors wish to thank these Louvre staff members and colleagues who made special contributions to this exhibition and publication: Bruno Alet, Delphine Aubert de Tregomain, Christine Chabod, Valérie Corvino, Clarine Guillou, Christelle Lemoyne, André Le Prat, Federica Mancini, Jean-François Méjanès, Marie Catherine Sahut, and Françoise Viatte. We are also grateful to Anne-Marie Logan, Simonetta Prosperi Valenti Rodinò, and Jeremy Wood.

We wish to thank our friends at the Denver Art Museum, an affiliate partner for this project, and especially Lewis Sharp, Director, for his vision and commitment to the effort. He was supported by Timothy Standring, Deputy Director for Collections and Programs; Janet Meredith, Director of Marketing; and Melora McDermott-Lewis, Director of Education.

Of course, the idea that was initially conceived in 2003 would not have been possible without the extraordinary generosity and vision of a consortium of donors. The lead individual patron, the Honorable Anne Cox Chambers, embraced the opportunity immediately for its significance to the museum and Atlanta. The Presenting Partner, Accenture, a global management consulting, technology services, and outsourcing company, is collaborating with the High to provide expertise across key areas designed to enhance the experience for Museum guests and members. They join other Lead Corporate Partners —UPS, Turner Broadcasting System, the Coca-Cola Company, Delta Air Lines, and AXA Art Insurance—who contributed critical financial support as well as the expertise of their most senior leadership and employees and in-kind assistance. We owe special thanks to Mike Eskew of UPS and Evern Cooper Epps of the UPS Foundation, Phil Kent, Louise Sams and Mark Lazarus of Turner Broadcasting, Neville Isdell and Ingrid Saunders Jones of The Coca-Cola Company, Gerald Grinstein of Delta Air Lines, and Christiane Fischer of AXA Art Insurance for sharing our vision. Foundation support was provided by the Forward Arts Foundation, the Sara Giles Moore Foundation, The Tull Charitable Foundation, and The Rich Foundation, the latter as a planning partner. Additional individual support was provided by longtime patron Frances B. Bunzl. The Samuel H. Kress Foundation and John Treacy and Darcy F. Beyer Foundation provided grants to support the symposium *Raphael, Castiglione, and European Courtly Culture.* Funding for the student exchange component of *Louvre Atlanta* was provided by the American Friends of the Louvre and the Charles Engelhard Foundation. The *Louvre Atlanta* Summer Teachers Institute received support from The Goizueta Foundation, French Cultural Services of the French Embassy, and the French Consulate in Atlanta. We are grateful to French Ambassador Jean-David Levitte for his assistance and good counsel and to Philippe Ardanaz, Consul General in Atlanta, and his staff for championing the project in the United States and abroad. We also wish to acknowledge the significant support that the *Louvre Atlanta* project has received through an Indemnity from the Federal Council on the Arts and Humanities. We salute this important government program that provides support for international exhibitions in the United States.

HENRI LOYRETTE
Président-Directeur
Musée du Louvre

MICHAEL E. SHAPIRO
Nancy and Holcombe T. Green, Jr. Director
High Museum of Art

A Century of
Royal Collecting

Catherine Loisel

The Foundation of the *Cabinet des dessins* during the Reign of Louis the Sun King

The creation of the Cabinet du Roi to accommodate the king's collection of drawings dates back to the beginning of the long reign of King Louis XIV (1643–1715). The establishment of this new component of the royal collections came about as the result of a convergence of circumstances, most important and immediate being the offering for sale of the fabulous hoard of drawings of the German banker Everhard Jabach, known across Europe for its size and brilliant quality. The particular circumstance that precipitated the royal acquisition was an urgent, pressing need for money of Jabach, one of the richest businessmen living in the French capital. But however attractive the prospect of obtaining such a collection on such obviously favorable terms, the opportunity would not have been so eagerly grasped by the king and his most influential minister, Jean-Baptiste Colbert, had the idea of holding great collections not become so emblematically important for the prestige of a great prince and the projection of his grandeur.

During the seventeenth century, drawings became desirable collection objects on a par with paintings and objets d'art. Cardinal Leopoldo de Medici assembled the core of the Uffizi Gallery drawings collection in Florence in the 1660s,[1] at about the same time the Dukes of Este in Modena[2] were forming their own collection of Old Master drawings. By the middle of the century, collecting drawings had become a widespread and socially advantageous passion in Rome. Scholars and writers like Francesco Angeloni[3] and, later, Giovanni Pietro Bellori helped set the tone. In 1651, Queen Christina of Sweden acquired books of drawings by Raphael, Michelangelo, and other artists, which had previously belonged to Joachim von Sandrart, as well as valuable drawings by Hendrick Goltzius, said to have been looted by Swedish troops from the Prague palaces of Rudolf II, Emperor of the Holy Roman Empire. In 1658, when the Swedish Queen settled in the Eternal City, she dedicated her energy to enhancing her collection, engaging Giovanni Pietro Bellori as her librarian.[4]

When Jabach proposed the sale of part of his precious collection to the French king, the investment was seen as important for promoting royal prestige. Jabach came from a family of Cologne bankers who had a long tradition of art patronage; they had commissioned an altarpiece from Albrecht Dürer around 1503–1505.[5] Jabach moved to Paris in 1638, where his business skills generated a considerable fortune, which enabled him to collect art on a large scale throughout the European market. During a trip to London, where he commissioned Anthony Van Dyck[6] to paint his portrait, Jabach established contacts with other wealthy collectors. London was the place of residence of the diplomat and traveler Thomas Howard, Earl of Arundel and Surrey, Earl Marshal of England (1585–1646), who had one of the largest collections in seventeenth-century Europe.[7] Arundel had organized a network of agents throughout Italy to procure artworks for him, and his interest in German art compelled him to acquire Northern European works with great passion, especially those of Hans Holbein and Dürer. In a remarkable initiative, Arundel

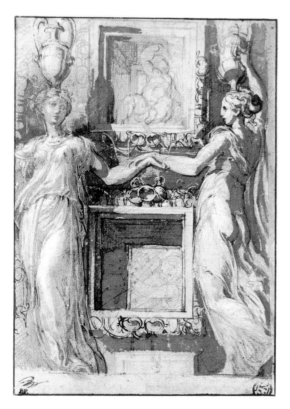

Fig. 1. Francesco Mazzola, called Parmigianino (1503–1540), *Two Canephorae,* pen and brown ink, red chalk, brown and red wash, and white gouache, Département des Arts Graphiques, Musée du Louvre, Inv. 6466. From the Arundel and Jabach collections. Purchased by the Cabinet du Roi in 1671.

arranged to display books of drawings in his home, Arundel House, where art enthusiasts and collectors could view them. This surely made a strong impression on Jabach, who in 1653 bought no fewer than one thousand drawings (for 10,000 florins) from the widow Lady Arundel,[8] who was at the time a refugee in Holland.

The Arundel provenance is sometimes difficult to ascertain because this pioneer collector did not mark his drawings. However, some of the works were etched and a few can be identified among those Jabach eventually acquired. This was true for a famous Parmigianino drawing (fig. 1), a study for the caryatids in the Madonna della Steccata church in Parma.[9] The group of drawings from the famous painter and art theorist Giorgio Vasari in Jabach's collection probably came from Arundel, who, around 1637, had bought an entire lot of Vasari drawings once belonging to Niccolò Gaddi.[10] Other works in the banker's collection of drawings bear the marks of other great English collectors, notably Nicholas Lanier[11] and Peter Lely.[12]

Although it was his collection of drawings that made him famous, Jabach also collected Old Master and contemporary paintings and sculptures. In 1637 Jabach commissioned Rubens to paint a *Crucifixion of Saint Peter* for his family's funerary chapel in Saint Peter's Church in Cologne. But when in Paris he surrounded himself with French artists and was one of the first to commission Charles Le Brun, who painted the *Family Portrait,* formerly in Berlin.[13] Jabach put his private collection on display and received connoisseurs in his *hôtel particulier* near the Saint-Merry Church in the center of Paris.[14] The *Cavaliere* Bernini, invited to Paris by King Louis XIV, was one of Jabach's guests at a dinner given for connoisseurs and artists, including Pierre Mignard and Le Brun. There Bernini had the chance to examine Jabach's collections. One of Paul Fréart de Chantelou's letters documents that he particularly admired a Poussin drawing, *Renaud and Armide,*[15] and a large sheet by Raphael.[16] Chantelou does not inform us, however, of how Jabach acquired a preparatory drawing for Bernini's 1631 engraving *David Smothering a Lion,* today in the Louvre.[17]

Jabach's social relationships were at the highest level. He was Cardinal Minister Mazarin's banker,[18] and they kept in close contact on the subject of collecting. Between 1650 and 1653, Jabach acquired works from the sales following the 1649 execution of King Charles I of England and Scotland. Charles I, an eminent collector, had assembled masterpieces by great Italian Renaissance artists, notably in his purchases from the Dukes of Gonzaga of Mantua, who had been forced by urgent financial necessity to relinquish works commissioned by their ancestors over a period of four centuries, including works by Mantegna, Correggio, and Titian. Jabach's acquisitions were more than impressive: he acquired several Correggio paintings (from the *Studiolo* of Isabella d'Este), Titian's *Entombment of Christ,* and Caravaggio's *Death of the Virgin,* in the Louvre today. He sold several works to Mazarin, but managed to keep some major ones for himself.

Comparatively little is known about Jabach's acquisitions of drawings. Recent research on the milieu of Parisian collectors[19] indicates frequent exchanges and gifts, impassioned discussions about acquisitions, and great intellectual debate between the *curieux* (connoisseurs and collectors) adhering to two opposing aesthetic camps: the colorists (the *Rubénistes,* partisans of Rubens's method of painting), who defended the overriding importance of color, versus those who upheld the superiority of drawing. It is difficult to place Jabach within this elite society: born outside of France and having obtained his *Lettres de Naturalité* in 1647,[20] he was neither aristocrat nor intellectual. Yet he

met and negotiated with the most influential people and probably had an unusually strong and overbearing personality—at least this conclusion can be drawn from the disparaging remarks made about him in Christiaan Huygens's letters to his brother Constantyn: *Je n'en ay point sceu avoir de Jabak, quoyque je luy en aye demandè et envoiè pour cela chez luy plus de 3 fois. C'est un vray porc, dont on ne peut avoir raison. Il s'entend pourtant assez bien au dessein, force d'en avoir veu beaucoup.* (I've never known how to get any out of Jabak, although I've asked him for some and have sent for them more than 3 times. He's a real swine, someone you can't get the better of. Even so, he's pretty good at judging drawings, by dint of having seen so many.)[21]

If Pierre-Jean Mariette's account in the 1741 Crozat sale catalogue[22] and the presence of a series of drawings once belonging to Rubens in the collection sold in 1671 are taken into consideration, it would seem that Jabach had acquired some of the drawings from the Rubens atelier directly, either before the artist's death in 1640 (they had had a business relationship) or from his heirs or from Canon Jan Philip Happart, who bought the bulk of the artist's studio in 1657.[23]

One source of French acquisitions has been securely identified: works from the combined collections of two Parisian connoisseurs, the brothers Christophe and Israël Desneux, distinguished members of the Parisian bourgeoisie.[24] When Israël died in 1635, his significant *cabinet des curiosités* was put up for sale and his eight albums of drawings were dispersed. His nephew François de la Noüe, who had the title of *commis au plumitif de la Chambre des Comptes* (secretary in the Ministry of Finance), was one of the buyers. Mentioned as a lover of drawings by the other well-known Parisian amateur-collector, the Abbé de Marolles, de la Noüe frequented painters and sculptors in the Parisian art circle, socializing with the painter Simon Vouet (from whose widow he bought seventeen drawings in 1649) and the sculptor Jacques Sarrazin. Numerous documents reveal that he owned important paintings—including a Michelangelo *Crucifix* and a Raphael *Holy Family*— and that he had bought a *Virgin and Saint Francis* by Domenichino at the sale of Queen Marie de Medici's collection, which later was owned by Jabach.[25] We can surmise that Jabach acquired some of François de la Noüe's drawings collection either after de la Noüe's death in 1656 or around 1665, following the death of his brother and sole heir, Aubin de la Noüe. The provenance of at least some of these sheets in the Jabach collection is indicated by the annotation *Desneux Delanoue* inscribed on the backs of the drawings and mounts. Comparative examination of the works bearing the *Desneux* and *Delanoue* annotations in the Louvre's Jabach collection supports the theory that François or Aubin de la Noüe invented the mount—white with a large gold border—that Jabach subsequently imitated and slightly transformed, using thicker cardboard backing and a superior quality of gold for the border. Mariette indicated the de la Noüe provenance on the cartouche of a Toussaint Dubreuil drawing currently in the Louvre,[26] an unambiguous sign of the notoriety of its provenance. There is a remarkable group of Dubreuil drawings in the Desneux collection as well as drawings by Francesco Vanni, Nicolò dell'Abate, and Guido Reni.[27] Several important sheets by Vanni[28] and Parmigianino bear the de la Noüe annotation alone.

Mariette repeatedly mentions the fine quality of the de la Noüe drawings in the Crozat sale catalogue. Many of them had been acquired either with Jabach serving as an intermediary or directly. On the subject of Michelangelo, Mariette writes: "*M. de la Noüe & M. Jabach, avaient recueilli la plus grande partie des Desseins de Michel-Ange, qui forment la collection de M. Crozat*" (Mr. de la Noüe & Mr. Jabach had gathered the largest part of Michelangelo's drawings forming the collection of Mr. Crozat). Following the listing of the ninety-three Francesco Vanni drawings divided into ten lots, the catalogue states: "*Ceux qui sont ici ont appartenu à M. de la Noüe fameux curieux, & c'est à leur occasion que le comte d'Arundel se détermina à faire un voyage à Paris*" (These belonged

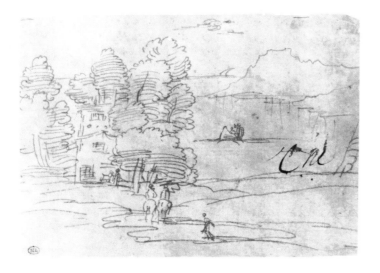
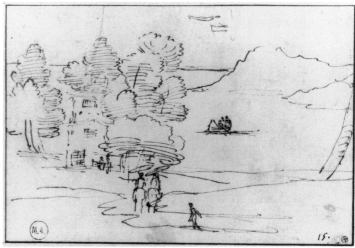

Fig. 2. Michel Corneille le Jeune (1642–1708) after a drawing by Annibale Carracci (1560–1609), *Landscape,* red chalk on oiled paper, Département des Arts Graphiques, Musée du Louvre, Inv. 7641. From the Jabach collection. Purchased by the Cabinet du Roi in 1671.

Fig. 3. Annibale Carracci (1560–1609), *Landscape,* pen and brown ink. Musée Atger, Montpellier, Inv. MA 413. From the Jabach, Crozat, Mariette, and Atger Collections. Original of the preceding drawing (fig. 2). It was kept by Jabach and used as a model by Macé for one of the engravings in the *Recueil Jabach.*

to Mr. de la Noüe, renowned collector, & it is for these that Lord Arundel decided to make the trip to Paris). The drawings were repeatedly remounted over the centuries, and numerous annotations made in black chalk have disappeared, either erased or covered by new mounts. If the Louvre holds the greatest number of identifiable drawings from the Desneux and de la Noüe collections today, it is due to the good conservation policy for the drawings in the king's possession and respect for their mounts.

Jabach was a businessman in the modern sense of the word. He applied his business talent to the exploitation of his drawings collection: in 1666 he started the publication of an album of prints after his drawings, an idea probably inspired by Arundel. To accomplish this, he engaged the artists Michel Corneille le Jeune (1642–1708), Jean-Baptiste Corneille (1649–1695), Claude Macé (died 1670), Jacques Rousseau (1630–1693), and Jean Pesne (1623–1700). Jabach began with a group of homogeneous drawings, possibly his favorites, the landscapes by Annibale and Agostino Carracci. The *Recueil de 283 Estampes Gravées à l'Eau forte par les plus habiles peintres du tems d'Apres Les Desseins des Grands Maitres que possedait autrefois M. Jabach, et qui depuis ont passé AU CABINET DU ROY* (Album of 283 Etchings by the Most Gifted Painters of the Time after Great Master drawings once owned by Mr. Jabach, which have since gone to the King's Cabinet) was not published until 1754, but we know from Jabach's letters dated March 1671 that 212 plates were ready by that date.[29] It is not known how Jabach acquired the drawings in question, whether he purchased them as an entire lot from the heirs of Francesco Angeloni or if he searched for them all over Europe. These landscape drawings, harbingers of a new way of depicting nature, used by the etchers for the album, are now dispersed among various collections. Besides those held by the Louvre, other sheets reproduced in the album have been identified, for example, in the Kupferstichkabinet of Berlin and in the Musée Atger of Montpellier (figs. 2 and 3). Sometimes, Jabach kept the original and sold a copy to the royal collection.[30] It was probably this group of drawings that Carlo Cesare Malvasia had in mind when he mentions the Jabach collection in his lives of the Carracci: "*li tanti di Monsù Jabach, oggi presso la Maestà Cristianissima*" (the many owned by Mr. Jabach, now in the collection of His Royal Christian Majesty).[31]

Unfortunately, Jabach's commercial drive pushed him to organize a workshop for the production of copies of his paintings and drawings. It is known that he employed Sebastien Bourdon—an otherwise admirable painter from whom he obtained important commissions, notably for his native Cologne—to make copies Jabach intended to sell as originals. The Duc de Brienne recounts Jabach's selling two paintings to the Duc de Liancourt, an Annibale Carracci *Virgin* and

a Giorgione *Portrait of Gaston de Foix,* which were later shown to be fakes. So it would seem that a lucrative forgery operation was in place. While such duplicity in the world of painting has had a long and documented history, the practice has only recently been discovered in the case of drawings, as a careful study of the sheets in the Louvre collections has clearly demonstrated. Two features were considered suspect: first, the copies of red chalk drawings sometimes reversed the originals conserved in the Louvre or other museum; secondly, the frequency of heavy white gouache heightening gave a "family air" to drawings made by different artists. Catherine Goguel's in-depth study shows that Jabach had enlisted Michel Corneille's intervention on this score.[32] Corneille was to "renovate" the drawings to give them a fresher look but also to produce copies— sometimes using a tracing system in which a sheet of glass was placed on top of the drawing to produce an exact copy. It is true that the status of original drawings was not as clear in the seventeenth century as it is now and that in the eighteenth century Parisian sales copies were sold alongside original works, but one cannot help being amazed by Jabach's ingenuity and calculation. One must conclude that the king of France was among the victims of the shrewd banker's curious industry: in his 1671 sale to the king, Jabach sold a number of copies in red chalk or pen in place of original drawings that remained in his possession.

The 1671 sale is well documented. We know that as far back as 1662 Jabach had sold the king approximately one hundred paintings;[33] in 1671 he proposed another sale of 101 paintings and 5,542 drawings. The minister Jean-Baptiste Colbert (1619–1683), an outstanding administrator wholly devoted to promoting the king's glory, led the negotiations and appointed a commission of experts. Jabach initially requested over 580,000 livres; Colbert had it lowered to 280,839 livres, still a considerable sum. In the end, Jabach was paid 222,000 livres. This did not prevent him from recovering financially, probably as an arms supplier in a period of constant warfare led by the French king. He returned to collecting art with renewed vigor. At his death in 1695, he left 698 paintings and 4,515 drawings. Recent studies treating this second phase of Jabach's collecting career[34] show that he sold copies of original drawings he had every intention of keeping himself (figs. 2 and 3).

Jabach had the inventory of his 1671 sale compiled, dividing it in two parts. The first group, estimated as the more valuable: "*2316 desseins d'ordonnance collés et dorés, rangés en six portefeuilles*" (2,316 compositional drawings, glued and gilded, arranged in six portfolios), was taken over in January 1672 by Le Brun, the King's First Painter—who, in this case, played the role of a sort of superintendent for the Beaux-Arts—and by the Controller General of the Crown's Furniture. These drawings of *ordonnance* were glued onto a white cardboard backing and framed with a wide and beautiful gold-leaf border. The mount was a patent imitation of de la Noüe's mounts, but from that time on it became known as the "Jabach mount." It took much longer to inventory the drawings that were not mounted: "*2911 desseins d'ordonnance, figures et têtes, non collés ni dorés*" (2,911 compositional drawings, figures, and heads, neither glued nor gilded), which were delivered only in 1676. Each drawing, mounted or not, bore Jabach's paraph on the verso (fig. 4, the famous Lugt 2959).[35] Thus the new *Cabinet des dessins* of the king came to be.

The fact that Michel Corneille's hand has been identified in so many copies of original drawings Jabach kept in his collection raises a legitimate question: was Jabach so disgruntled by what he considered the paltry price fixed by Colbert that he deliberately replaced the originals with copies, exacting retribution and delivering works of art to the king he esteemed worth the amount the king was willing to pay? It is curious that Le Brun, a reputed connoisseur, did not detect the replacement of original works by copies. As Jabach's friend, Le Brun knew the collection well and even owned drawings coming from Jabach.

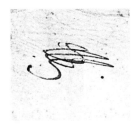

Fig. 4. Jabach's paraph, pen and brown ink, inscribed on the verso of the sheets sold to the king in 1671. Cat. 4 verso (detail).

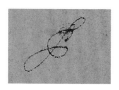

Fig. 5. Jean Prioult's paraph, pen and brown ink, added in 1690 on the recto of the sheets seized from Charles Le Brun's private collection, and on the verso of the sheets from Le Brun's studio. Cat. 65 recto (detail).

Setting Up a Systematic Management

When Le Brun's studio collection was confiscated and entered the royal collection in 1690, there was a beginning of an organizational effort. As First Painter to the King, Le Brun had been responsible for managing the royal art collections, was director of the Gobelins factory, and supervised all the work on Louis XIV's great royal artistic projects. Le Brun died on 12 February 1690; two days later, his residence was sealed, and Jean Prioult, *Commissaire Enquesteur et examinateur au Châtelet de Paris* (Commissioner and Examiner at the Châtelet of Paris) was charged to compile an inventory. He was to check the drawings destined for the king's collection, conserved at the Hôtel de Gramont, and to inscribe a paraph, sheet by sheet, on all the works Le Brun had left in his ateliers (fig. 5), in his Paris and Montmorency residences, and at the Gobelins factory. The extent of the confiscation is still impressive today because it included works executed by Le Brun prior to his nomination as First Painter, as well as works in his private collection, all shamelessly confiscated by order of Minister Louvois. By virtue of this seizure the Louvre holds an almost intact studio collection of a great seventeenth-century master.

From then on, management rules were established, and the drawings left by Pierre Mignard, Le Brun's successor in the office of First Painter from 1690 to 1695, were paraphed by Antoine Desgodetz, Controller of the King's Buildings. The same was true for Mignard's 300 studio drawings as well as for Pieter Boel's drawings. In the case of Antoine Coypel, First Painter from 1715 to 1722, the system seems to have gone awry, and it was his son who had the luxury of bequeathing his father's works to the king in 1752, thirty years after his father's death.

The end of Louis XIV's reign heralded a less favorable period for the royal collection, enriched anew in March 1712 with the purchase of 168 sheets belonging to the *Garde des Pierreries de la Couronne* (Keeper of the Crown's Gems), Pierre Tessier de Montarsy.[36] His annotated name is still visible on the verso of some Louvre drawings; relatively little is known about what motivated this acquisition, except the friendship between the collector and Antoine Coypel, newly appointed *Garde des Dessins* (Keeper of Drawings). Among the sheets whose Montarsy provenance is clear, there are a number of copies (notably, after Poussin) but also some beautiful original compositions by Pietro Testa, a rare Annibale Carracci drawing, and landscape drawings (figs. 6 and 7). Mariette wrote:"*Après la mort de M.Bourdalouë, de M. de Montarsis, de M. de Piles & de M.Girardon, tous noms célèbres dans la Curiosité; M.Crozat choisit à leurs Ventes, ce qu'il y avait de plus singulier en Desseins dans leurs Cabinets*" (Following the deaths of Mr. Bourdalouë, Mr. de Montarsis, Mr. de Piles & Mr. Girardon, all distinguished connoisseurs, Mr. Crozat selected, at their Sales, the most singular drawings from their Cabinets), showing that he was aware of this collection's reputation. It is unfortunate that the royal purchases did not include the most beautiful works, such as Raphael's *Transfiguration* (no. 29, Crozat sale catalogue). Antoine Coypel was in charge of the purchases; he signed a receipt in September 1712, at the time of the works' entry. It is possible that he was mistaken concerning the quality of "*huit desseins du Corrège ou de son escolle, vingt desseins du Titien ou de son escolle, quarante-quatre desseins du Poussin ou de son escolle, quarante-trois dessins de Rubens ou de son escolle, cinquante-trois de divers maîtres d'Italie*" (eight drawings by Correggio or his school, twenty drawings by Titian or his school, forty-four drawings by Poussin or his school, forty-three drawings by Rubens or his school, fifty-three of other Italian masters).

The Cabinet du Roi during the Reign of Louis XV: 1715–1774

When René-Antoine Houasse died in 1710, Antoine Coypel was appointed *Garde des Tableaux et des Dessins de la Coronne* (Keeper of the Crown's Paintings and Drawings). It was not until 1714 that he was elected Director of the Académie, and he was awarded the title of *Premier Peintre du*

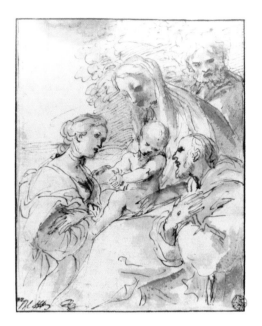

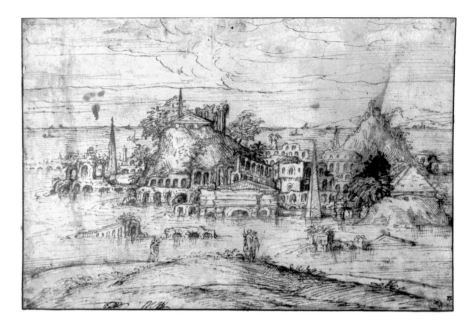

Fig. 6. Annibale Carracci (1560–1609), *The Holy Family with Saints Catherine and Francis,* pen and brown ink, and brown and gray wash. Département des Arts Graphiques, Musée du Louvre, Inv. 7917. From the Montarsy collection. Purchased by the Cabinet du Roi in 1712.

Fig. 7. Giovanni Battista Pittoni the Elder (1520–1587), *Landscape with a Town on a Riverbank,* pen and brown ink, Département des Arts Graphiques, Musée du Louvre, Inv. 5588. From the Lely and Montarsy collections. Purchased by the Cabinet du Roi in 1712.

Roi only in October of the following year. The regency of Duc Philippe d'Orléans (1715–1723), who had been Coypel's patron for many years, made it possible for him to acquire the most honorific titles bestowed upon a French artist of the period. Except for the acquisition of the Montarsy collection, he does not seem to have been interested in enriching the royal drawings cabinet. On the other hand, he spared no effort in organizing the collection in his charge. This task presented pedagogical concerns that Coypel evoked in speeches he delivered before the Academicians; they were also reflected in the choices for his own painting and drawing collection. He organized meetings of connoisseurs in order to establish the best possible classification method for the king's drawings. His son Charles-Antoine reported how seriously his father took this responsibility: "*M. Coypel n'eut pas plutôt entre ses mains ce magnifique dépôt que son premier soin fut de faire valoir la beauté des recueils divers qui la composent par l'agrément qu'un certain ordre y sait ajouter, il sépara les desseins mis depuis longtemps au rebut, et parmi lesquels cependant il s'en trouva beaucoup d'originaux d'une rare beauté . . . pendant plusieurs hivers il consacra un jour de chaque semaine à ces assemblées*" (Mr. Coypel had no sooner gotten hold of that magnificent lot [of drawings] than his first step was to enhance the beauty of the various groupings by arranging them to their best advantage. He separated out drawings that had long been set aside, but among which he found many of surpassing beauty. During several winters he spent one day a week at these gatherings).[37] Indeed, Coypel arranged these meetings of artists and art lovers in order to elicit opinions most helpful to his task of reclassifying. At the time, the drawings were kept in the Keeper's lodgings in the Palais du Louvre. Antoine Coypel succeeded in increasing the space allotted to the collection and set up a room for these meetings, from then on called the *Gallerie des Desseins du Roy,* the very first Study Room. One of his principal interventions on the sheets was the mounting of 340 of Le Brun's drawings. In his son's words: "*Feu mon père a fait coler et mestre en ordre 340 desseins de feu M. Le Brun*" (My deceased father glued and reorganised 340 drawings by the deceased Mr. Le Brun). When Charles-Antoine succeeded his father in 1722, he was given charge of the drawings alone, a responsibility he assumed until 1752. For these thirty years, nothing seems to have disturbed the tranquility of the king's portfolios, save for the visits made by artists eager to study them. Looking back today, it appears that the most resounding failure in the history of collecting—the refusal to buy Pierre Crozat's collection for the king in 1740—took

place during Charles-Antoine's apathetic direction. And, even if his 1752 bequest of Carracci drawings and 269 of his father's sheets gave him the opportunity to redeem himself in the eyes of posterity, just reading the Crozat drawings sale catalogue can only rekindle the regret of an opportunity lost.

The financier Pierre Crozat (1665–1740) came to Paris with his older brother Antoine (nicknamed "the Rich"), who had one of the greatest fortunes in the capital and who owned a large private residence on the Place Vendôme.[38] Pierre's numerous activities included tax-collecting for the king in Languedoc. He began collecting drawings in his youth in Toulouse, and though drawings remained the focus of his interests, he must be considered one of the most eclectic art collectors of the period. He also accumulated Old Master and contemporary paintings, prints, and engraved stones.[39] The chief reason he traveled to Italy (November 1714 to October 1715) was to negotiate purchases on behalf of the Regent, the Duc Philippe d'Orléans, an inveterate collector himself, who wished to acquire Prince Livio Odeschalchi's paintings. The prince had inherited part of Queen Christina of Sweden's estate. The transaction was finally crowned with success in 1721, when the paintings were sent to the Galerie du Palais Royal in Paris[40] and Crozat received a magnificent lot of drawings as a gift from the Roman prince. He also succeeded in buying the contents of entire cabinets during this expedition, including part of Raphael's studio collection from the heirs of Timoteo Viti in Urbino and valuable drawings by Bolognese masters (that Malvasia had assembled) from the Boschi family in Bologna. The acquisition policy of buying entire collections echoes the methods practiced by Jabach. Crozat was certainly aware of them, since he bought a good number of Jabach's drawings from his heirs between 1696 and 1712.[41]

Cultivated art collectors convened in Crozat's private residence on the rue de Richelieu every Sunday, where they discussed both art theory and contemporary painting. Crozat was a patron of La Fosse, Watteau, and Vleughels, and there is no doubt that the discussions he led there played a preponderant role in the evolution of current tastes in art. Crozat's will of 21 May 1740 explicitly stated his desire that all of his drawings, engraved stones, and prints be acquired by the king or, in the case of refusal, that a public sale take place, the funds of which were to be distributed among the poor in Parisian parishes.[42] The Duc d'Orléans bought the whole collection of engraved stones, but the drawings ended up being dispersed throughout the collections of Europe. For some of them, the provenance can be traced all the way back to the eighteenth century. They form the most distinguished part of the drawings collection in Stockholm's Nationalmuseum; some entered the Louvre and the Albertina in Vienna, and public collections around the world gradually were enriched by drawings scattered at the 1741 Paris sale. Cardinal Fleury, Louis XV's chief minister, when solicited for this acquisition flatly refused it, arguing "*que le Roy avait déjà assez de fatras sans encore en augmenter le nombre*" (that the king already has enough clutter without increasing its quantity).[43]

The sale took place in one of the rooms of the Convent des Grands Augustins in Paris from Monday, 10 April, to Saturday, 13 May 1741. In preparation, Pierre-Jean Mariette began his work on the drawings arranged in 202 portfolios in the very room in which the Sunday meetings had been held. He reclassified, catalogued, and numbered the 19,202 drawings (fig. 8)—the first example of scientific cataloguing in the history of art. Mariette bought a good number of sheets himself. These can be identified among those sold in his own collection.

When Charles-Antoine Coypel died in 1752, the drawings cabinet was further enriched by his bequest of a group of drawings by Annibale and Agostino Carracci, which had belonged successively to Francesco Angeloni, Pierre Mignard, and himself. Charles-Antoine also bequeathed part of his father Antoine's studio collection to the king, belatedly following the tradition of leaving

Fig. 8. Order number, pen and brown ink, inscribed by Mariette on the drawings during the organization of the Crozat sale in 1741. Detail of cat. 76.

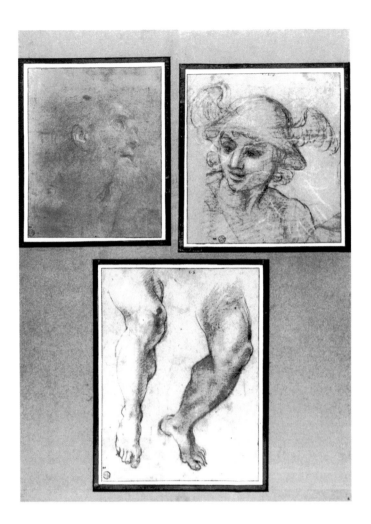

Fig. 9. Reconstructed mount from the 1752 bequest of Charles-Antoine Coypel, combining three drawings: Annibale Carracci (1560–1609), *Head of Mercury,* Inv. 7179; Andrea Sacchi (1599–1661), *Head of an Old Man,* Inv. 7624; Annibale Carracci (1560–1609), *Amphinomus's Father's Legs,* Inv. 7406, all in the Département des Arts Graphiques, Musée du Louvre.

Fig. 10. Jean-Charles Garnier d'Isle's paraph, pen and brown ink, inscribed on the recto of drawings remounted for the Cabinet du Roi in 1752. Detail of cat. 17.

the contents of the First Painter's workshop to the king. Before his death, he had taken care to have them mounted on blue cardboard, which led to their very recent identification (fig. 9).

Then Charles-Nicolas Cochin entered the scene. He began his directorship of the Cabinet du Roi by checking the contents of the collection and remounting many sheets. These were either glued directly on new mounts or detached from their old mounts and re-glued on new ones. This new mount consists of an elegant blue cardboard with golden fillets framing the drawing, easily identifiable today (see cats. 5, 6, 8, 9, and 10). The paraph of Jean-Charles Garnier d'Isle, who was at that time Controller of the King's Buildings, appears on the remounted drawings. For a long time this paraph (fig. 10) was known as the *paraphe des dessins remontés* (the remounted drawings paraph).[44] The Director of the King's Buildings (*Directeur des Bâtiments du Roi*), the Marquis de Marigny, found an efficacious second in Cochin, who had accompanied him to Italy and remained faithful to him.[45] Marigny's great projects were thwarted by ambitious rivals in the government and persistent financial difficulties. He resigned in 1773, without having been able to conclude the projects he had envisaged—notably, finishing work on the Louvre. Lacking acquisition funds, Cochin seems to have acquired a limited number of drawings for the collection, but he probably deserves credit for the purchase of a preparatory study for one of François Boucher's *Les Amours des Dieux* tapestries.[46] When he was relieved of his administrative duties in 1770, Cochin nonetheless remained secretary of the Royal Academy, and his influence and expertise were such that the Comte d'Angiviller, Marigny's successor, consulted him regularly on acquisitions of significant drawings.

17

From the Accession to the Throne of Louis XVI in 1774 to the Outbreak of the French Revolution in July 1789

Evidence of a new state of mind surfaced when Mariette's death (10 September 1774) gave rise to questions regarding the fate of his print and drawing collections. For three generations the Mariettes had collected and sold exceedingly rare prints of the highest quality. Their shop, *Aux Colonnes d'Hercule,* had supplied royals and European art collectors, and their commercial network extended to all European capitals. In 1717 Pierre-Jean was sent by his father to Prince Eugene de Savoie in Vienna to catalogue his collection and attend to its enrichment. His letters, now at the Louvre,[47] describe his adventures during the journey he made from Amsterdam to Vienna via Nuremberg. Pierre-Jean was able to leave Vienna for Italy only in 1719, and there he marveled at the riches of all the cities he traveled through. He was above all interested in acquiring prints and books for the family business and expressed his enthusiasm for the paintings and all the art he encountered. His stay in Venice gave him the opportunity to meet the pastellist Rosalba Carriera and the collector Anton Maria Zanetti, with whom he maintained close friendships. Not only did Mariette collect art with great passion, he was also a critic and a polyglot art historian with encyclopedic expertise. His notes on artists are gathered in the *Abecedario,*[48] and they provide an inexhaustible mine of firsthand information. He was consulted as an expert for Crozat's succession, which seems to have influenced from then onwards his work as an art historian and collector. From that time on, drawings remained at the heart of his research, and diverse accounts describe his activity purchasing from living artists' workshops (for example, those of Boucher, Natoire, and Hubert Robert) and in great sales such as the 1756 Duc de Tallard sale, the 1767 Jullienne sale, and the 1771 François Boucher sale—during which the "collecting fever" made him ill.[49] Each work was carefully selected, attentively studied, its association with an engraving or a painting closely examined, and the attributions were the fruit of patient research. This dedicated work

Fig. 13. Gabriel de Saint-Aubin (1724–1780), annotations and sketches of works put up for sale, alongside the printed descriptions on page 80 of Pierre François Basan (1723–1797), *Catalogue Raisonné des différens objet de curiosités dans les sciences et arts, qui composaient le Cabinet de feu Mr Mariette.* Paris: Guillaume Desprez, 1775. Museum of Fine Arts, Boston, Bequest of William A. Sargent, 37.1713.80.

Fig. 14. Gabriel de Saint-Aubin (1724–1780), annotations and sketches of works put up for sale, alongside the printed descriptions on page 73 of Pierre François Basan (1723–1797), *Catalogue Raisonné des différens objet de curiosités dans les sciences et arts, qui composaient le Cabinet de feu Mr Mariette.* Paris: Guillaume Desprez, 1775. Museum of Fine Arts, Boston, Bequest of William A. Sargent, 37.1713.73.

led to the Mariette collection's holding (in 1774) 3,400 drawings in 100 portfolios (probably the drawings that were glued on the elegant mount perfected by the collector) as well as 6,000 other sheets in albums and portfolios.

The status of the work of art had evolved considerably since 1740, probably as a result of the keen interest generated by the Crozat sale. The social function of collecting had become apparent: it was elegant to collect, and polite society rushed to the Salons and sales, as can be seen in the sketches by Gabriel de Saint-Aubin, chronicler of his time (figs. 11–14). New ideas about the educational value of art, derived from the Enlightenment and the tenets espoused by its proponents, proliferated in the second half of the eighteenth century and spread throughout Europe. A new attitude was developed by a circle of writers and thinkers such as Louis Petit de Bachaumont, La Font de Saint-Yenne, and the Comte de Caylus, who in 1752 published his *Recueil d'antiquités* (Album of Ancient Art), calling on collectors to open up their personal cabinets: "*On ne saurait trop exhorter ceux qui rassemblent des monumens de les communiquer au public. . . . L'éclaircissement d'une difficulté historique dépend peut-être d'un fragment d'antiquité qu'ils ont entre les mains. Ce motif m'a engagé à publier ce petit recueil et à léguer au cabinet du Roy les monumens qu'il renferme*" (One could not exhort enough those who assemble artworks to share them with the public. . . . The clarification of a historical problem could depend on a fragment of an ancient work of art that they have in their hands. This rationale motivated my commitment to publish this small album and to bequeath to the king's Cabinet the works that it contains).[50] After Marigny's resignation in 1773, the task of devising an efficient policy for the royal collection's development and enrichment fell to his successor, the Comte d'Angiviller (1730–1809).

Eventually the idea of establishing a painting gallery open to the public became imperative. It opened in October 1750 in the Palais du Luxembourg, with a selection of 99 paintings and 20 drawings from the royal collection, in addition to the Rubens cycle dedicated to Marie de

Medici (still there, in its original location). Up until 1779 these galleries were open two days per week. Jacques Bailly's catalogue shows that the drawings were displayed amid paintings hung in arrangements organized to highlight the contrasts between schools. When the Palais du Luxembourg was allocated in 1779 to the Comte de Provence (the future Louis XVIII), the galleries were closed to the public, and the Comte d'Angiviller devoted his energies to creating a museum in the Grande Galerie of the Louvre. Concerned with giving a new élan to French art, he was aware that royal prestige could be promoted through the museum, where monarchic treasures would be exhibited alongside works commissioned from the best artists in the nation. In spite of this strongly assertive political intention, the concretization of his plans was stalled by numerous deliberations concerning the decoration on a portion of the vaulting left unfinished by Poussin and the type of lighting the gallery would require. The committee, composed of architects and painters like Germain Soufflot and Hubert Robert, had only just produced its report when the French Revolution broke out.

The decision to buy Mariette's drawings collection reflected a very clear political orientation and an undeniable patriotic tendency. It was public knowledge that numerous foreign sovereigns had already made serious attempts to acquire the entire collection. Unfortunately, these good intentions were frustrated by the collector's heirs, who wished to obtain the greatest possible profit from their inheritance.[51] The Comte d'Angiviller had the dealer and art collector J.B. Denis Lempereur intercede, asking him to make an offer of 300,000 livres for the collection in its entirety. The family rejected the offer, intent on putting the works up for sale. It was only after the opening of the sale that the funds were released by order of the minister of finance, Anne Robert Jacques Turgot. By this point, some of the prints had already been sold, and the greater portion of the royal funds was spent making the winning bids for an impressive number of drawings for the king's Cabinet. Lempereur orchestrated this success by hiring a strawman to do the bidding: Sieur Lenoir, who was well paid for his services.[52] Lempereur's exceedingly precise report discloses that the sale did not proceed according to the order published in Basan's catalogue but that lots from each school were chosen so that each session—there were thirteen sessions for drawings—offered a varied artistic range. After the sale, 1,061 first-class works entered the collection, among them a Domenichino cartoon for a fresco of San Luigi dei Francesi in Rome. Some of the prints that had eluded Hugues-Adrien Joly, Keeper of the Royal Prints, were resold to the royal collection, so the final acquisition in engravings was also of the highest order; they are now in the collection of the Bibliothèque Nationale.

That same year the Director General succeeded in buying a ceiling painted by Jean Jouvenet for the Hôtel de Saint-Pouange. Lempereur served as intermediary for the purchase, which was meant to complete the holdings of French paintings in the royal collection. Acquisitions in the following years were also aimed at increasing the number of French works held by the king. Paintings such as Le Nain's *Blacksmith at his Forge* and Le Sueur's *Life of Saint Bruno* are among the acquisitions due to d'Angiviller's focused policy. For the drawings, the patriotic strategy of illustrating the glory of France through acquisitions of French art led in the same direction. Le Sueur's album of *The Life of Saint Bruno*[53] was acquired from the dealer Le Brun between 1776 and 1781, and eight sheets by Baullery illustrating the Tournament of Sandricourt were bought in 1785.[54] Archival sources allow us to follow the dealings of the Cabinet du Roi with regard to the painter Pierre Peyron's collection. He had lived in Rome for a long time and began to collect art with passion. On 12 March 1786, he wrote d'Angiviller about a sale he was planning, particularly recommending eighteen drawings. The painter Jean-Baptiste Pierre (1714–1789) and Cochin were immediately charged to examine this proposal. Cochin's report, dated 17 March, recommends that

Fig. 15. Stamps added in 1794 by the Commission du Museum (MN: Museum National) and by the Conservatoire (RF: République Française). Details of lower left and lower right corners of cat. 2.

eleven sheets be purchased: *"En général ces dessins sont bons, mais ne sont pas d'espèce à être vendus fort cher, ainsi il y a à présumer que ce sera une petite dépense. Je me propose de charger de leur acquisition M. Rémi, marchand, dont la probité m'est connue depuis longtemps"* (In general, these drawings are good, but they are not of the kind to be sold very dearly, thus one can presume that the expense will be small. I propose that Mr. Rémi be charged with their acquisition, a dealer whose integrity I have been familiar with for a long time).[55] The eleven drawings were indeed purchased, and one can judge by their mediocre quality that the only truly interesting sheet was by Giovanni Odazzi.[56] Nevertheless, this episode shows the speed with which the Director General's decision was made; his actions were propelled by a concern for efficacy, not less powerfully driven than those of a museum director of our own time.

The night before the Bastille was stormed by the revolutionary Parisian mob on 14 July 1789, the king's drawings collection was perfectly well kept, easily accessible, and its importance widely recognized. Thanks to the discriminating judgment of several generations of the monarchy's royal servants, who had assured the collection's preservation and enrichment, it appeared sufficiently important in the eyes of the new decision-makers forming the Revolutionary committees for them to agree to conserve it intact at the Museum National. The drawings were stamped (fig. 15) with the initials RF MN (République Française, Museum National) so that today, the collection having increased considerably, the drawings from the Cabinet du Roi can be immediately identified.

NOTES

1. Giovanni Agosti, "Introduzione. Cenni sulle provenienze dei disegni," *Disegni del Rinascimento in Valpadana,* exhibition catalogue (Florence: Gabinetto Disegni e Stampe degli Uffizi, 2001), p. 87, 1–16.

2. Françoise Viatte, Jadranka Bentini, Hélène Sueur, Catherine Loisel, *Disegni da una grande collezione. Antiche raccolte estensi dal Louvre e dalla Galleria di Modena,* exhibition catalogue, Sassuolo (Modena: Palazzo Ducale di Sassuolo, 1998).

3. Fiorenza Rangoni, "Per un ritratto di Francesco Angeloni," *Paragone* 499 (1991), 46–67; Catherine Loisel, "La collection de dessins italiens de Pierre Mignard," *Pierre Mignard "le Romain." Actes du colloque organisé au Musée du Louvre par le Service Culturel le 29 septembre 1995* (Paris: La documentation française, 1997), 53–88; *L'Idea del Bello. Viaggio per Roma nel Seicento con Giovan Pietro Bellori,* exhibition catalogue (Rome: Palazzo delle Esposizioni, 2000).

4. Bernard Quilliet, *Christine de Suède, un roi exceptionnel* (Paris: Presses de la Renaissance, 1982).

5. Bernadette Py, *Everhard Jabach, collectionneur (1618–1695): Les dessins de l'inventaire de 1695* (Paris: Réunion des musées nationaux, 2001), p. 11, note 4.

6. Ibid., p. 11, note 7.

7. Varena Forcione, "L'album du Louvre: les grotesques de Léonard de Vinci, originaux, dispersion, copies, estampes," *Léonard de Vinci, dessins et manuscrits,* exhibition catalogue (Paris: Musée du Louvre, 2003), pp. 206–216. See note 18 for a basic bibliography on Lord Arundel.

8. London, Public Records Office, Court of Delegates Processes VII, no. 14, 882; Forcione, "L'album du Louvre," p. 208, note 28.

9. Parmigianino, *Two Canephorae,* Département des Arts Graphiques, Musée du Louvre, from the Arundel and Jabach collections, Musée du Louvre; A. E. Popham, *Catalogue of the Drawings of Parmigianino* (New Haven and London: Yale University Press, 1971), no. 450.

10. Catherine Monbeig Goguel, "Le *Libro de' disegni* de Giorgio Vasari dans la première collection Jabach," *Collections de Louis XIV,* exhibition catalogue (Paris: Musée National de l'Orangerie des Tuileries, 1977), pp. 45–47.

11. Francesco Brizio, *The Holy Family in a Landscape,* Département des Arts Graphiques, Inv. 6057, Musée du Louvre, Paris. From the Lanier and Jabach collections. On Lanier, see Jeremy Wood, "Nicholas Lanier (1588–1666) and the Origins of Drawings Collecting in Stuart England," *Collecting Prints & Drawings in Europe c. 1500–1700,* eds. Christopher Baker, Caroline Elam, and Genevieve Warwick (Aldershot: Ashgate in association with the *Burlington* magazine, 2003), pp. 85–121.

12. Lely's drawings were sold after 1688. Jabach bought some of them after his own 1671 sale to the king—for example, the drawing after Giulio Romano, *Saint Ambrose Writing, with Six Angels,* pen and brown ink, brown wash, and white heightening on beige paper, Windsor Castle, The Royal Library, R.L. 0486. See Py, *Everhard Jabach,* no. 16. For further information on Peter Lely, see Diana Dethloff, "The Executors' Account Book and the Dispersal of Sir Peter Lely's Collection," *Journal of the History of Collections* 8, no. 1 (1996): 15–51; "Sir Peter Lely's collection of prints and drawings," in Baker et al., *Collecting Prints & Drawings in Europe c. 1500–1700,* pp. 123–139.

13. Destroyed in Berlin during the Second World War. See Jacques Thuillier, "Les tableaux et les dessins d'Evrard Jabach," *L'œil* 31 (1961): 33.

14. Ibid.

15. Nicolas Poussin, *Renaud and Armide,* Département des Arts Graphiques, Musée du Louvre, Inv. 32435; Thuillier, "Les tableaux," p. 34.

16. Raphael, *The Apparition of Saints Peter and Paul to Atilla and Leon I,* Département des Arts Graphiques, Musée du Louvre, Inv. 3873; ibid.

17. Gian Lorenzo Bernini, *David Smothering a Lion,* Département des Arts Graphiques, Musée du Louvre, Inv. 12093.

18. Py, *Everhard Jabach,* p. 11.

19. Antoine Schnapper, *Curieux du grand siècle. Collections et collectionneurs dans la France du XVIIe siècle* (Paris: Flammarion, 1994).

20. These papers gave foreigners, should they die on French soil, the right to bequeath their possessions to heirs. Christine Raimbault, "Evrard Jabach, quelques précisions sur la constitution des collections," *Bulletin de l'Association des Historiens de l'Art Italien* 8 (2002): 35–45.

21. *Œuvres complètes de Christiaan Huygens, publiées par la Société Hollandaise des Sciences* (The Hague: M. Nijhoff, 1888–1905), 10 vols., vol. VI, 1895, *Correspondance 1666–1669* (The Hague: M. Nijhoff, 1888–1905), 542. Letter no. 1774, Christian Huygens to Constantyn, Paris, November 14, 1669.

22. Pierre-Jean Mariette, *Description sommaire des desseins des grands maistres d'Italie, des Pays-Bas et de France, du Cabinet de Feu M. Crozat. Avec des Réflexions sur la manière de dessiner des principaux Peintres* (Paris, 1741). Lot numbers 813, 816, 818, and 830 contained drawings of Jabach provenance.

23. Jeremy Wood, "Rubens's Collection of Drawings: His Attributions and Inscriptions," *Wallraf-Richartz-Jahrbuch. Jahrbuch für Kunstgeschichte,* band 55 (1994): 333–351.

24. Mickaël Szanto, "Du cabinet des frères Israël et Christophe Desneux aux collections de François de La Noüe. Mise au point sur l'historique des dessins 'Desneux de la Noüe,'" *Revue du Louvre et des Musées de France* 4 (Paris: Conseil des musées nationaux, 2002): 50–59.

25. Antoine Schnapper, "La cour de France au XVIIe siècle et la peinture italienne contemporaine," in Jean-Claude Boyer, *Seicento: La peinture italienne du XVIIe siècle et la France,* Rencontres de l'Ecole du Louvre (Paris: Documentation française, 1990), p. 424.

26. Toussaint Dubreuil, *Angels in the Clouds Holding a Franciscan Girdle,* Département des Arts Graphiques, Musée du Louvre, Inv. 8539, *FRANC. PRIMATICCIO. / Olim D. De la Noue & P. Crozat, nunc P.J. Mariette / 1741.*

27. Guido Reni, *The Resurrection of Lazarus,* Département des Arts Graphiques, Musée du Louvre, Inv. 8932.

28. Francesco Vanni, *The Denial of Saint Peter,* Département des Arts Graphiques, Musée du Louvre, Inv. 1978; *Saint Helen Holding a Cross Upheld by Two Angels,* Inv. 2004; *Saint Catherine of Siena in Meditation, Leaning Her Head against the Cross,* Inv. 2020. *The Blessed Ambrogio Sansedoni Before the Pope,* Inv. 11576, bears only the paraph accompanied by a

numbering written in letters that was characteristic of de la Noüe, which also appears on a Parmigiano drawing, *Landscape with a Young Man Leading an Ass,* Inv. 40992, recently purchased by the National Gallery of Ottawa. See David Franklin, *L'art de Parmesan,* exhibition catalogue (Ottawa: Musée des Beaux-Arts, 2003–2004; and New York, The Frick Collection, 2004), no. 82. The drawing of *Saint Catherine of Siena Healing a Possessed Woman,* Inv. 2022, of de la Noüe provenance, does not bear any annotation indicating it, but Mariette, who acquired it, describes it in the Crozat catalogue.

29. Stephen Michael Bailey, "Carracci Landscape Studies: The Drawings Related to the 'Recueil de 283 Estampes de Jabach,'" PhD diss. (University of California, 1993), p. 22.

30. Catherine Loisel, "Dessins d'Annibale, 1588–1594," *Nuovi Studi* 3 (1997): 41–51.

31. Carlo Cesare Malvasia, *Felsina Pittrice. Vite de' pittori bolognesi* (Bologna, 1678, Zannetti edition, 1841), p. 334.

32. Catherine Monbeig Goguel, "Taste and trade: the retouched drawings in the Everard Jabach collection at the Louvre," *Burlington Magazine* 130, no. 1028 (1988): 821–835.

33. Arnauld Brejon de Lavergnée, *L'inventaire Le Brun de 1683* (Paris: Editions de la Réunion des musées nationaux, 1987).

34. Py, *Everhard Jabach.*

35. Frits Lugt, *Les Marques de collection de dessins & d'estampes* (Amsterdam, 1921), *Supplément* (The Hague: M. Nijhoff, 1956).

36. Archives nationales, O i 1965, dossiers nos. 2–8; Nicole Garnier, *Antoine Coypel (1661–1722)* (Paris: Arthena, 1989), p. 264.

37. Nicole Garnier, *Antoine Coypel (1661–1722),* p. 35.

38. This was to become the Hôtel Ritz.

39. Margaret Stuffmann, "Les tableaux de la collection de Pierre Crozat. I: Tableaux figurant dans l'inventaire après décès de Pierre Crozat, 30 mai 1740," *Gazette des Beaux-Arts* 71 (1968): 11–141. For the Crozat drawings, see Cordélia Hattori, "The drawings collection of Pierre Crozat (1665–1740)," in *Collecting Prints & Drawings in Europe c. 1500–1700,* ed. Baker et al., pp. 173–181.

40. Unfortunately, this collection, at least as beautiful as the king's if not more so, was dispersed by his grandson, Philippe Egalité, in 1791.

41. Py, *Everhard Jabach,* p. 18.

42. Archives nationales, Minutier central, Etude XXX, Liasse 278, in E. L. Faucheux, "Testament de Crozat," *Revue Universelle des Arts* (1857): 433–439.

43. Louis Courajod, "Documents sur la vente du Cabinet de Mariette," *Nouvelles Archives de l'Art Français* (1872): 350.

44. Lina Propeck and Laurence Lhinares, "Signatures, marques et paraphes administratifs des dessins du Louvre, 1671–1796," *Revue du Louvre* 2 (2003): 45–55.

45. Christian Michel, *Charles-Nicolas Cochin et l'art des Lumières* (Rome: Ecole Française de Rome, 1993).

46. François Boucher, *Neptune and Amymone,* Département des Arts Graphiques, Musée du Louvre, Inv. 24752; cf. Françoise Joulie, in *François Boucher hier et aujourd'hui,* exhibition catalogue (Paris: Musée du Louvre, 2003), cat. 39.

47. Valentine de Chillaz, *Musée du Louvre. Département des Arts Graphiques. Musée d'Orsay. Inventaire Général des Autographes* (Paris: Réunion des musées nationaux, 1997), nos. 1602–1652bis.

48. Philippe de Chennevières and Anatole de Montaiglon, *Abecedario de Mariette et autres notes inédites de cet amateur sur les arts et les artistes. Ouvrage d'après les manuscrits autographes conservés au Cabinet des Estampes de la Bibliothèque Impériale et annoté par Ph. de Chennevières et A. de Montaiglon,* 6 vols. (Paris, 1851–1860).

49. Roseline Bacou, *Le Cabinet d'un Grand Amateur P.J. Mariette* (Paris: Musée du Louvre, 1967), p. 17ss.

50. Andrew McClellan, *Inventing the Louvre: Art, Politics, and the Origins of the Modern Museum in Eighteenth-Century Paris* (Berkeley: University of California Press, 1999), pp. 217–218, note 9.

51. Courajod, "Documents sur la vente du Cabinet de Mariette," pp. 347–348.

52. Ibid., p. 368.

53. Its provenance was known; it had belonged to the Neapolitan painter Francanzano, then was passed on to Crozat and the Marquis de Gouvernet.

54. Département des Arts graphiques, Musée du Louvre, Inv. 23703 to 23710; cf. Jean-François Méjanes, in *Le Paysage en Europe du XVIe au XVIII siècle,* exhibition catalogue (Paris: Musée du Louvre, 1990), cat. 41.

55. Pierre Rosenberg and Udolpho van de Sandt, *Pierre Peyron, 1744–1814* (Paris: Arthena, 1983), p. 168.

56. Giovanni Odazzi (1663–1731), *Annunciation,* Département des Arts Graphiques, Musée du Louvre, Inv. 3344; cf. Catherine Loisel Legrand, *La Rome baroque de Maratti à Piranesi,* exhibition catalogue (Paris: Musée du Louvre, 1990), cat. 91.

I *The Collection of Everhard Jabach*

It is well known that the 1671 acquisition of Everhard Jabach's collection brought important masterpieces into the Cabinet du Roi. Quantitatively, works from the Italian school predominate: more than 4,000 out of 5,227 drawings are Italian, even though other European artists, such as Dürer and Rubens, figured strongly in Jabach's research.

At the time, many of the drawings were still unmounted loose sheets, called by Jabach *de rebut* (set aside) drawings in the sale inventory. These drawings can be identified today because they bear the Jabach paraph on the verso. Although

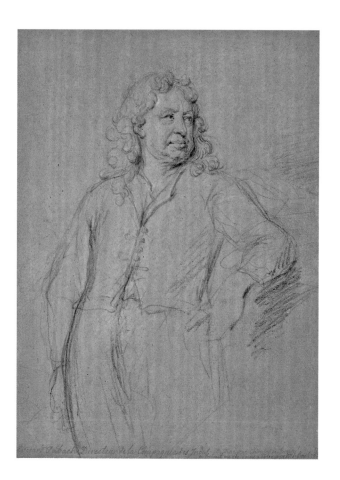

Hyacinthe Rigaud (French, 1659–1743), *Everhard Jabach,* black and white chalk on buff paper, Kupferstichkabinett, Staatliche Museen zu Berlin, Berlin.

the *de rebut* drawings were often sketches or details, some of them (see cats. 1, 4, 29, 31, and 33) have been subsequently classified as major works by some of the greatest artists of the sixteenth century—from Andrea del Sarto to Hans Holbein.

The mounted sheets were glued onto what has been defined as the "Jabach mount," surrounded by the characteristic strip of pure gold leaf and described by the collector himself as drawings of *ordonnance* (usually, but not always, meaning those works that had a composition that could be described, such as *Fall of the Giants* or *Adoration*—for example, cats. 11, 12, 14, 15, 16, 19, 20, 25, 27, and 28). Several drawings of *ordonnance,* although considered finished and valuable works at the time, were considerably altered by heavy retouching with white gouache or brown ink wash (cat. 28). It is known that Jabach employed Michel Corneille le Jeune to "rejuvenate" his drawings. The collector deserves credit for having kept numerous pages of Giorgio Vasari's *Libro de' Disegni* (cats. 21–24) almost intact—although he systematically inserted his own gold-leaf border onto the Vasari mounts. In the case of some sketchbooks—such as Federico Zuccaro's travelogs (cat. 26), in which the artist recorded scenes of daily life in Florence—Jabach seems to have dismembered them. *CL*

Note to the Reader
In the entries that follow, bibliographical references are selective and limited by space.

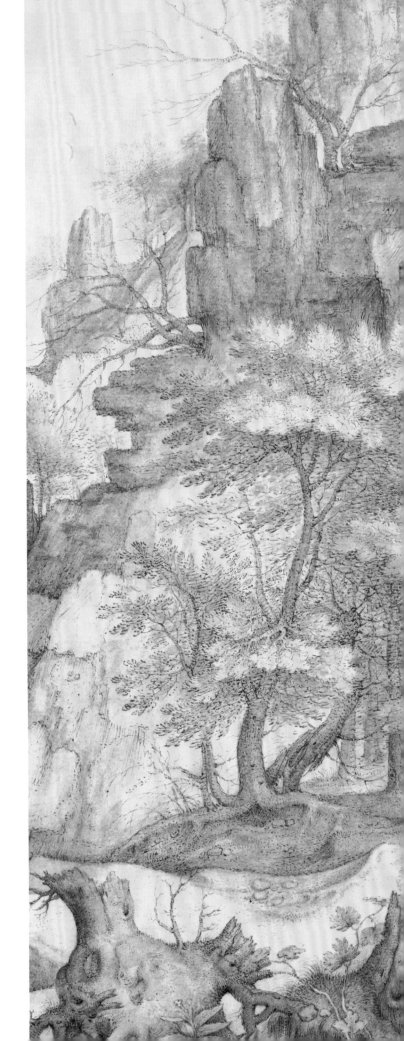

I

Lucas Cranach the Elder
(Kronach 1472–Weimar 1553)

Head of Young Boy with Reddish Blond Hair

Pen and brush, brown and black inks; brown, gray, and ochre
wash; gouache
8½ × 6¾ inches
Inv. 19207
Denver

Cranach was court painter to Frederick the Wise of Saxony, who called him to Wittenberg in 1505, where the artist remained all his life. Very closely linked to Martin Luther and the emergent Protestant Reformation, he is with Dürer and Grünewald one of the major figures of early German sixteenth-century art.

The striking immediacy of the young boy's image depicted in this sheet gives it a timeless and convincing quality that can be compared to a snapshot. It has not been connected to any painted work and was probably an exercise in life-study. This sheet has been placed early in Cranach's career and dated by specialists at around 1509. It was among the unmounted drawings (*de rebut*) in the collection of Jabach and was identified as a work by Cranach in the early twentieth century by Friedrich Winkler. Another drawing at the Louvre (fig. 16), with the same provenance, portrays a boy of about the same age but with shorter, blonder hair. The two sheets might well have been executed as a pair. Portrait images of young boys are rare in the art of the period, which focused on younger children, who could be used as studies for the Infant Christ or the young John the Baptist. *VF*

BIBLIOGRAPHY
Lucas Cranach: Glaube, Mythologie und Moderne, exhibition catalogue (Hamburg, Bucerius Kunst Forum), entry by Werner Schade with Ortrud Westheider and Silke Schuck. Ostfildern: Hatje Cantz Verlag, 2003, cat. 9.

Fig. 16. Lucas Cranach the Elder, *Head of a Young Boy with Blue Eyes,* black ink, gouache, brown wash, brown ink, charcoal, and pencil, Département des Arts Graphiques, Musée du Louvre, Inv. 19208.

2

Mathis Gothart Nithart, called Grünewald
(Würzburg circa 1470/1480–Halle 1528)

Portrait of a Woman Wearing a Bonnet

Black chalk; framing lines in black ink; glued to secondary support;
apocryphal monogram of Albrecht Dürer: *A D* on upper left
8 × 5 inches
Inv. 18588
Atlanta

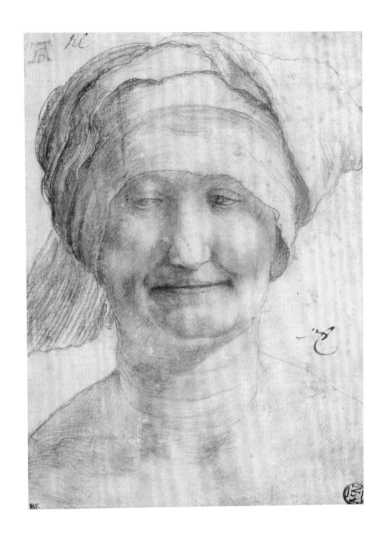

The nickname Grünewald was given to the artist by Joachim von
Sandrart, a painter and the author of the first history of German
art in the seventeenth century. Little is known of the painter who
was called "Master Mathis" by his contemporaries. We know that he
was employed by the Archbishop of Mainz, Uriel von Gemmingen,
and his successor, Albrecht von Brandenburg, who was also an impor-
tant patron of Cranach and Dürer. Grünewald's art is distinctive for
its visionary power, the force of its expression, the extraordinary use
of color, its magical light, and its inorganic forms that tend toward a
certain "expressionism" *avant la lettre.*

Attributed to Dürer in old Louvre inventories, probably because
of the apocryphal monogram, this sheet is one of the approximately
thirty known drawings by Grünewald and was identified as his work
by Max J. Friedländer in the early twentieth century. Scholars have
underlined the portrait-like quality of representation of the older
woman, shown with a squint in her left eye and the suggestion of a
smile. Her physical and psychological presence would indicate that
she was drawn from life in an effort to record her features rather than
to idealize them. The same model was drawn in two other works,
one in the Ashmolean Museum, Oxford, and another in the Reinhart
Foundation, Winterthur, Switzerland.

Between 1512 and 1516, Grünewald painted his most famous
work, the *Isenheim Altarpiece,* for the church of the Antonines in Isen-
heim, today in the Musée d'Unterlinden, Colmar, France. The woman
in this sheet has been related stylistically to the altarpiece, and a dating
has been suggested around the same period. *VF*

BIBLIOGRAPHY
Dessins de Dürer et de la Renaissance germanique, exhibition catalogue, entry by Emmanuel
Starcky. Paris: Musée du Louvre, 1991, cat. 124.

3

Albrecht Dürer

(Nuremberg 1471–Nuremberg 1528)

Study for Saint Barbara in *The Virgin Surrounded by Saints*

Black chalk on green prepared paper; framing lines in pen and black
ink; monogram *AD* and date *1521* at upper right in the artist's hand
16⁵⁄₁₆ × 11¼ inches
Inv. 18590
Atlanta

Dürer is, without doubt, the most important artist of sixteenth-century Germany, one of the first Northerners who can be called an artist of the Renaissance. He is distinguished by the broad range of his subject matter and his abundant production of paintings, drawings, and prints of religious subjects, mythologies, allegories, portraits, landscapes, animal studies, anatomies, and theoretical writings. Dürer can be seen as a bridge figure between the North and Italy, which he visited twice for lengthy stays.

This drawing on green prepared paper is of a type common in the art of Albrecht Dürer and German drawings in general. Probably sketched from life, it has been connected to the figure of Saint Barbara in *Virgin Surrounded by Saints,* a composition which was never executed as a painted work but for which many other studies survive.

Another Louvre drawing (fig. 17) records the entire scene with the Virgin and Child seated on an elevated throne at the center and a musical angel at her feet. She is flanked by four Old and New Testament characters and, at lower level, by three virgin martyrs. The third virgin saint from the left has been identified as Saint Barbara because of her attribute of a ciborium surmounted by a host. She is thus represented as the patron saint of "good death," a popular German theme. The composition is derived from the Venetian *Sacra Conversazione* (Sacred Conversation) type, with the Virgin on an elevated throne surrounded by saints in silent meditation. In the Louvre sheet of the larger composition, for which this Saint Barbara is a study, the Venetian scheme has been fused with a Northern *Holy Kinship* theme and the ancestry of Christ, including the named figures of Jacob, Joseph, Joachim, Zacharias, John, David, Elizabeth, and Anna. *VF*

Fig. 17. Albrecht Dürer, *Virgin and Child in Majesty, surrounded by Saints and Angels,* brown ink, Département des Arts Graphiques, Musée du Louvre, RF 1079.

BIBLIOGRAPHY

Dessins de Dürer et de la Renaissance germanique, exhibition catalogue, entry by Emmanuel Starcky. Paris: Musée du Louvre, 1991, cat. 69.

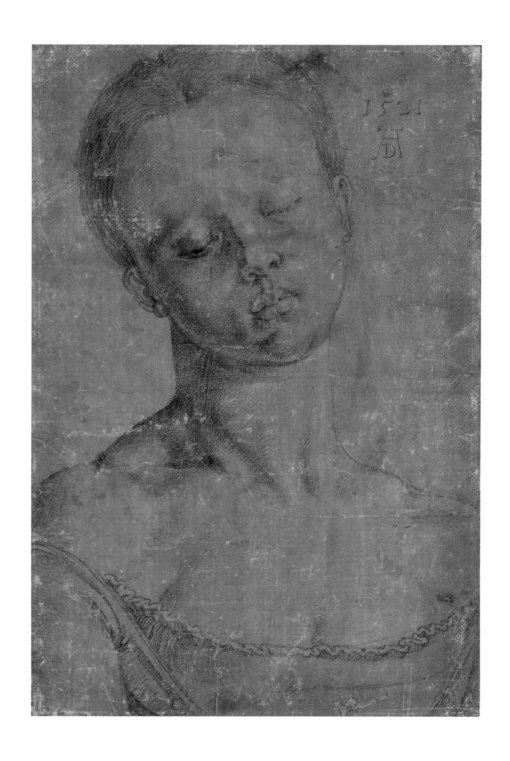

29

4
Hans von Aachen
(Cologne 1551/2–Prague 1615)

Venus and Adonis (recto)
Putto Lying on His Back (verso)

Pen and brown ink, brown wash (recto);
black chalk, pen, and brown ink (verso)
7⁵⁄₁₆ × 10 inches
Inv. 21071
Denver

The subject illustrated on this sheet is a free interpretation of an episode in Ovid's *Metamorphoses:* Venus is trying to hold back Adonis from going hunting, as he will be fatally gored by the boar he is set to hunt. The detail of the goddess embracing and restraining the hunter is not specifically described in the text, but the representation was a favorite one for Venetian artists such as Titian and Veronese, who depicted it in many painted versions. The drawing, dated to the 1580s, is preparatory for a painting in the Herzog Anton Ulrich-Museum, Braunschweig, Germany, in which Cupid is added to the left of the composition. Both the drawing and the painted version are clearly influenced by Venetian art in the technique and in the representation of the scene.

Von Aachen traveled extensively in Italy before becoming one of the court artists of Rudolf II in Prague, joining the company of Giuseppe Arcimboldo, Bartholomeus Spranger, and Joseph Heintz. *VF*

Verso

BIBLIOGRAPHY
Rudolf II and Prague: The Court and the City, exhibition catalogue, entry by Eliška
Fučiková. Prague: Prague Castle Administration, 1997, cat. I.137.

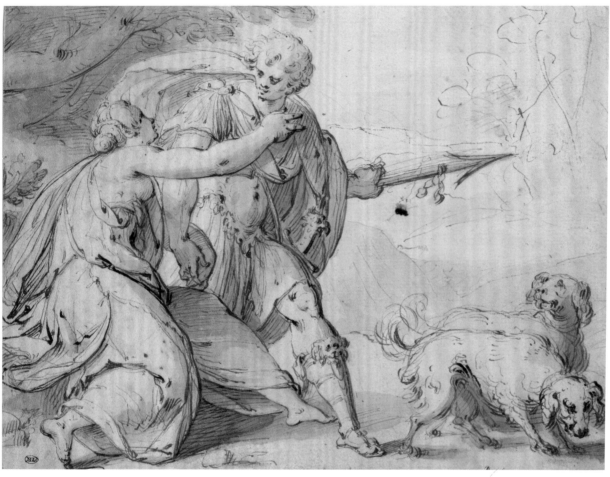

Recto

5

Joris Hoefnagel
(Antwerp 1542–Vienna 1601)

View of the Town of Alhama in Spain

Pen and brown ink, brown wash over traces of black chalk;
glued on a royal collection mount of the eighteenth century
15⅜ × 22⁵⁄₁₆ inches
Inv. 20722
Atlanta

Hoefnagel, who joined Rudolf II's court service in 1590, was a
painter, miniaturist, draftsman, cartographer, engraver, and poet.
Many of his topographical views executed between 1561 and 1567,
during his travels in Germany, England, Italy, France, and Spain, were
used to illustrate the *Theatrum Civitates Orbis Terrarum,* a compilation
of engravings in six volumes by G. Braun and F. Hogenberg, pub-
lished in Cologne between 1572 and 1612. The print after this draw-
ing is number 3 in volume 2. It represents the Spanish town of
Alhama, in the province of Grenada, which was destroyed during
an earthquake in 1884.

Although this sheet has lost the original gold band of Jabach's
drawings *d'ordonnance* (see introduction, page 25) when it was re-
mounted in the eighteenth century, it is described in his 1671 inven-
tory as "a drawing where there is a landscape representing a town and
several cliffs in the foreground." Interestingly, Jabach attributed it to
Gillis van Coninxloo, another landscape artist from Antwerp. It was
recognized as a work by Hoefnagel by Frits Lugt. *VF*

BIBLIOGRAPHY

Les Collections de Louis XIV, dessins, albums, manuscrits, exhibition catalogue, entry by Lise
Duclaux. Paris: Orangerie des Tuileries, 1977, cat. 110.
Lugt, Frits. *Inventaire Général des Dessins des Ecoles du Nord, Maîtres des Anciens Pays Bas
nés avant 1550.* Paris: Musées Nationaux, 1968, no. 375.

6

Roelandt Savery
(Courtrai 1576–Utrecht 1639)

Chimney Rock

Brush and gray ink, gray wash, pen and brown ink;
inscribed on lower center: *R. Saverÿ*; glued on a royal
collection mount of the eighteenth century
14⅜₆ × 21¼ inches
Inv. 20441
Denver

Savery practiced his art in his native Netherlands, before being called to the court of Rudolf II in Prague at the end of 1603. He thus joined the international group of artists who converged in the imperial city to form what would be called the School of Prague. He was later active in Amsterdam and Utrecht.

This landscape has been dated around 1605–1606, when the Emperor sent the artist around Bohemia to observe the wonders of nature and draw mountain landscapes, which would inspire his paintings. Savery used darker washes to stress the unusual shapes of the eroded rocks, leaving the background in gray outlines made with the brush. The light pen strokes reinforce the chimney rock and some areas of the view, becoming almost invisible as the space progresses into the distance. The play of light and dark washes and the fine pen strokes are brilliantly employed to guide the eye into the valley. *VF*

BIBLIOGRAPHY

Lugt, Frits. *Inventaire Général des Dessins des Ecoles du Nord. Ecole Hollandaise.* Paris: Musées Nationaux, 1968, no. 711.
Prag um 1600. Kunst und Kultur am Hofe Kaiser Rudolfs II, exhibition catalogue, entry by Joaneath Spicer. Vienna: Kunsthistorisches Museum, 1988, cat. 634.

7
Roelandt Savery
(Courtrai 1576–Utrecht 1639)

Limestone Cliffs

Pen and brown ink; glued to secondary support
20³⁄₁₆ × 19 inches
Inv. 20721
Atlanta

This study of a valley with vertiginous limestone cliffs has been linked to a landscape in southwestern Bohemia, where the artist traveled, and has been dated around 1606, slightly later than the *Chimney Rock*. The river flowing at the bottom of the valley has been identified as the Barrandian Basin, southwest of Prague. Great attention is given to depicting rock formation and rock layering. The immensity of nature is underscored by the small figure of the draftsman in the lower left corner, placed there almost as a signature. The darkness of the ink in the foreground fades as the eye moves into the distance. The thickness of the lines is also modulated to translate the effects of light. *VF*

BIBLIOGRAPHY
Lugt, Frits. *Inventaire Général des Dessins des Ecoles du Nord. Ecole Hollandaise.* Paris: Musées Nationaux, 1968, no. 710.
Spicer, Joaneath. "The Drawings of Roelandt Savery," PhD diss., Yale University, 1979, 53–54, fig. 13.

8

Matthijs Bril the Younger
(Antwerp 1550–Rome 1583)

*The Arch of Septimius Severus
in Rome*

Pen and brown ink; glued on a royal collection
mount of the eighteenth century; verso has been
opened up on the area of the annotation to allow
reading; annotated on verso in brown ink by Paul
Bril: *dit is een van die besste desenne die/Ick van matijs
mijn broeder nae het leeven hebbe* (this is one of the
best drawings after nature that I own by my brother
Matthijs)
8⅟₁₆ × 10⅞ inches
Inv. 20955
Atlanta

Matthijs Bril, who died very young, was the older brother of
the better-known Paul Bril. These drawings were done during
the years Matthijs and Paul lived in Rome, where Matthijs had gone
around 1574. A number of his drawings, including this and the follow-
ing sheet, were later copied by artists such as Jan Bruegel the Elder.

Jabach owned ninety-seven Bril drawings, which were attributed
solely to Paul Bril in his inventory. Jabach attributed these two draw-
ings to Paul, but they are by Matthijs, who was more interested in
topography and architecture than in landscape, which was Paul's pre-
dilection. Matthijs worked from life, as the annotation on the verso
of the sheet with the triumphal arch testifies: *"nae het leeven"* (after
nature). This statement, deciphered by Frits Lugt, was essentially
important for the reattribution to the older brother of many drawings
at the Louvre and in other collections. Sheets such as this show the
Renaissance interest in the remnants of Antiquity and lie at the origin
of the Italian genre of the *veduta* (view). Matthijs is also seen as an
early practitioner of the Classical landscape, a precursor of Nicolas
Poussin and Claude Lorrain, two other artists from the North who
worked in Rome. *VF*

BIBLIOGRAPHY

Les collections de Louis XIV, dessins, albums, manuscrits, exhibition catalogue, entry by Arlette
Sérullaz. Paris: Orangerie des Tuileries, 1977, cat. 132.

Lugt, Frits. *Inventaire Général des Dessins des Ecoles du Nord. Ecole Flamande.* Vol. 1. Paris:
Musées Nationaux, 1949, no. 356.

9
Matthijs Bril the Younger
(Antwerp 1550–Rome 1583)

The Septizonium in Rome

Pen and brown ink; glued on a royal collection
mount of the eighteenth century
8 × 10¹³⁄₁₆ inches
Inv. 20960
Atlanta

The Septizonium was erected under Septimius Severus and demolished by Domenico Fontana between 1588 and 1589 on the orders of Pope Sixtus V. *VF*

BIBLIOGRAPHY

Les collections de Louis XIV, dessins, albums, manuscrits, exhibition catalogue, entry
by Arlette Sérullaz. Paris: Orangerie des Tuileries, 1977, cat. 133.
Lugt, Frits. *Inventaire Général des Dessins des Ecoles du Nord. Ecole Flamande.* Vol. 1.
Paris: Musées Nationaux, 1949, no. 361.

10

Paul Bril
(Antwerp 1554–Rome 1626)

Landscape with Figures and a Cross

Pen and brown ink, brown and gray wash; annotated
on lower right in pen and ink: *Pauwels Bril / 1604
Roma;* glued on a royal collection mount of the
eighteenth century
7 × 10⅝ inches
Inv. 19772
Denver

The twenty-year-old Paul joined his older brother Matthijs in Rome and stayed on long after Matthijs's early death. This signed and dated sheet was done in Rome in 1604. It offers a good example of the means by which Paul composed his many landscapes, a subject much favored by Northern artists. The Bril brothers were important in developing the taste for landscape in Italy. Paul uses rather old-fashioned curved "shelves," or slopes, of landscape stacked one behind the other to suggest the recession into depth. These present a gradation of tone, working here from the dark foreground to a pale middle distance, where he places the small figures and a tall cross, and on to the distant horizon. The composition was etched by the Comte de Caylus in *Recueil d'Estampes d'après les plus beaux tableaux et d'après les plus beaux dessins qui sont en France dans le Cabinet du Roy,* Paris, 1742, plate 221. This drawing has not been exhibited since the beginning of the nineteenth century. *VF*

BIBLIOGRAPHY
Ruby, Louisa Wood. *Paul Bril. The Drawings.* Turnhout, Belgium: Brepols, 1999, p. 94, no. 42, pl. 44.

I I

Circle of Giulio Romano, retouched by

Peter Paul Rubens

(Siegen, Westphalia 1577–Antwerp 1640)

Head of a Man with a Helmet

Pen and brown ink over traces of black chalk, retouched by
Rubens with oil-based pigments; inscribed in pen on upper
left corner: *Jul R.* (*J* cut by the mount; *R* followed by other
letters also cut by the mount—probably for *Jiulio Romano*);
mount of Jabach's drawings of *ordonnance*

11⅜₁₆ × 7⅛ inches

Inv. 20251

Atlanta

Rubens went to Italy in 1600 and only returned to Antwerp in 1608 after visiting several Italian cities. In 1601 he entered the service of Duke Vincenzo I Gonzaga at Mantua. There he was surrounded by the work of Giulio Romano, who had been court artist of Federico Gonzaga in the previous century (see cats. 18 and 19). Recent scholarship has argued that Rubens not only executed copies after works he saw in Italy but also acquired copies by many other artists (see Wood 2002, cited in cat. 12). His collection thus constituted a sort of "paper museum" that he brought back to Antwerp and used as inspiration throughout his career, retouching the drawings as he saw fit.

Jabach, whose family had employed Rubens to paint an altarpiece in the family chapel in Cologne, attributed the present drawing to Rubens. Lugt argued in 1949 that this sheet is derived from Giulio Romano, and Rubens specialists such as Anne-Marie Logan (to this author, 2005) have identified Rubens's hand particularly in the oil-based heightening around the edge of the helmet and in the group of the three figures. Other interventions by Rubens are the darker ink lines, both in pen and brush, found in several areas, such as on the right side of the helmet. The scene represents Hercules fighting the Centaur Nessus, who is attempting to abduct Deianeira. This sheet has never before been exhibited. *VF*

BIBLIOGRAPHY

Lugt, Frits. *Inventaire Général des Dessins des Ecoles du Nord. Ecole Flamande.* Vol. 2. Paris: Musées Nationaux, 1949, no. 1103.

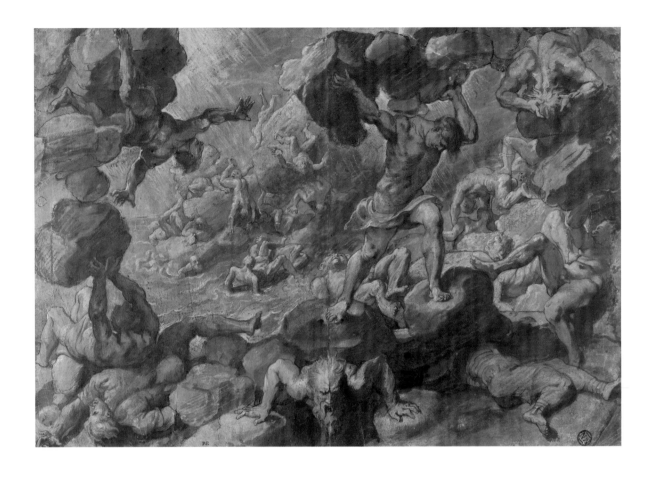

12

Anonymous sixteenth-century artist after
Giulio Romano, retouched by

Peter Paul Rubens

(Siegen, Westphalia 1577–Antwerp 1640)

The Fall of the Giants

Pen, black and brown inks over traces of black
chalk; brown and gray wash; gouache, and oil-based
pigments; mount of Jabach's drawings of *ordonnance*
10 × 15 ¹¹⁄₁₆ inches
Inv. 20177
Atlanta

The fight between the Olympian Gods and the rebel Giants was
the subject of the entire *Sala dei Giganti,* decorated by Giulio
Romano in the Palazzo Te at Mantua in 1532–1534 (see cat. 19).
The Fall of the Giants is the narrative's dramatic culmination. Although
Rubens knew the original frescoed room well from his years in Man-
tua, the composition of this sheet seems to have been copied from
another source—an anonymous sixteenth-century Netherlandish
drawing at the Rijksprentenkabinet, Amsterdam—itself reproduced
in an engraving attributed to Cornelis Bos. The heavy reworking of
this sheet by Rubens, with interventions over the whole surface, has
been dated by Jeremy Wood to the 1620s. The original idea's evolu-
tion from one great artist to another (Giulio Romano to Rubens),
carried by intermediary links (anonymous Netherlandish copy,
engraved by a Northern printmaker), makes for a very intricate
art historical problem. *VF*

BIBLIOGRAPHY
Wood, Jeremy. *Rubens: Drawings on Italy,* exhibition catalogue. Edinburgh: National
Gallery of Scotland and Nottingham, Djanogly Art Gallery, 2002, cat. 35.

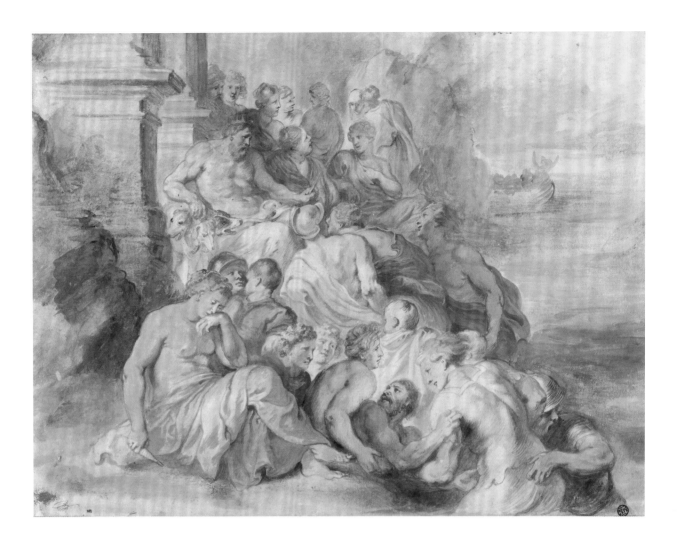

13

Peter Paul Rubens
(Siegen, Westphalia 1577–Antwerp 1640)
after Francesco Primaticcio

King Minos Judging the Dead at the Entrance to the Underworld

Brush and colored wash, heightened with gouache and oil-based pigments
16¹⁄₁₆ × 21¹⁄₁₆ inches
Inv. 20262
Denver

This is a drawn copy entirely made by Rubens—these are fewer in number than his interventions on drawings by other artists (see cats. 11 and 12). In the 1620s Rubens traveled to Fontainebleau, where he visited the château, including the Galerie d'Ulysse. The scene represented here, frescoed by Primaticcio, no longer survives. It is derived from Homer's *Odyssey* and shows King Minos seated next to Cerberus, the three-headed watchdog of the Underworld. Ariadne, daughter of Minos, is sitting pensively in the left foreground holding a spindle. Primaticcio also had worked in Mantua, under Giulio Romano, and had been called to work in France by King Francis I in 1532. The use of only the brush and multiple color washes points to a date in the 1630s, according to Jeremy Wood, who relates it to the artist's colored oil sketches. *VF*

BIBLIOGRAPHY
Wood, Jeremy. *Rubens Drawing on Italy,* exhibition catalogue. Edinburgh: National Gallery of Scotland and Nottingham, Djanogly Art Gallery, 2002, cat. 63.

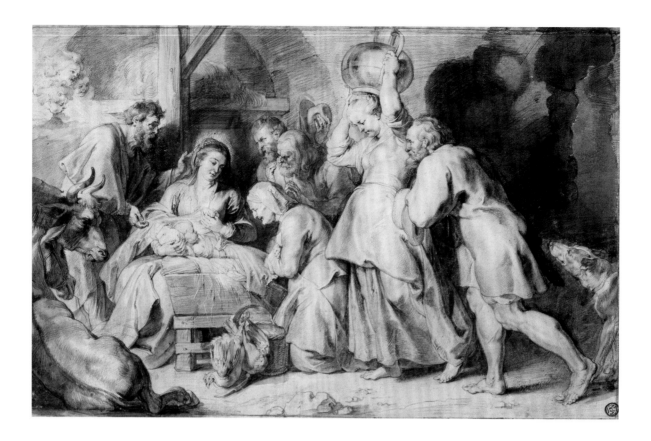

14

Anthony Van Dyck

(Antwerp 1599–London 1641) retouched by

Peter Paul Rubens

(Siegen, Westphalia 1577–Antwerp 1640)

The Adoration of the Shepherds

Black chalk, pen and brown ink, gray wash, white
gouache; traces of stylus; framing lines in black chalk;
mount of Jabach's drawings of *ordonnance*
11⅜ × 10 inches
Inv. 20318
Denver

After his return from Italy in 1608, Rubens decided to engage in the production of prints after his painted works, employing artists who could draw the compositions and others who would engrave them. Thus, in 1619, he sought to obtain the patent-like protection known as the "privilege" in France, Brabant, the Spanish Netherlands, and Holland.

The preliminary design for the print of the *Adoration of the Shepherds* was executed by his young assistant, Van Dyck, after the left scene of the *predella* of a triptych painted for the church of Saint John in Mechelen, now in the Musée des Beaux-Arts, Marseille. The engraving, dated 1620, was done by Lucas Vorsterman, who was frequently employed by Rubens. Van Dyck drew the night scene using black chalk and a gradation of gray washes, following the painting closely except for the shepherd at the right, who is more bent forward and who, in the print, is shown leaning on a stick. Rubens retouched the work minimally with lines in pen and brown ink. The very dark area on the right of the sheet is probably a stain. *VF*

BIBLIOGRAPHY

Antoine van Dyck et l'estampe, exhibition catalogue, entry by Carl Depauw. Antwerp: Plantin-Moretus/stedelijk Prenten Kabinet, 1999; Amsterdam: Rijksmuseum, Rijksprentenkabinet, 2000, cat. 3.

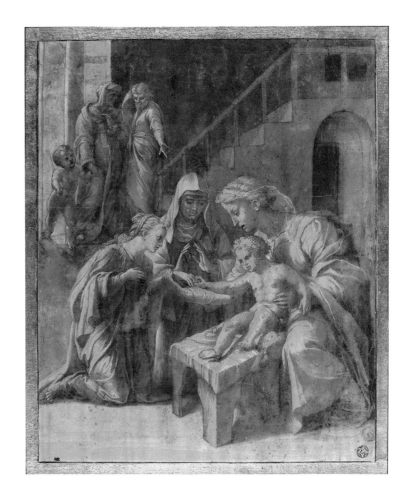

15

Girolamo Genga
(Urbino ca. 1476–Urbino 1551)

The Mystic Marriage of Saint Catherine of Alexandria with Saints

Pen and brown ink, brown wash, and white gouache over traces of black chalk on paper tinted light brown; mount of Jabach's drawings of *ordonnance*
13⁷⁄₁₆ × 11 inches
Inv. 3462
Denver

This sheet, dated around 1519, is preparatory for a painting of the same subject in the Galleria Nazionale d'Arte Antica, Palazzo Barberini, in Rome (fig. 18). It was previously thought to be a work by Giulio Romano because of stylistic similarities, until Philip Pouncey made the new attribution to Genga, relating it to the painting. The subject of the mystic marriage of Saint Catherine of Alexandria is taken from the *Golden Legend,* a thirteenth-century compilation of saints' lives by the Dominican bishop of Genoa, Jacopo da Voragine. Catherine—a high-born, learned, and beautiful maiden from Alexandria, patron of education and learning—had a vision during which she underwent a mystic marriage with the infant Christ, shown here on his mother's lap. The female figure next to her is Saint Catherine of Siena, wearing the white tunic and veil and black cloak of the tertiary sisters of the Dominican order. Elizabeth, her husband, Zacharias, and their young son, John the Baptist, are in the background. In the painting, Bernardino of Siena, an old man with emaciated features dressed as a Franciscan friar, has been added on the right. Scholars have suggested a possible link with the Oratory of the Sienese in Rome, dedicated to Saint Catherine. *VF*

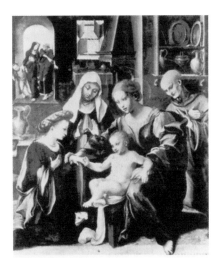

Fig. 18. Girolamo Genga, *The Mystic Marriage of Saint Catherine of Alexandria with Saints,* oil on canvas, Galleria Nazionale d'Arte Antica, Palazzo Barberini, Rome.

BIBLIOGRAPHY

L'Œil du Connaisseur, exhibition catalogue, entry by Dominique Cordellier. Paris: Musée du Louvre, 1992, cat. 6.

16

Francesco di Cristofano, called Franciabigio
(Florence ca. 1484–Florence 1524/1525)

Man Wearing a Bonnet
Black chalk and stumping; mount of Jabach's drawings of *ordonnance*
11³⁄₁₆ × 9¹⁵⁄₁₆ inches
Inv. 1204
Denver

The attribution of this impressive portrait has changed over the years from Baldassarre Peruzzi, as Jabach thought, to Andrea del Sarto, before being attributed to his collaborator Franciabigio in 1866 by Frédéric Reiset, then curator of drawings at the Louvre. The careful study of the man's features, his furrowed brow, the circles under his eyes—rendered without idealization, with the intention of conveying his psychological state—is a characteristic also found in Andrea del Sarto and could be related to Northern drawings such as the Grünewald woman (cat. 2). The skillful use of black chalk, varied in its thickness of line due to a change in the pressure of the artist's hand, carefully smudged in some areas, is employed to render the transition from light to shadow over the structure of the face. The portrait has been dated by scholars to the 1520s. *VF*

BIBLIOGRAPHY
Cordellier, Dominique. *Hommage à Andrea del Sarto,* exhibition catalogue. Paris: Musée du Louvre, 1986–1987, cat. 66.

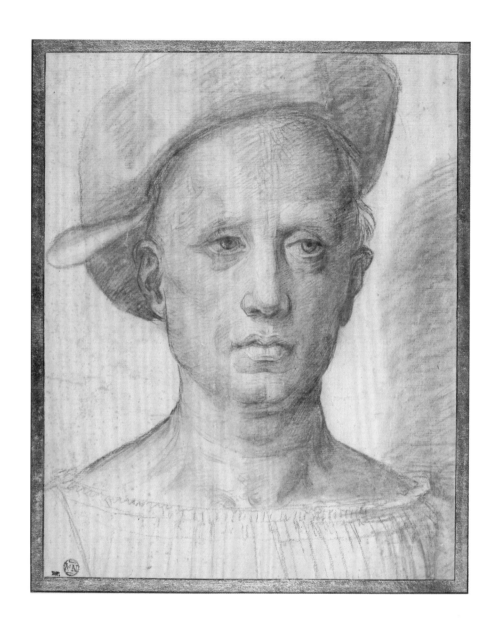

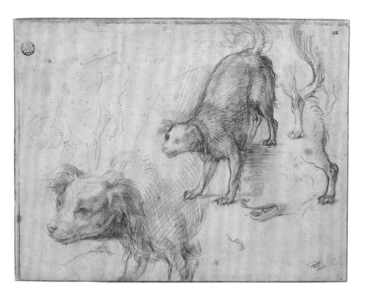

Recto

Verso

17

Andrea d'Agnolo, called Andrea del Sarto

(Florence 1486–Florence 1530)

Study of Dogs (recto)
Study of Dogs (verso)

Red chalk; annotated on center verso with pen: *Turpilio,* and with black chalk on lower right: *Andrea del Sarto Pittor fiorentino*
7½ × 10 inches
Inv. 1687
Denver

The studies represented on the recto and on the verso of this sheet are for the dog running down the steps in the fresco of *The Tribute to Caesar* in the Medici villa at Poggio a Caiano, dated 1519–1521, commissioned by the Medici Pope Leo X. The image has the immediacy of a drawing done from life, with some details taken up separately. The use of the red chalk is masterly; the possibilities of the medium are exploited here to the maximum. The lines' variable thickness, changes in direction, and intensity reproduce the liveliness of the dog's movements. The attention to living beings such as animals, as well as the use of both black and red chalk, can be traced back to another Florentine, Leonardo da Vinci: a "portrait" of a dog in red chalk is found on one of the pages of the pocket-sized manuscript I, at the Institut de France in Paris, dated circa 1497. *VF*

BIBLIOGRAPHY

Cordellier, Dominique. *Hommage à Andrea del Sarto*, exhibition catalogue. Paris: Musée du Louvre, 1986–1987, cat. 30.

18

Giulio Pippi, called Giulio Romano
(Rome 1492/1499–Mantua 1546)

Jupiter's Eagle Bringing Psyche the Water of the River Styx

Pen and brown ink, brown wash, and white gouache on paper tinted with brown wash; glued to secondary support

7⅜ × 11 inches

Inv. 3676

Denver

Fig. 19. Giulio Romano, *Wedding Feast of Cupid and Psyche* (detail) from the *Sala di Psiche,* Palazzo Te, Mantua, Italy.

Giulio Romano was the chief assistant in Raphael's *bottega* in Rome before moving to Mantua in 1524 to work for the Marquess Federico Gonzaga. He worked at the Palazzo Te, which he designed as an architect and then decorated with the help of many assistants. It is there that his Mannerist art developed to its fullest. Each room is dedicated to a different theme. One is the Hall of Psyche, 1528–1530, decorated with the episodes of the love story between Cupid and Psyche, derived from the *Golden Ass* by Apuleius. It was a subject very familiar to Giulio, who had worked with Raphael for Agostino Chigi on the frescoes of the *Loggia di Psiche,* in what is now the Villa Farnesina in Rome.

The drawing of *Jupiter's Eagle Bringing Psyche the Water of the River Styx* is preparatory for one of the room's twelve lunette frescoes, this one placed above the *Wedding Feast of Cupid and Psyche* (fig. 19). Venus, jealous of Cupid and Psyche's love, imposed many impossible tasks on the maiden, trying to put obstacles between them. Psyche had to get a vase of the water of the river Styx, which flows in the Underworld. In the scene drawn here, Jupiter, trying to help Psyche, sends his eagle to fetch the water for her. Although the drawing has lost its original mount, in Jabach's 1671 inventory there is a description of "a witch sitting on a mountain and an eagle brings her a vase and two dragons," which has enabled scholars to identify it. *VF*

BIBLIOGRAPHY

Autour de Raphaël, exhibition catalogue, entry by Roseline Bacou. Paris: Musée du Louvre, 1983–1984, cat. 48.

19

Giulio Pippi, called Giulio Romano
(Rome 1492/1499–Mantua 1546)

Study for the *Sala dei Giganti: The Gods of Olympus Frightened by the Attack of the Giants*

Pen and brown ink, brown and ochre wash, and white gouache over traces of black chalk on paper tinted gray-beige; traces of squaring in black chalk; three sheets of paper joined vertically, with missing parts on the left and right edges; mount of Jabach's drawings of *ordonnance*

19¾ × 36¼ inches

Inv. 3476

Denver

This very large sheet illustrates one of the Greek myths of creation derived from Hesiod's *Theogony*. It is preparatory for part of the frescoed ceiling of the *Sala dei Giganti* (fig. 20), the most singular room of the Palazzo Te, which is one enormous Mannerist illusion and almost a paradigm of Mannerist art. It depicts the revolt of the Giants, children of Gaia (the Earth), who want to take over Olympus. The Olympian Gods are frightened by the violent attack, as they are shown here, but the Gods ultimately will crush the Giants. Some of the Gods can be identified: Neptune with his trident, Minerva with her helmet, Diana on a chariot with the crescent moon on her hair. The scene is one of terror and fright, in total contrast with the cycle of Psyche (see cat. 18), where the theme is voluptuous love. *VF*

BIBLIOGRAPHY

Autour de Raphaël, exhibition catalogue, entry by Roseline Bacou. Paris: Musée du Louvre, 1983–1984, cat. 57.

Giulio Romano, exhibition catalogue, entry by Konrad Oberhuber. Mantua, Italy: Palazzo Te, 1989, p. 376.

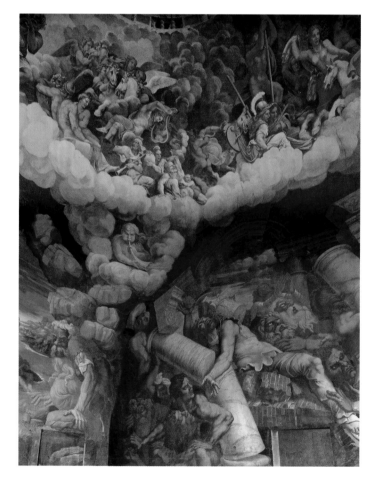

Fig. 20. Giulio Romano, *Giants Assault on Olympus* (detail) from the *Sala dei Giganti,* 1532–1534, Palazzo Te, Mantua, Italy.

20

Giorgio Vasari
(Arezzo 1511–Florence 1574) and

Jacopo Zucchi
(Florence 1542?–Rome 1596)

Study for an Altarpiece with the "Last Judgement"

Pen and brown ink with brown wash over traces of black
chalk on paper; gold band of Jabach's drawings of *ordonnance*
28¹⁵⁄₁₆ × 18 inches
Inv. 2153
Atlanta

Giorgio Vasari was a painter, architect, decorator, and collector. But he is best known as an art historian, author of *Le Vite de' più eccellenti Pittori, Scultori ed Architettori* (1550 and 1568), a compendium of biographies of artists and the basis for modern art history. It is mostly dedicated to the rise of Italian art, beginning in the thirteenth century and ending with artists still alive when he was writing. As a collector, Vasari focused on drawing, which he considered to be the "mother of all arts." He gathered works on paper by many of the artists whose lives he described and mounted them onto the pages of the volumes of his *Libro de' disegni*. It has been estimated that by the end of his life he owned between eight and twelve volumes, each with at least a hundred pages. The drawings were inserted in folio-sized books, sometimes with more than one drawing glued onto a page. Vasari then had another artist draw a decorative border in pen and ink directly onto the page, individually designed according to the size and subject of the work. Occasionally, the author's name was written in a cartouche inserted in the border.

On this large sheet, two drawings by Vasari are glued onto the center of the page: the lower rectangular work with the Archangel Michael brandishing a sword and separating the saved from the damned, and the lunette above, with Christ in glory surrounded by the saints. The very complex architectural structure of the altarpiece around the Vasari drawings has been recently attributed to Jacopo Zucchi, Vasari's pupil and collaborator. He was one of the draftsmen who often drew the borders in Vasari's *Libro*.

According to Catherine Goguel, the work exhibited here looks like a page from the *Libro* but is in fact a *modello* for a very specific project: a large, freestanding high altar—conceived as a triumphal arch—commissioned by Pope Pius V for the church of Santa Croce

in his native town of Bosco Marengo in northern Italy. The pope's arms appear on the bottom. This *grande macchina* was executed between 1567 and 1569 and exists today in a dismembered state. *VF*

BIBLIOGRAPHY

Cecchi, Alessandro. "Jacopo Zucchi da Firenze a Roma," in *Villa Medici, il sogno di un cardinale, collezioni e artisti di Ferdinando de' Medici,* exhibition catalogue. Rome: Villa Medici, 1999–2000, 107.

Goguel, Catherine Monbeig. *Musée du Louvre. Cabinet des dessins. Inventaire général des dessins italiens I. Maîtres toscans nés après 1500, morts avant 1600. Vasari et son temps.* Paris: Musées Nationaux, 1972, no. 198.

LIONARDO CANGI DAL BORGO PITTORE :-

21

Leonardo Cungi

(Borgo San Sepolcro 1520/1530–
Rome 1569)

Standing Man Seen from Behind

Black chalk on blue paper; Vasari mount with
cartouche: *Lionardo Cangi dal Borgo Pittore;* gold
band of Jabach's drawings of *ordonnance*
20⁷⁄₁₆ × 10 inches
Inv. 1113
Atlanta

The decorative border of this study of drapery, with the label
containing the name of its author, indicates that it is a page from
Vasari's *Libro de' Disegni* (see cat. 20) that has been cut down from its
original size. The beautiful fall of the fabric as rendered by Cungi
finds an echo in the falling curves of the foliage set at the upper cor-
ners and in the bits of fabric falling along the sides of the imagina-
tively drawn frame. Catherine Goguel has compared the strikingly
illuminated figure of the man seen from behind to an apostle in the
foreground of the *Ascension,* a painting by Cungi dated 1558, in the
Oratorio of San Francesco in Perugia. This sheet has never before
been exhibited. *VF*

BIBLIOGRAPHY

Goguel, Catherine Monbeig. "Drawings by Vasari and His Circle in the Collection of
the Louvre: An Examination and New Findings." *Drawing* 11.1 (1989): 4–5, fig. 13.

22

Giovanni Taraschi
(Modena, active in mid-sixteenth century)

Female Warrior with a Putto Carrying Her Helmet and Spear

Pen and brown ink, brown and gray wash, with white and gray gouache heightening; Vasari mount with cartouche: *Giouanni Tarasco P.*, and gold band of Jabach's drawings of *ordonnance*
17¼ × 10⁵⁄₁₆ inches
Inv. 6789
Atlanta

Giouanni Tarasco P:~

Very few sources mention the two Taraschi brothers, Giulio and Giovanni, who remain rather shadowy figures. Local art historians like Girolamo Tiraboschi (1786) comment on their work and note the strong influence of Raphael, Giulio Romano, and Correggio. Giovanni is mentioned as a decorator involved in the preparation of the triumphal carriage used in 1556 for the celebration of the feast of the Corpus Domini, commissioned by the Compagnia di San Pietro Martire in Modena, to which he belonged. In the church of San Pietro are the tribune for the organ and two shutters painted by both brothers, dated 1546. The frescoed tribune shows narratives from the Old Testament; the organ's shutters show miracles of Saints Peter and Paul on one side and the Crossing of the Red Sea on the other. The metallic representation of the drapery found in the drawing exhibited here, the marmoreal stiffness of the female figure, and a certain theatricality of the gestures have parallels in the figures on the organ shutters.

This page from the *Libro de' Disegni* of Vasari (see cat. 20), cut down from its original size, has a border imitating architecture into which is set the arched-top drawing of the niche. Although the manner of doing this seems extremely simple, great care has been taken with the presentation: the gray curve at the top of the drawing by Taraschi has been enlarged, and the lower left corner, which was missing, has been reconstituted. This sheet has never before been exhibited. *VF*

23

Marco del Moro
(Verona 1535/1536–Verona after 1586)

Diana and Endymion

Pen and brown ink, indigo wash, white gouache on light
brown paper; Vasari mount with cartouche: *Giulio del Moro
Pittor Veronese;* gold band of Jabach's drawings of *ordonnance*
14½ × 10⁵⁄₁₆ inches
Inv. 5083
Denver

Diana, or the moon goddess Luna or Selene, with whom
she became identified, fell in love with the handsome Endymion, who had been put to endless sleep by Jupiter in exchange for
being granted eternal youth. Their love story is told by the Greek
writer Lucian in his *Dialogues of the Gods,* composed in the second
century AD. Marco del Moro has represented the moment of night
when the goddess discovers the sleeping youth and is struck by his
beauty. The scene, bathed in moonlight, is masterfully rendered by
a variety of indigo and gray washes with white heightening. The
concert of colors played on the sheet is typical of Veronese art and
is reminiscent of the art of Paolo Veronese. Certain departures from
canonical representation of the story, such as the young man's wearing armor rather than being dressed as a shepherd or the female
deity's not having the crescent moon headdress of Diana, have led
to an alternative identification of the couple as Venus and Adonis.

 The decorative border of Vasari's *Libro* (see cat. 20) is very elaborate and dedicated to the theme of sleep/death. All the figures around
the frame have covered heads, and the torches turned downward
symbolize the end of life, although they are not extinguished as they
would traditionally be to signify death. It is possible that Vasari himself, who commissioned the border, may have been uncertain about
the significance of the central scene. It must also be noted that Vasari
attributed the drawing to Giulio del Moro, Marco's uncle. *VF*

BIBLIOGRAPHY

Le dessin à Vérone aux XVIe et XVIIe siècles, exhibition catalogue, entry by Hélène Sueur.
Paris: Musée du Louvre, 1993, cat. 61.

24

Paolo Farinati
(Verona 1524–Verona 1606)

Saint Jerome

Pen and black ink with white gouache over paper
tinted in light, greenish-brown wash; Vasari mount
with cartouche: *Paolo Farinata Pitt: Ver.,* and gold
band of Jabach's drawings of *ordonnance*
16¾ × 10¹⁵⁄₁₆ inches
Inv. 4847
Atlanta

Giovanna Baldissin Molli has related this sheet to a painting of
The Virgin and Child with Saints Albert and Jerome in the church
of San Tommaso Cantuariense in Verona, on which a recent restora-
tion has revealed both the signature of Farinati and the date of 1555.
Hélène Sueur has questioned the attribution of the drawing to Paolo
Farinati because of the heaviness of the pen line and of the white
heightening, possibly due to later retouching.

The decorative border of Vasari's *Libro* (see cat. 20) reflects the
collector's desire to complement the central drawing. Here, large
volutes echo the curves of the drapery and the old man's curls. This
sheet has never before been exhibited. *VF*

BIBLIOGRAPHY

Baldissin Molli, Giovanna. "Nuovi affreschi di Paolo Farinati e qualche considerazione
sugli inizi." *Prospettiva* 71 (1993): p. 64, fig. 1B; p. 67, note 23.
Le dessin à Vérone aux XVIe et XVIIe siècles, exhibition catalogue, entry by Hélène Sueur.
Paris: Musée du Louvre, 1993, in cat. 32.

25

Paolo Farinati
(Verona 1524–Verona 1606)

Virgin and Child with the Young Saint John the Baptist

Pen and brown ink with brown wash and white gouache over traces of black chalk on faded blue paper; mount of Jabach's drawings of *ordonnance*

9 × 7 inches

Inv. 4813

Denver

This drawing has been related to a painting of the same subject in the Galleria Nazionale d'Arte Antica, Palazzo Barberini, in Rome, traditionally attributed to Farinati. The Virgin and Child is a subject that recurs frequently in his art. Hélène Sueur dates the drawing to around 1570 for stylistic reasons and underlines the strong influence of the art of Giulio Romano, especially evident in the type of the Virgin and the grouping of the figures. Farinati had a predilection for using blue paper, or paper given a colored wash, for his drawings. Combined with the pen and ink, the wash, and the white heightening, the result is a tonal work of distinct presence and character. *VF*

BIBLIOGRAPHY

Le dessin à Vérone aux XVIe et XVIIe siècles, exhibition catalogue, entry by Hélène Sueur. Paris: Musée du Louvre, 1993, cat. 34.

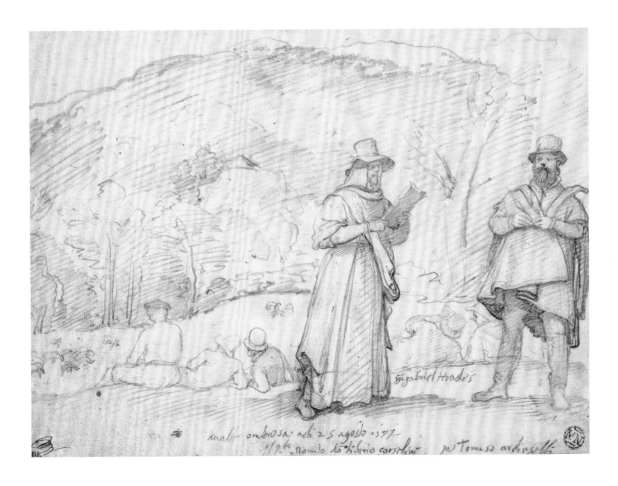

26

Federico Zuccaro
(Sant'Angelo in Vado 1539/1540–Ancona 1609)

Excursion to the Abbey of Vallombrosa,
25 August 1577

Black and red chalk; annotated by the artist in black chalk: *aualle*
ombrosa adi 25 agosto 1577 / Il Rto Romito dō Lidino Carselini and
M. Tomaso ardingelli / S.re Gabriel Terades
7⁵⁄₁₆ × 10 inches
Inv. 4582
Atlanta

Federico Zuccaro was trained by his older brother Taddeo and
collaborated on many of his projects. After his brother's death,
Federico had an international career in several European courts,
including France, the Netherlands, England, Spain, and many Italian
cities. In 1593 he was elected president (*Principe*) of the Accademia
del Disegno in Rome, an educational institution that aimed at pro-
ducing a new type of artist by training both the hand and the mind
in the study of nature, antiquity, and the great artists of the early
Renaissance.

In 1607, while in the service of the Savoy court in Turin, Zuccaro
published the theoretical treatise *Idea de' Pittori, Scultori ed Architetti.*
In a passage of this text, exhorting the young art student to study
nature, he writes, "if the painter, sculptor, and architect must operate,
paint, sculpt, or fabricate something, he must necessarily have as his
first model nature and the outer natural form of the skies, the stars,
comets, clouds, rain, snow, storms, the elements, stones, thickets,
mountains, hills, countryside, fields, valleys. . . ."

The Louvre sheet was drawn on an outing to the abbey of
Vallombrosa outside Florence on 25 August 1577. The date is noted
as well as the name of the friends who accompanied him. One is
standing next to the monk who is reading to the company; Federico
and the others are sitting or lying on the grass, observing and medi-
tating. The drawing is part of a series, coming from a dismembered
sketchbook, that describes the group's journey to the abbey, with
the crossing of the forest, the picnic stop with bread and wine, the
moment when the artist sketches the views, the arrival, and so on.
Zuccaro is historically significant in the way he exploits the expres-
sive possibilities of red and black chalk. *VF*

BIBLIOGRAPHY

Le Paysage en Europe, exhibition catalogue, entry by Catherine Loisel. Paris: Musée du
Louvre, 1989–1990, cat. 53.

27

Circle of Federico Zuccaro

Architectural Project

Pen and brown ink with brown and violet wash over traces
of black chalk; mount of Jabach's drawings of *ordonnance*
22⅝ × 16½ inches
Inv. 11054
Atlanta

This fanciful architectural composition proposes an alternative
solution for either side of the imaginative façade. On the right,
the lower scene shows the *Forge of Vulcan;* above, *Hercules* is set within
a niche. On the left side there is an opening at middle level, where
two figures—who appear to have been derived from a fresco by Paolo
Veronese—lean on a baluster while a dog walks on the outside edge.
At the top level on either side, naked figures stretch on a pediment;
they are derived from Michelangelo's *Times of Day* in the Sacrestia
Nuova of San Lorenzo in Florence.

Although Jabach attributed this very impressive sheet to Federico
Zuccaro, upon close examination one could argue that the line is too
forceful and some of the figures do not seem to fit into the artist's
known corpus. Federico Zuccaro painted a fresco in the Oratorio of
Santa Lucia del Gonfalone in Rome, dated 1569, where the *Flagellation*
is set within an architectural fantasy of many levels, with engaged col-
umns, arches, and moldings, and receding and projecting spaces that
recall the exhibited work. It is possible that an artist from Federico's
workshop executed it. Simonetta Prosperi Valenti Rodinò has sug-
gested Cesare Nebbia, an artist from Orvieto who also was active in
Rome in the 1570s and 1580s and whose figure style and drawing
manner are similar to the Louvre drawing. Carel Van Tuyll suggests
the name of Raffaellino da Reggio. This sheet has never before been
exhibited. *VF*

28

Federico Barocci
(Urbino 1535–Urbino 1612)

The Adoration of the Shepherds

Pen and brown ink, brown wash on paper tinted brown; squared
for transfer in the upper part; white gouache added by Corneille;
mount of Jabach's drawings of *ordonnance*
9⅜ × 6 inches
Inv. 2844
Denver

Coming from Urbino in the Marche, like Raphael, Barocci was one of the more influential central Italian painters of the second half of the sixteenth century. His patrons included the Pope, the Emperor, the Grand Duke of Tuscany, and the ruling family of his hometown, the Della Rovere.

Although no painting can be directly related to this sheet, the subject is a favorite of the artist's, developed in other drawings, and has been dated to his stay in Rome around 1561–1563. The point of view from below and the arched top would seem to indicate the artist was considering the composition for an altarpiece. The nocturnal setting of the scene, beautifully developed, shows the influence of Titian, as well as Correggio—although the heavy white heightening can be attributed to later retouchings on the sheet by Michel Corneille (1642–1708). One can sense the artist's fascination with the effects of light and shadow, the illusionistic perspective, and the preference for crowded scenes developed around an empty space. Reflecting the nascent mood of the Counter-Reformation, Barocci is moving away from the convoluted images of Mannerism toward the representation of a religious scene expressing humbler emotions that might evoke a similar response in the viewer. *VF*

BIBLIOGRAPHY
Roman Drawings of the Sixteenth Century from the Musée du Louvre, Paris, exhibition
catalogue, entry by Françoise Viatte. Chicago: Art Institute, 1979–1980, cat. 3.

29

Giuseppe Cesari d'Arpino, called Il Cavaliere d'Arpino
(Arpino 1568–Rome 1640)

Man with a Long Moustache

Black and red chalk
6½ × 4⅞ inches
Inv. 21070
Atlanta

Born in Arpino, a town in the Kingdom of Naples, Giuseppe Cesari had a very successful career in Rome, where he worked for three popes—Gregory XIII, Clement VIII, and Paul V—and was employed by various cardinals and members of the aristocracy. He was elected president (*Principe*) of the Accademia di San Luca in Rome three times: in 1599, 1615, and 1619. He was highly appreciated in France, where he was called Josepin. Roger de Piles, teacher at the Académie Royale de Peinture et de Sculpture and an influential theoretician, included him among the best-known painters in his *Balance of Painters* of 1708. In this computation, each artist was given a score (out of 20) on composition, drawing, color, and expression. *Josepin* scored 28, equal to Caravaggio, higher than Giovanni Bellini (24), but lower than Rubens or Raphael, who shared the highest total score of 65. Although we do not know under which name Jabach kept the present sheet because it was among the unmounted works yet to be catalogued, it must have met his criteria for excellence.

The drawing has not been connected to any specific painted work, but there is a similarity in the type of "barbarian" with long, unkempt hair and moustache found in the 1597 fresco of the *Battle of the Romans against the People of Veii,* in the Palazzo dei Conservatori in Rome. Like the drawing by Federico Zuccaro (cat. 26), this sheet shows a harmonious combination of red and black chalk. The sheet has never before been exhibited. *VF*

30

Giovanni Benedetto Castiglione,
called Il Grechetto
(Genoa 1609–Mantua 1664)

*The Animals Leaving Noah's Ark and
the Sacrifice of Noah*

Brush, oil, and colored pigments on brown paper
11½ × 16¹¹⁄₁₆ inches
Inv. 9444
Denver

Castiglione is one of the most original figures of Genoese seventeenth-century painting, as he absorbed not only the local style but also the influence of the Flemish colony of artists gathered in Genoa around the brothers de Wael, as well as Rubens and van Dyck. During his Roman period, Castiglione was in contact with the broad circle of Poussin, Bernini, Pietro da Cortona, and the Northern painters active in the city. The last part of his life was spent in Mantua working for the ruling Gonzaga family.

Castiglione was very much appreciated in France, where he was called *Benedette.* In the seventeenth century, Jabach owned four drawings by him, including the present one, which he sold to King Louis XIV. In the next century, Castiglione's *pittoresque* style was prized by other French collectors, such as Pierre Crozat and Pierre-Jean Mariette. His pastoral scenes, crowded with shepherds and animals, played a considerable role in the evolution of François Boucher's art.

The episodes of Noah's sacrifice and the animals entering or leaving the ark were developed several times by the artist throughout his career, in both paintings and drawings. In his graphic corpus, fifteen drawings, two prints, and one monotype survive that represent one or both of the scenes. This drawing has been dated by scholars to the 1630s. The technique of the dry brush dipped in oil, then passed over the colored pigments and applied directly onto the paper, is used to impressive effect. *VF*

BIBLIOGRAPHY

Il genio di Giovanni Benedetto Castiglione, exhibition catalogue, entry by Laura Tagliaferro. Genoa, Italy: Accademia Ligustica di Belle Arti, 1990, cat. 33.

31

Claude Vignon
(Tours 1593–Paris 1670)

Study of a Young Girl
Red chalk
11 13/16 × 5 1/2 inches
Inv. 13681
Denver

Vignon came from the city of Tours in central France. After his formative years in Paris, where he studied Mannerism and the court art of Fontainebleau, he went to Rome around 1616–1622, where he was exposed to the art of the diverse group of Roman followers of Caravaggio. His art retained and reflected these diverse influences throughout his career. His Parisian protectors were King Louis XIII and Cardinal de Richelieu.

The young woman depicted here was engraved in the same direction by Gilles Rousselet and Abraham Bosse. In this print, she is identified in an inscription as the Cimmerian Sibyl, who predicted the birth of the Son of God from a virgin. Some differences in the dress and the addition of the Annunciation in the background of the print would suggest that the drawing was part of the earlier research for the finished image. The free and fluid style of the red chalk has led scholars to date the drawing relatively early in the artist's career, in the 1630s. *VF*

BIBLIOGRAPHY
Claude Vignon 1593–1670, exhibition catalogue, entry by Paola Pacht-Bassani. Tours, France: Musée des Beaux-Arts, 1993–1994, cat. 53.

32

Claude Vignon
(Tours 1593–Paris 1670)

Queen Monime

Red chalk; framing lines in red chalk; annotated
on lower edge in red chalk: *Monime*
12¹³⁄₁₆ × 8⅜ inches
Inv. 15047
Denver

Previously kept among the anonymous seventeenth-century works, this red chalk study was attributed to Vignon by Jacob Bean in the 1960s. It is preparatory for a print executed in the same direction as the drawing by Abraham Bosse and Gilles Rousselet, which was included in Pierre Le Moyne's book *La Galerie des Femmes Fortes,* published in 1647. The book presents images of exemplary women from the ancient past—Jewish, Greek, Roman, and Christian.

The print after the present drawing has an added background landscape as well as a more extensive inscription identifying the woman as Monime, wife of Mithridates, King of Pontus and enemy of the Romans. The Queen tried to kill herself while in the Romans'

captivity, trying first to hang herself. Removing the diadem from her head and fastening it around her neck, she suspended herself from it. After it broke, she lamented loudly and blamed the headband, which is the scene shown in the drawing. She died when her throat was cut by Bacchides, a eunuch sent by her jealous husband. The story is told by Plutarch in the life of Lucullus. *VF*

BIBLIOGRAPHY
Nouvelles attributions: Dessins du XVIe au XVIIIe siècle, exhibition catalogue, entry by Roseline Bacou. Paris: Musée du Louvre, 1978, cat. 120.

33

Claude Gellée, called Le Lorrain
(Chamagne 1600–Rome 1682)

Landscape with the Rape of Europa

Pen and brown ink, brown and gray wash, with white gouache
on beige paper; mount of Jabach's drawings of *ordonnance*
12¼ × 16¾ inches
Inv. 26683
Atlanta

Claude left his native Lorraine as a teenager and spent virtually all of his working life in Rome. He became a member of the Accademia di San Luca in 1633. Two years later he began to keep a systematic record of his paintings by drawing their compositions onto the pages of an album of two hundred drawings known as the *Liber Veritatis (Book of Truth),* now in the British Museum in London. Number 111 of the *Liber* is his record of the *Landscape with the Rape of Europa,* painted around 1647, now in the Museum Boymans-van Beuningen in Rotterdam (fig. 21). The sheet exhibited here has the same general composition as the canvas and is considered as being preparatory for it.

Claude treated this theme, taken from Ovid's *Metamorphoses,* several times during his career in paintings, drawings, and an etching. This work follows the narrative closely. Jupiter fell in love with Europa, daughter of King Agenor of Tyre, in Phoenicia. Disguising himself as a white bull, he came to the seashore where she was playing with her maidens. Attracted by the bull's mild nature, Europa put flowers around his neck and climbed onto his back—the episode shown here. Jupiter bore her out to sea and to the island of Crete, where he resumed his shape and ravished her.

This drawing is a typical poetic landscape by Claude, where an idyllic view of Nature dominates the small human figures. A burst of light is usually placed in the center of the composition, with dark trees in the foreground to increase the contrast, along with some architectural elements.

Interestingly, this sheet is the only drawing by Claude owned by Jabach, who bought it and then sold it to the French king even before the artist's death. *VF*

Fig. 21. Claude Lorrain, *Landscape with the Rape of Europa,* ca. 1647, oil on canvas, The Netherlands Institute of Cultural Heritage, The Hague Collection Goudstikker. Museum Boijmans Van Beuningen, Rotterdam.

BIBLIOGRAPHY

Boyer, Jean-Claude. *Claude le Lorrain et le monde des dieux,* exhibition catalogue (Epinal, Musée départemental d'Art ancien et contemporain). Paris: Réunion des Musées Nationaux, 2001, in cat. 8, fig. 2.

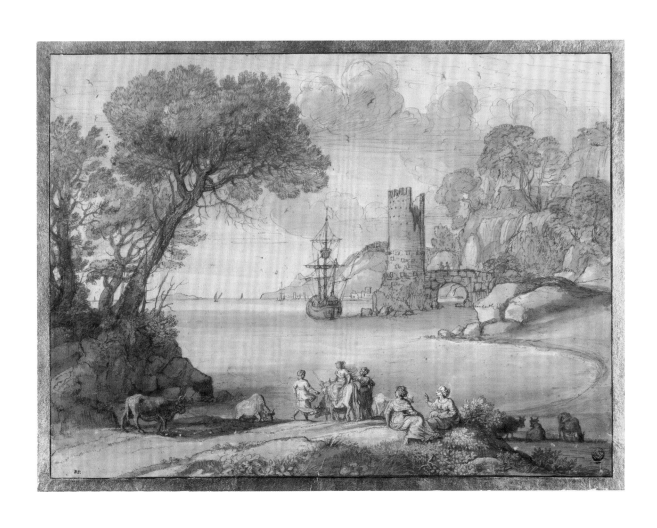

II *The Studio Collections of the Painters to the King*

Charles Le Brun, First Painter to the King, 1664–1690
When Charles Le Brun's works were confiscated from his residences and from his workshop at the Manufacture des Gobelins, the royal collections acquired works representing the full spectrum of his artistic production. The most fragile ones, those preparatory for large-scale decorative fresco cycles and large paintings such as *The History of Alexander the Great,* were thus conserved—an extremely rare occurrence in the history of seventeenth-century art. The Louvre collection holds 3,051 drawings, which allow for a complete study of the oeuvre of this major painter and decorator, who had a hand in all the great artistic projects distinguishing the reign

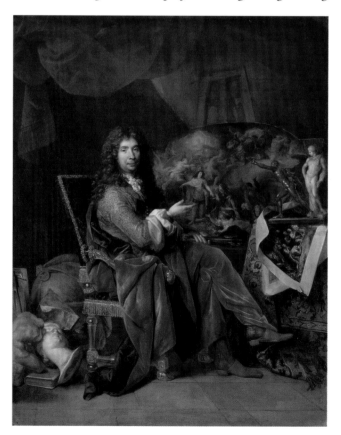

Nicolas de Largillière (French, 1656–1746), *Portrait of Charles Le Brun,* ca. 1685, oil on canvas, Musée du Louvre.

of King Louis XIV. Le Brun supervised the decoration cycles of the Château de Versailles and directed tapestry production at the Gobelins factory, founded by the powerful minister Jean-Baptiste Colbert. Le Brun also provided drawings for monuments dedicated to the glory of the king. He was a true entrepreneur, capable of organizing and managing the collaboration of the wide range of workmen and artisans employed on royal decorative projects, including painters, sculptors, gold- and silversmiths, and cabinetmakers.

As a youth Le Brun was apprenticed to Simon Vouet and was taken under the patronage of Chancellor Pierre Séguier. (Le Brun's portrait of the chancellor in the Louvre is one of his masterpieces.) The young artist accompanied Nicolas Poussin to Rome in 1642, a sojourn that lasted until 1645. In Italy, Le Brun had the opportunity to see and study the art of Renaissance fresco masters such as Raphael and those of the early seventeenth century such as Annibale Carracci and Pietro da Cortona, each of whom left indelible impressions on him. The Superintendent of the Royal Buildings, Nicolas Fouquet, noticed his talents and employed Le Brun in 1658 to decorate the grand salon of the Château de Vaux le Vicomte, the splendor of which elicited the jealousy of the young Louis XIV. Colbert also hired Le Brun to decorate his château in Sceaux. In 1664 Le Brun was named *Premier Peintre* (the King's First Painter) and became a founding member of the Académie Royale de Peinture et de Sculpture. The rest of his career was dedicated to carrying out royal commissions, and it was only in 1683, when Colbert died and François Michel Le Tellier, Marquis de Louvois and protector of Pierre Mignard, rose in power, that Le Brun's domination of French artistic activity suffered a decline.

Heir of the greatest trends in the development of French painting under the aegis of Simon Vouet (cats. 88 and 89) and Eustache Le Sueur (cats. 90 and 91), Le Brun epitomizes the spirit of seventeenth-century French Classicism. *CL*

34

Charles Le Brun
(Paris 1619–Paris 1690)

Study of a Woman in *The Massacre of the Innocents*

Red and white chalk over traces of black chalk
on beige paper
12¹⁄₁₆ × 10⅞ inches
Inv. 27824
Atlanta

This drawing is an early study for *The Massacre of the Innocents,* a painting begun before 1650, commissioned by a member of the Parisian clergy and now at the Dulwich Picture Gallery in Great Britain. The mother, defending her infant child and scratching the man trying to attack her, was not used in the painted work. This sheet is considered one of the most beautiful female nudes drawn by the artist. The subject is taken from the Gospel of Matthew, which recounts the slaying of male infants under the age of two in Bethlehem, ordered by Herod the Great, King of the Jews. *VF*

BIBLIOGRAPHY

Beauvais, Lydia. *Musée du Louvre, Département des Arts Graphiques. Inventaire Général des Dessins de l'Ecole Française Charles Le Brun 1619–1690.* 2 vols. Paris, 2000, vol. 1, no. 1245.

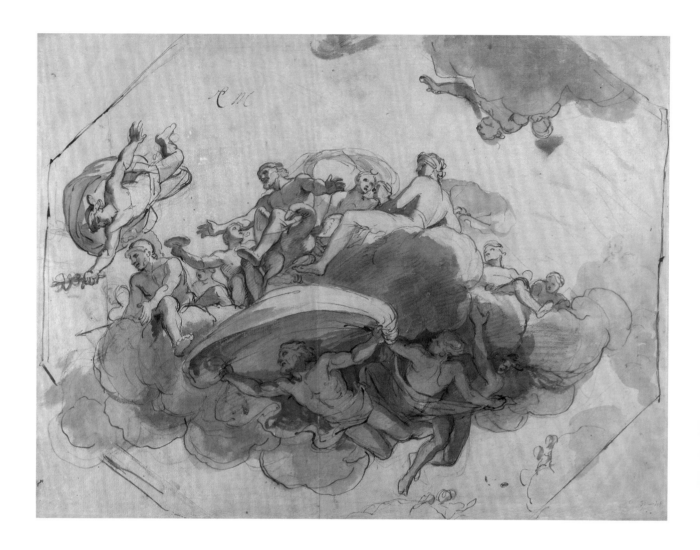

35

Charles Le Brun

(Paris 1619–Paris 1690)

Jupiter and Juno with the Gods of Olympus

Pen, brown and black ink, brown and gray wash, over traces of black and red chalk and stylus lines; octagonal framing lines in pen and ink

14⁹⁄₁₆ × 19⅝ inches

Inv. 29457

Atlanta

Between 1650 and 1658, while also working on other projects, Le Brun decorated the residence of Nicolas Lambert de Thorigny, President of the Chamber of Accounts, located at the end of the Ile Saint Louis in central Paris. The *Assembly of the Gods* was part of the cycle on the gallery vault dedicated to the legend of Hercules. In the episode represented here, Jupiter and Juno, presiding over the assembly, await the arrival of Hercules to introduce him to Hebe, his future bride. *VF*

BIBLIOGRAPHY

Beauvais, Lydia. *Musée du Louvre, Département des Arts Graphiques. Inventaire Général des Dessins de l'Ecole Française Charles Le Brun 1619–1690.* 2 vols. Paris, 2000, vol. 1, no. 9.

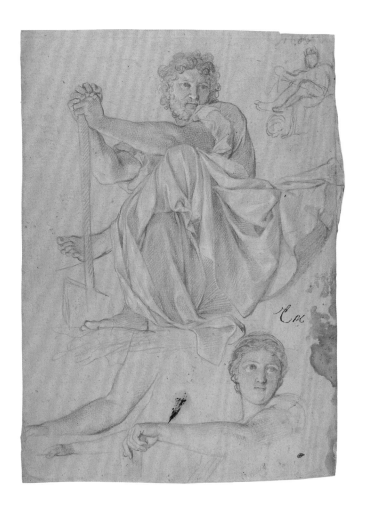

36

Charles Le Brun
(Paris 1619–Paris 1690)

Studies for a Muse (after a Male Model)

Red, white, and black chalk on beige paper
15¾ × 11⁷⁄₁₆ inches
Inv. 29067
Atlanta

Between 1653 and 1655, Le Brun decorated the Hôtel de la Rivière, residence of the Abbé de la Rivière, Bishop of Langres, located on the Place Royale in Paris (today's Place des Vosges). The ceiling of the large room on the first floor, depicting the story of Psyche, was removed in 1878 and remounted in the Musée Carnavalet in Paris, where it is still visible today. This drawing is a study for the muse Clio, placed in one of the ceiling's corners. The artist's working method is well illustrated in this sheet. After studying the position of the figure in his workshop using a draped male model, Le Brun changed the bearded face to that of a lovely female and gave her a more graceful arm. *VF*

BIBLIOGRAPHY

Beauvais, Lydia. *Musée du Louvre, Département des Arts Graphiques. Inventaire Général des Dessins de l'Ecole Française Charles Le Brun 1619–1690.* 2 vols. Paris, 2000, vol. 1, no. 33.

37

Charles Le Brun
(Paris 1619–Paris 1690)

Drapery for a Kneeling Figure

Black and white chalk on sheets of beige paper,
assembled
51¼ × 48⅛ inches
Inv. 29847-171
Atlanta

In 1670 Jean-Baptiste Colbert, who administered the finances of Louis XIV, acquired a castle at Sceaux which he enlarged with the addition of wings that included a chapel. In 1674 Le Brun decorated the vault of the chapel in fresco, which survived only until 1801. The circular central scene represented the adoration of God by angels and the Virtues. The composition is known through prints and a reduced copy by François Verdier. The cartoon exhibited here is for a figure of an angel kneeling on clouds, hands joined in prayer and looking up toward the center. *VF*

BIBLIOGRAPHY

Beauvais, Lydia. *Musée du Louvre, Département des Arts Graphiques. Inventaire Général des Dessins de l'Ecole Française Charles Le Brun 1619–1690*. 2 vols. Paris, 2000, vol. 1, no. 133.

The Ambassadors Staircase

From 1674 to 1679 the entire team working under
Le Brun's orders executed the frescoed decoration of
the vault (fig. 22) and the walls of the recently constructed
staircase leading to the apartments of King Louis XIV,
to the north of the Marble Court in the Château de
Versailles. This new access, or "Grand Degré" as it was
called, offered a grandiose setting for the entrance of
visitors admitted to the king's audiences, especially ambas-
sadors of foreign countries, whence the later name of
Escalier des Ambassadeurs. This grand staircase was demol-
ished in 1752, on the orders of King Louis XV. The lively
setting of the scenes on the walls, showing the inhabitants
of the four parts of the world leaning out of a balcony
in their picturesque costumes, brought a special lifelike
accent to the decoration (fig. 23). This aspect might have
been suggested to Le Brun by the recollection of frescoes
by Giovanni Lanfranco and Agostino Tassi on the long
walls of the Sala Regia in the Palazzo del Quirinale in
Rome. *VF*

Fig. 22. Charles Simmonneau the Elder, after Charles
Le Brun, *Escalier des Ambassadeurs* (ceiling), print, Paris,
Bibliothèque nationale de France, cabinet des Estampes.

Fig. 23. Louis Surugue, after Charles Le Brun, *Escalier des
Ambassadeurs* (north side), print, Paris, Bibliothèque nationale
de France, cabinet des Estampes.

38

Charles Le Brun
(Paris 1619–Paris 1690)

King Louis XIV Re-Establishing Commerce

Black chalk and gray wash; squared for transfer
13¹⁄₁₆ × 11³⁄₁₆ inches
Inv. 29757
Atlanta

On the ceiling of the grand staircase were placed eight rectangular scenes illustrating some of the major military, civic, and diplomatic events in the life of King Louis XIV. Other compositions made reference to the king's virtues. This scene stresses the importance given to commerce by the powerful minister Colbert, who wanted France to rival the great merchant nations, especially Holland. A boat on the left side of the sheet makes reference to this objective. A woman, standing next to the king, holds a horn of plenty, symbolizing the benefits deriving from a flourishing commerce. *VF*

BIBLIOGRAPHY

Beauvais, Lydia. *Musée du Louvre, Département des Arts Graphiques. Inventaire Général des Dessins de l'Ecole Française Charles Le Brun 1619–1690.* 2 vols. Paris, 2000, vol. 1, no. 296.

39

Charles Le Brun

(Paris 1619–Paris 1690)

King Louis XIV Rewarding His Army Chiefs

Black chalk and gray wash, with framing lines; squared for transfer with black chalk; annotated in black chalk above the framing lines: *hau.*
13⅜ × 11⅞₁₆ inches
Inv. 29754
Denver

This is another of the scenes on the ceiling of the grand staircase illustrating events in the life of King Louis XIV in military, civic, and diplomatic fields. This scene shows the king dressed in Roman armor and wearing a laurel crown, the figure of Justice standing behind him, while he rewards his army chiefs. *VF*

BIBLIOGRAPHY

Beauvais, Lydia. *Musée du Louvre, Département des Arts Graphiques. Inventaire Général des Dessins de l'Ecole Française Charles Le Brun 1619–1690.* 2 vols. Paris, 2000, vol. 1, no. 294.

40

Charles Le Brun
(Paris 1619–Paris 1690)

Study of Two Men in Conversation

Black, white, and red chalk on beige paper
11½ × 17 inches
Inv. 28785
Atlanta

These two figures were depicted by Le Brun among the group of people from the different nations of America on the walls of the staircase. The full-scale cartoon for this scene, at the Louvre also, measures 6 by 7½ feet. *VF*

BIBLIOGRAPHY

Beauvais, Lydia. *Musée du Louvre, Département des Arts Graphiques. Inventaire Général des Dessins de l'Ecole Française Charles Le Brun 1619–1690.* 2 vols. Paris, 2000, vol. 1, no. 271.

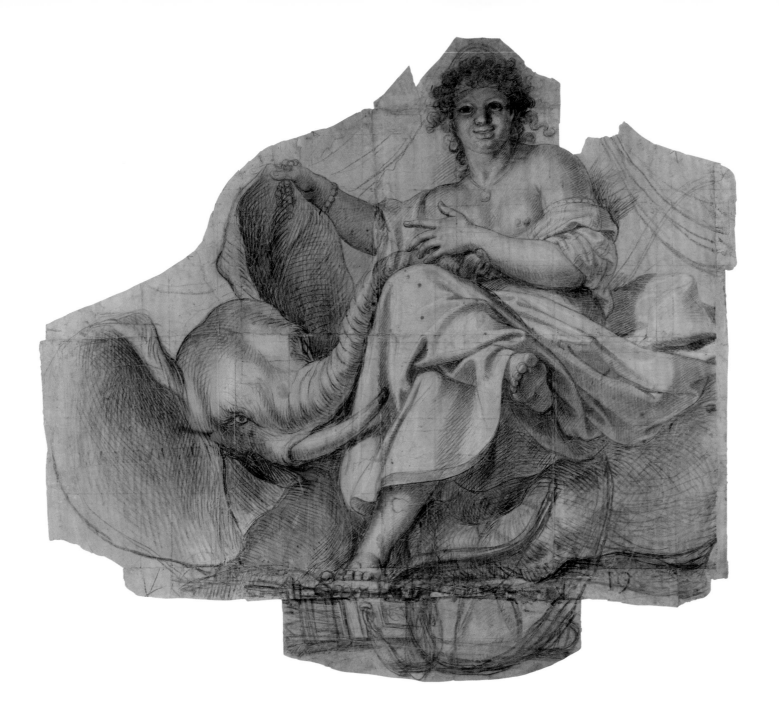

41

Charles Le Brun

(Paris 1619–Paris 1690)

Africa

Black and white chalk on assembled sheets of beige
paper; traces of stylus; irregular contours; mounted
onto canvas

70 1/16 × 76 7/8 inches

Inv. 29847/62

Denver

Figures representing the four parts of the world (Africa, Europe, America, and Asia) were placed next to the four corners of the wall, under the vault. They had corresponding scenes below, representing the inhabitants of the world leaning out of a balcony, for which the Louvre retains all four full-scale cartoons. *VF*

BIBLIOGRAPHY

Beauvais, Lydia. *Musée du Louvre, Département des Arts Graphiques. Inventaire Général des Dessins de l'Ecole Française Charles Le Brun 1619–1690*. 2 vols. Paris, 2000, vol. 1, no. 366.

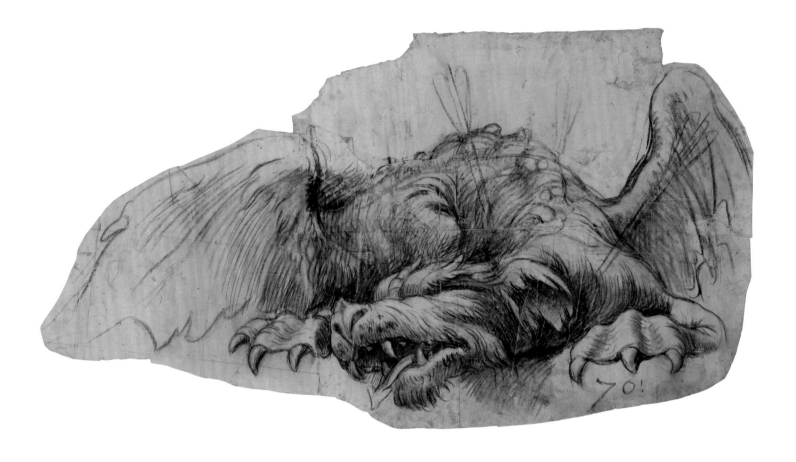

42

Charles Le Brun
(Paris 1619–Paris 1690)

Monster Pierced with Arrows

Black and white chalk on sheets of beige paper,
assembled; some sheets pricked for transfer
36¾ × 50⅜ inches
Inv. 29847-61
Atlanta

Apollo, Minerva, and Hercules were depicted above the walls of the staircase to represent the king's virtues. The monster studied in this cartoon is the serpent Python, killed by Apollo. It symbolized the dangers that had threatened the French monarchy from the inside, which the king had overcome. *VF*

BIBLIOGRAPHY

Beauvais, Lydia. *Musée du Louvre, Département des Arts Graphiques. Inventaire Général des Dessins de l'Ecole Française Charles Le Brun 1619–1690.* 2 vols. Paris, 2000, vol. 1, no. 338.

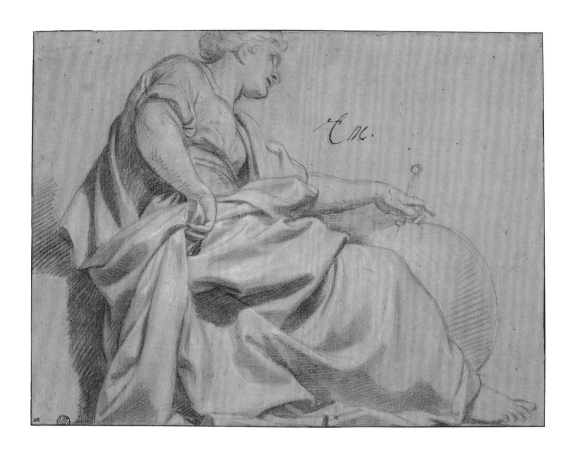

43
Charles Le Brun
(Paris 1619–Paris 1690)

Study of Urania, Muse of Astronomy

Black and white chalk on gray paper
11³⁄₁₆ × 15⅛ inches
Inv. 27915
Atlanta

In the staircase at Versailles, the representation of the muses was an allusion to the king's virtues. Urania, muse of astronomy, is holding a compass over a globe. In the fresco, her image was slightly modified, so that she was looking up toward the sky. She was facing Euterpe, muse of music and lyrical poetry, at the level of the rising of the vault. *VF*

BIBLIOGRAPHY

Beauvais, Lydia. *Musée du Louvre, Département des Arts Graphiques. Inventaire Général des Dessins de l'Ecole Française Charles Le Brun 1619–1690.* 2 vols. Paris, 2000, vol. 1, no. 356.

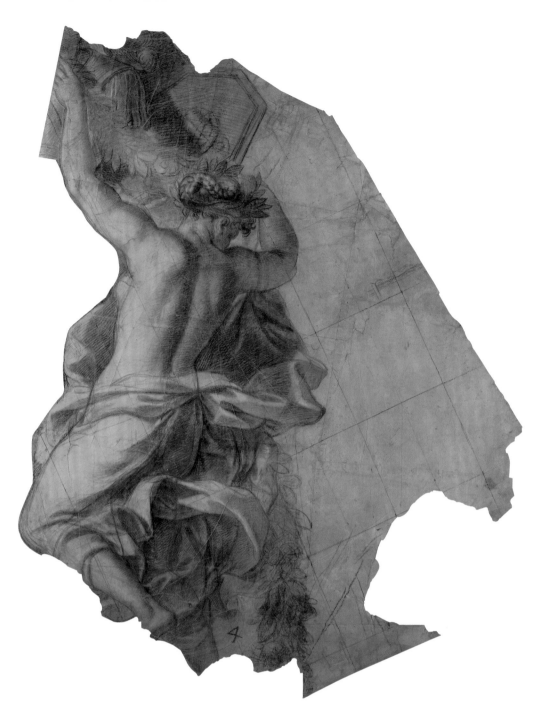

44

Charles Le Brun
(Paris 1619–Paris 1690)

Study of a Draped Woman with Raised Arms

Black and white chalk on several assembled sheets of beige paper; traces of stylus; squared for transfer; annotated in black chalk, on lower edge: *4;* irregular contours; mounted onto canvas
79¹⁵⁄₁₆ × 72¹³⁄₁₆ inches
Inv. 29847/165
Denver

This is a cartoon preparatory for the figure of Victory, but without wings, the standard attribute of the allegory. Le Brun represented two Victories in each of the four corners of the ceiling, holding garlands around a trophy, to commemorate the 1676 naval combat of the French fleet against the Dutch, near Messina, in Sicily. *VF*

BIBLIOGRAPHY

Beauvais, Lydia. *Musée du Louvre, Département des Arts Graphiques. Inventaire Général des Dessins de l'Ecole Française Charles Le Brun 1619–1690.* 2 vols. Paris, 2000, vol. 1, no. 400.

Pieter Boel, Official Painter to the King, 1668–1674
After a period of apprenticeship in Antwerp and a trip
to Italy, where he saw the work of Giovanni Benedetto
Castiglione, Pieter Boel returned to work in his native city
and specialized in animal painting. After 1668, he settled
in Paris with the title of Official Painter to the King and
worked under the direction of Charles Le Brun at the fac-
tory at Gobelins, preparing tapestry cartoons. His drawings
remained in Le Brun's studio and entered the king's collec-
tion when the contents of the studio were confiscated in
1690. He drew animals from life in the royal menageries
of Vincennes and of Versailles. The fiercest animals, such
as lions and tigers, were kept at Vincennes, while the exotic
animals that had been given to the king as diplomatic gifts
were kept at Versailles. The menagerie at Versailles, part of
the extraordinary architectural complex designed by Louis
Le Vau, was one of the notable curiosities of the park.

Through the use of colored paper and pastels heighten-
ing the black chalk, the artist achieves naturalistic effects
and translates on paper convincing views of live animals
kept in captivity. Neither their melancholic look nor their
frightened gaze escapes his observation. *CL*

45
Pieter Boel
(Antwerp 1622–Paris 1674)

Study of a Dog

Black chalk; white, brown, red, and yellow
pastels on gray-beige paper
11⁷⁄₁₆ × 17½ inches
Inv. 29596
Atlanta

BIBLIOGRAPHY

Starcky, Emmanuel. *Musée du Louvre. Cabinet des Dessins. Inventaire Général des Dessins des Ecoles du Nord. Ecoles allemande, des Anciens Pays-Bas, flamande, hollandaise et suisse. XVe–XVIIIe siècles. Supplément aux inventaires publiés par Frits Lugt et Louis Demonts.* Paris, 1988, no. 123.

46
Pieter Boel
(Antwerp 1622–Paris 1674)

Study of Two Elephants' Heads
Black chalk, white and yellow pastels on
gray-beige paper
11⅝ × 17½ inches
Inv. 29590
Atlanta

BIBLIOGRAPHY
Pinault Sørensen, Madeleine. *Sur le vif. Dessins d'animaux de Pieter Boel (1622–1674).*
Paris: Musée du Louvre, 2001, p. 38.

47
Pieter Boel
(Antwerp 1622–Paris 1674)

Study of a Goat

Black chalk; yellow, white, brown,
and green pastels on gray-beige paper
11⅜ × 17⅛ inches
Inv. 19574
Atlanta

BIBLIOGRAPHY
Pinault Sørensen, Madeleine. *Sur le vif. Dessins d'animaux de Pieter Boel (1622–1674).*
Paris: Musée du Louvre, 2001, p. 66.

48

Pieter Boel
(Antwerp 1622–Paris 1674)

Lion Seen from the Back

Black chalk; white, red, and yellow pastels
on gray-beige paper
11¹¹⁄₁₆ × 17⁹⁄₁₆ inches
Inv. 19561
Atlanta

BIBLIOGRAPHY

Pinault Sørensen, Madeleine. *Sur le vif. Dessins d'animaux de Pieter Boel (1622–1674).*
Paris: Musée du Louvre, 2001, p. 61.

Pierre Mignard, First Painter to the King,
1690–1695

From 1635 to 1656, after a period of apprenticeship with
Simon Vouet, Pierre Mignard settled in Rome, where
he studied the great masters of the past and became a
friend of Giovanni Pietro Bellori, the artistic historiog-
rapher and champion of Classicism. Mignard's works
at that time were marked by a search for elegance and
refinement of colors. Because of his long stay in Rome,
Mignard acquired the nickname "the Roman." Upon
his return to France, he had to face the supremacy of
Charles Le Brun, whom he succeeded as First Painter
of the King in 1690 upon Le Brun's death. His appoint-
ment was due to the protection of François Michel Le
Tellier, Marquis de Louvois, the king's minister, successor
of Jean-Baptiste Colbert. Mignard's last years were filled
with intense activity, notably in the decoration of the
dome of the churches of Saint-Louis-des-Invalides and
of the Val de Grâce in Paris. *CL*

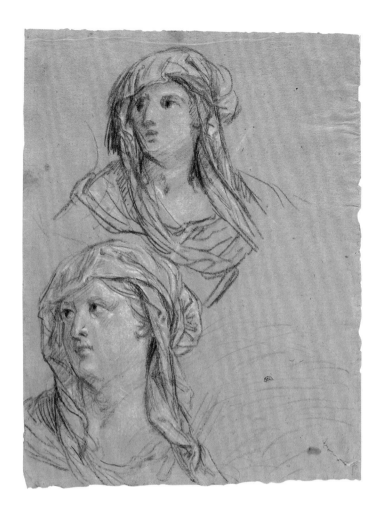

49

Pierre Mignard
(Troyes 1612–Paris 1695)

Two Studies of a Woman's Head

Black, red, and white chalk on beige paper
11 7/16 × 8 7/8 inches
Inv. 31092
Atlanta

Two painted compositions by Mignard, signed and dated 1692,
were recorded in Versailles in 1695. One was the figure of Hope,
the other of Faith. The two paintings are today in the Musée des
Beaux-Art of Quimper, France. The present drawing is a study for
the head of the figure of Hope seen from two different angles. *VF*

BIBLIOGRAPHY
Le Brun à Versailles, exhibition catalogue, entry by Jean-François Méjanès. Paris: Musée
du Louvre, 1985–1986, cat. 146.

50
Pierre Mignard
(Troyes 1612–Paris 1695)

Study of an Angel Holding a Small Jar

Red and white chalk on beige paper
11⁷⁄₁₆ × 8¹³⁄₁₆ inches
Inv. 31115
Atlanta

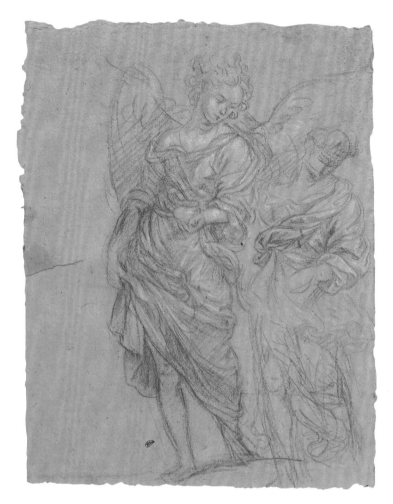

Mignard was named First Painter to the King in 1690, just five years before his death. The approximately 300 drawings that entered the king's collection, including the present sheet, all come from this brief final period of activity.

The angel holding a jar could be a study for a composition on the theme of Tobias and the Angel, illustrating an episode from the Book of Tobit in the Old Testament. The young Tobias has to fetch the liver, heart, and gall of a fish, with the help of an angel, and use it to cure his father's blindness. Three other sketches in the Louvre (Inv. 31114, Inv. 31127, and Inv. 31223) explore the same figure. Seen together, they show the artist working out his ideas on paper, drawing the angel in various poses, focusing on details such as the jar, the drapery, or the arm. As depicted, the angel would be looking down at the young Tobias. All are workshop sheets—sometimes ripped, some with stains —typical of drawings piled in stacks in the atelier. *VF*

BIBLIOGRAPHY

Guiffrey, Jean, and Pierre Marcel. *Inventaire général des Dessins du Musée du Louvre et du Musée de Versailles. Ecole Française,* vol. X, *Meissonier–Millet.* Paris: Librairie centrale d'art et d'architecture, 1927, no. 10045.

Antoine Coypel, First Painter to the King, 1715–1722

Antoine Coypel was the son of Noël, a painter in Charles Le Brun's circle and director of the Académie de France in Rome between 1672 and 1675. Antoine grew up surrounded by the artists in his father's workshop and accompanied him to Rome at the age of eleven. He was thus exposed at a very young age to Roman Baroque art as well as that of other Italian cities he visited on the way south: Turin, Milan, Modena, Bologna, and Florence. Upon his return to Paris in 1676, he lived with his father in the Louvre, where other artists in the royal service also resided, such as Antoine Stella and the sculptor François Girardon. Antoine was a precocious artist and successful from the age of twenty. He received several royal commissions for Marly, Trianon, Meudon, and Versailles, and, in 1685, was named Official Painter of Monsieur, Duc d'Orléans, the only brother of Louis XIV. He was later to become First Painter to Duc Philippe d'Orléans, the older son of Monsieur and future regent of France during the minority of Louis XV (1715–1723). The Orléans family, supporters of Antoine Coypel throughout his life, had gathered an extraordinary collection of paintings in the Palais Royal. In 1710 Coypel received the title Keeper of the Royal Paintings and Drawings and in 1715 was named First Painter to the King.

Coypel was a great decorator of large illusionistic spaces, following the Roman Baroque tradition and the great Venetian painters like Veronese. His style is characterized by an abundance of figures, very expressive and full of color, with the draftsmanship of a virtuoso. *CL*

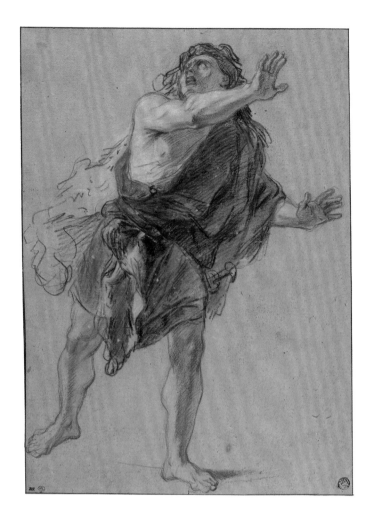

51

Antoine Coypel
(Paris 1661–Paris 1722)

Study of a Fleeing Soldier for *The Resurrection*

Black, white, red, and yellow chalk on beige paper
14⅜ × 10½ inches
Inv. 25725
Denver

This study of a fleeing soldier was for a now-lost painting, *The Resurrection,* for the Louvois Chapel in the Eglise des Capucines, on the Place Louis le Grand (today's Place Vendôme) in Paris. The painting was probably commissioned after the sudden death of Louvois in 1691. *VF*

BIBLIOGRAPHY

Garnier, Nicole. *Antoine Coypel (1661–1722).* Paris: Arthena, 1989, cat. 210, fig. 56.

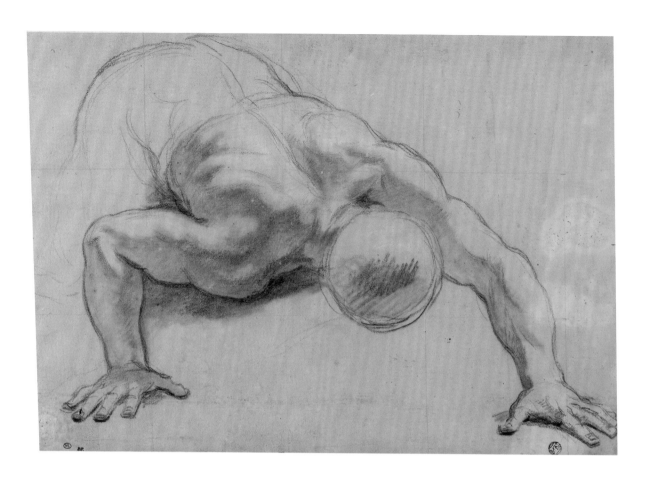

52

Antoine Coypel

(Paris 1661–Paris 1722)

Study of a Soldier for
The Resurrection

Black and red chalk and stumping on
gray-green paper; squared for transfer
12³⁄₁₆ × 17¼ inches
Inv. 25717
Denver

This is a study of a soldier on the ground for *The Resurrection,* commissioned by Louis de France, called the Grand Dauphin, son of Louis XIV and grandfather of Louis XV. The painting was executed in 1702 for the main altar of the chapel of the Château de Meudon, but it quickly deteriorated and does not survive today. *VF*

BIBLIOGRAPHY

Garnier, Nicole. *Antoine Coypel (1661–1722).* Paris: Arthena, 1989, cat. 289, fig. 169.

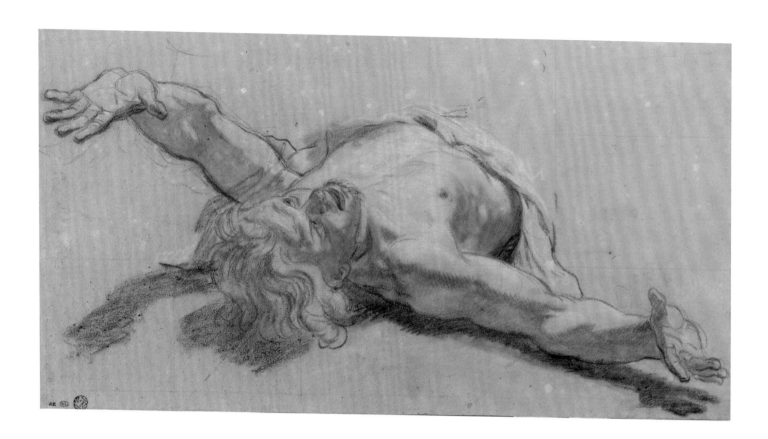

53
Antoine Coypel
(Paris 1661–Paris 1722)

Study of a Soldier for
The Resurrection

Black, red, and white chalk on gray-tinted paper;
squared for transfer
9¾ × 18½ inches
Inv. 25766
Atlanta

Study for another soldier on the ground for the same painting of the Resurrection as in cat. 52. *VF*

BIBLIOGRAPHY
Garnier, Nicole. *Antoine Coypel (1661–1722)*. Paris: Arthena, 1989, cat. 292, fig. 170.

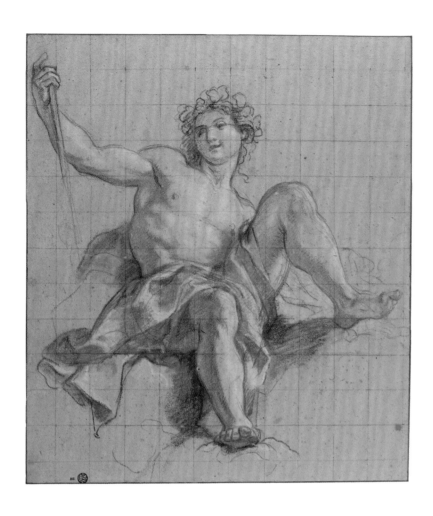

54
Antoine Coypel
(Paris 1661–Paris 1722)

Study of Bacchus for
The Assembly of the Gods

Black, red, and white chalk on gray-
green paper; squared for transfer
16¹³⁄₁₆ × 14⅞ inches
Inv. 25805
Denver

This is a study of the figure of Bacchus in *The Assembly of the Gods,* which was executed in 1702 for the ceiling of the gallery of the Palais Royal in Paris—150 feet long—and which no longer survives. The decoration was commissioned by Philippe d'Orléans, nephew of Louis XIV and future regent of France during the minority of Louis XV. The ceiling decoration was dedicated to the theme of Aeneas. A sketch for the entire composition is in the Musée des Beaux-Arts of Angers, France. In 1715–1717 Antoine Coypel executed paintings to be hung on the walls of the gallery (see cats. 57, 58, 59). *VF*

BIBLIOGRAPHY
Garnier, Nicole. *Antoine Coypel (1661–1722).* Paris: Arthena, 1989, cat. 313, fig. 195.

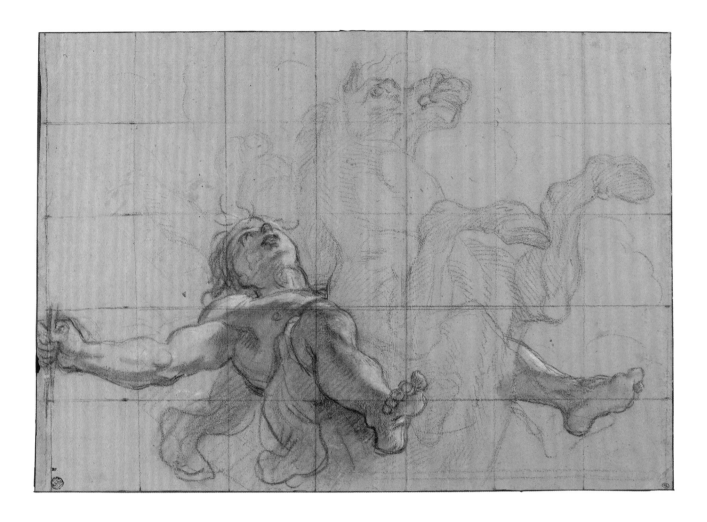

55

Antoine Coypel
(Paris 1661–Paris 1722)

Study of Castor Riding a Horse for
The Assembly of the Gods

Black and white chalk on gray-beige paper;
squared for transfer
13¹⁵⁄₁₆ × 20¹⁄₁₆ inches
Inv. 25918
Atlanta

This is a study for the figure of Castor in *The Assembly of the Gods* in the gallery of the Palais Royal in Paris (see cat. 54). *VF*

BIBLIOGRAPHY

Garnier, Nicole. *Antoine Coypel (1661–1722)*. Paris: Arthena, 1989, cat. 328, fig. 207.

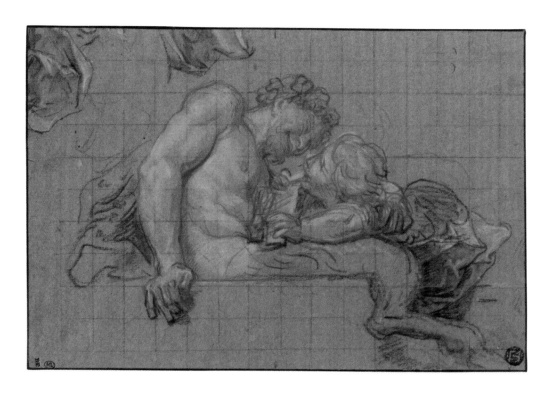

56

Antoine Coypel
(Paris 1661–Paris 1722)

Study of a Satyr and Cupid for
The Triumph of Love over the Gods

Black, red, and white chalk on blue paper; squared
for transfer
6⅞ × 10⅜ inches
Inv. 25708
Denver

In 1708 Antoine Coypel painted the fresco decoration of the ceiling of the residence of Mademoiselle de Séry, Comtesse d'Argenson, mistress of Philippe d'Orléans, who commissioned the work. The Hôtel d'Argenson was situated very close to the Palais Royal, the residence of Philippe d'Orléans, who would later serve as regent of France. Appropriately, the theme chosen was The Triumph of Love over the Gods. The building was later acquired by the Banque de France, which dismounted the ceiling and conserves it in storage. *VF*

BIBLIOGRAPHY
Garnier, Nicole. *Antoine Coypel (1661–1722)*. Paris: Arthena, 1989, cat. 420, fig. 325.

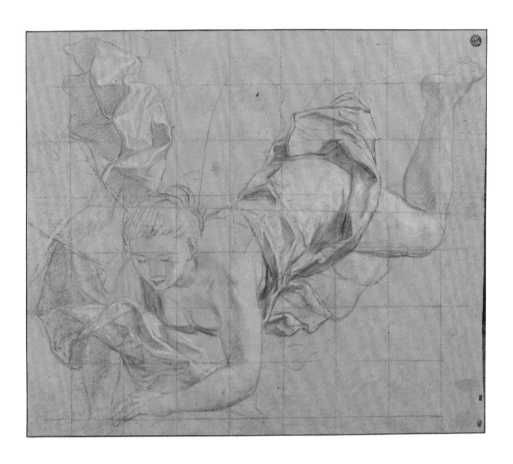

57

Antoine Coypel
(Paris 1661–Paris 1722)

Study of Iris for *The Death of Dido*

Black, white, and red chalk on beige paper; squared for transfer
13⅞₁₆ × 15¹³⁄₁₆ inches
Inv. 25726
Atlanta

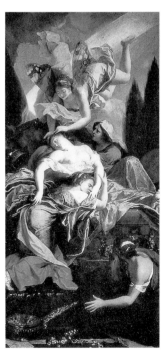

This is a study for the figure of Iris in *The Death of Dido,* 1715–1717, a painting commissioned by Philippe d'Orléans, nephew of Louis XIV and regent of France during the minority of Louis XV (1715–1723). The painting (fig. 24) was to be hung in the Aeneas Gallery in the Palais Royal, where in 1702 Antoine Coypel had frescoed *The Assembly of the Gods* (see cats. 54 and 55). The work is today in the Musée Fabre at Montpellier, France. *VF*

BIBLIOGRAPHY
Garnier, Nicole. *Antoine Coypel (1661–1722).* Paris: Arthena, 1989, cat. 508, fig. 421.

Fig. 24. Antoine Coypel, *The Death of Dido,* oil on canvas, Musée Fabre, Montpellier, France.

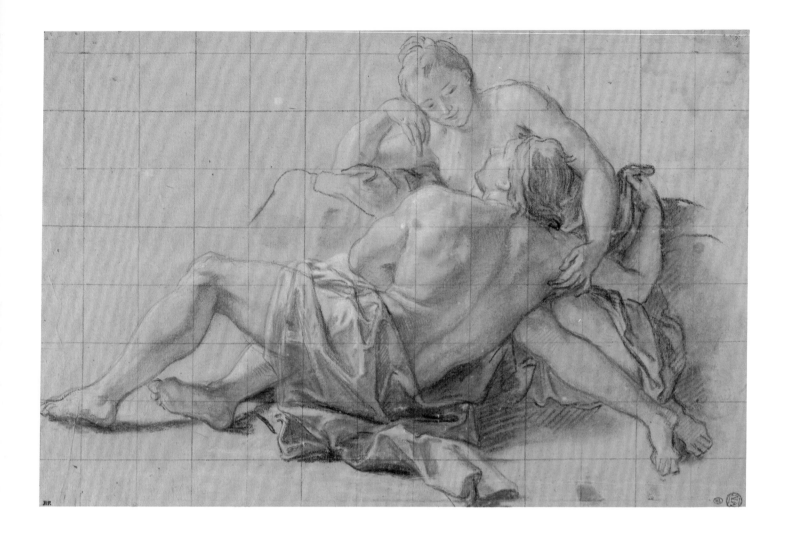

58

Antoine Coypel
(Paris 1661–Paris 1722)

*Study of a Man and a Woman
for* Aeneas Descending into the
Underworld

Black, white, and red chalk on beige paper; squared
for transfer
11³⁄₁₆ × 17³⁄₁₆ inches
Inv. 25884
Atlanta

The drawing of an embracing couple is a study for a large paint-
ing, *The Descent of Aeneas into the Underworld* (1716–1717), today
in the Louvre, and in very poor condition. It was to be hung on the
walls of the Aeneas Gallery (see cats. 57 and 59), where in 1702 the
artist had executed the decoration of the ceiling (see cats. 54 and 55).
VF

BIBLIOGRAPHY
Garnier, Nicole. *Antoine Coypel (1661–1722)*. Paris: Arthena, 1989, cat. 513, fig. 438.

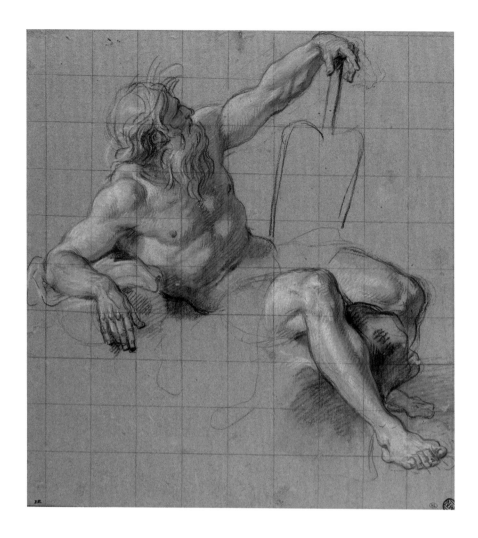

59
Antoine Coypel
(Paris 1661–Paris 1722)

Study of the River Tiber for *Jupiter Appearing to Aeneas*

Black, white, and red chalk on blue paper; squared
for transfer
13³⁄₁₆ × 12³⁄₁₆ inches
Inv. 25792
Atlanta

This is a study for the allegorical figure of the river Tiber in the painting *Jupiter Appearing to Aeneas,* to be hung in the Aeneas Gallery (see cats. 57 and 58) in the Palais Royal residence of the Regent Philippe d'Orléans, where the artist had frescoed the ceiling in 1702 (see cats. 54 and 55). The location of the painting is not known today. *VF*

BIBLIOGRAPHY
Garnier, Nicole. *Antoine Coypel (1661–1722).* Paris: Arthena, 1989, cat. 530, fig. 444.

III *The Collections of Charles Le Brun and Antoine Coypel*

Working artists played a leading role in the history of drawing collections. Their criteria for selecting works were very different from those of amateur collectors who, by and large, aimed for a sampling of famous and master drawings. The drawings assembled by artists in their workshops led to the conservation of nearly intact contents of another's studio and helped identify single sheets by lesser-known artists. For example, the sculptor Pompeo Leoni acquired a good part of Leonardo da Vinci's graphic work for his studio collection, and the painter Carlo Maratti bought the drawings from Annibale Carracci's and Domenichino's studio—thus, the workshop's contents were not dispersed but remained together in one place. The case of Giorgio Vasari is more complex. A painter, but also a historian and art theorist, he compiled a complete and representative stratigraphy of the art of his time in the *Libro de' Disegni* (see cat. 20). In this respect, his collection belongs to the special category of historiographers' collections, similar to those assembled by Carlo Cesare Malvasia and Filippo Baldinucci, each designed to illustrate a theory.

There is very little documentation about Charles Le Brun's personal drawing collection. The essential part—about 100 drawings—has been conserved in the Louvre since being seized in 1690. It was simple enough to identify Le Brun's private collection, since all the sheets by artists other than Le Brun bore Jean Prioult's paraph (fig. 5) on the recto. They include Italian, French, Spanish, and Northern European examples (cats. 60–66). Interestingly, for some of them there is an obvious Jabach provenance, indicated by the Jabach mount identical (with its gold band) to that of the drawings sold to the king in 1671 (see cat. 60). This fact may indicate that gifts or exchanges were involved, given the friendship existing between Jabach and Le Brun. The selection appears eclectic; the subjects are sometimes licentious, and the collection seems on the whole to constitute the fulfillment of a distraction more than a passion.

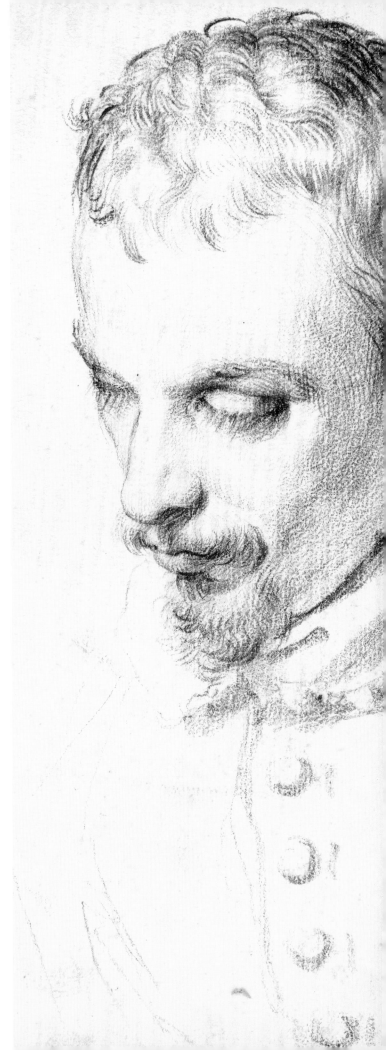

Antoine Coypel's collection is proof of a more assertive ambition: a portion of it has been preserved thanks to his son, Charles-Antoine Coypel, who bequeathed to the king in 1752 a group of drawings by Agostino and Annibale Carracci and their circle that had been acquired from Pierre Mignard's heirs. During his long stay in Rome, Mignard purchased three albums of drawings from the collection of the scholar Francesco Angeloni. Angeloni owned many drawings from Annibale Carracci's workshop. A significant number of these sheets belonged to Annibale's preparatory work for the decoration of the Galleria Farnese, in the Palazzo Farnese in Rome, and many art enthusiasts and collectors would have viewed them in the Cabinet Angeloni. Various artists were given access and allowed to make copies of the drawings, among them François Bourlier (in Rome between 1642 and 1644) and Charles Errard (1603–1689). When Mignard died, the prize he had brought back to France was divided between two buyers, Pierre Crozat and Antoine Coypel. The Angeloni drawings entered the royal collection from two distinct, illustrious sources: the 1752 Charles-Antoine Coypel bequest and the drawings that Mariette bought in 1741 at the Crozat sale, subsequently selected by J. B. Denis Lempereur for the king in 1775 at the Mariette sale.

The recent examination of the mounts allowed the identification of the sheets coming from the Coypel bequest (see fig. 9). It was observed that a certain number of drawings from the Louvre's Carracci holdings were glued onto pale, blue-chiné heavy paper and bordered with a thick, irregular line of black ink (see cats. 67 and 68), which made it possible to compare the information regarding the Angeloni drawings with the Coypel bequest and to reconstruct the latter. While Crozat, who was wealthier, selected the most accomplished and spectacular drawings from among Mignard's Carracci drawings, Antoine Coypel made his choices as an artist, collecting drawings of individual figures, nervous sketches, and attentive studies of anatomy and movement. *CL*

60

Francesco Mazzola, called Parmigianino
(Parma 1503–Casalmaggiore 1540)

Jupiter in the Form of a Satyr Uncovering Antiope

Pen and brown ink with brown wash over traces of red chalk; mount of Jabach's drawings of *ordonnance*

5 × 4³⁄₁₆ inches

Inv. 6414

Atlanta

Orphaned at an early age, Parmigianino was raised by his uncles Pier Ilario and Michele Mazzola, who were minor local painters. Very precocious, Francesco produced his first work, *The Baptism of Christ* (now in Berlin) in 1519, when he was only sixteen. His artistic talent was shaped by Correggio's works in Parma, such as the great fresco cycle in the monastery of San Paolo, *La Camera della Badessa,* dated 1519. In 1523 Parmigianino decorated a room dedicated to Paola Gonzaga, wife of Galeazzo Sanvitale, in the Rocca Sanvitale, their residence at Fontanellato, near Parma. The elegance, refinement of colors, and sophistication of the figures derive from the older master but are taken further toward the style that art historians would call Mannerism. Shortly afterward he moved to Rome, where he came into contact with the art of Michelangelo and Raphael. A new Medici pope, Clement VII, had just been elected, and around him was an artistic milieu in which Sebastiano del Piombo, Rosso Fiorentino, Baccio Bandinelli, Perino del Vaga, Polidoro da Caravaggio, and Benvenuto Cellini were all active. The 1527 sack of Rome by the troops of Emperor Charles V dispersed artistic talent throughout Italy and Europe, as many artists left the city. Parmigianino went to Bologna

and then returned to Parma. In 1531 he received the commission to decorate the church of Santa Maria della Steccata, a project that occupied him until his death at the age of thirty-seven.

This drawing illustrates an episode from Ovid's *Metamorphoses,* in which the sleeping nymph Antiope is seduced by Jupiter, who comes to her in the form of a Satyr. The scene was often used as an opportunity to paint the female nude. Parmigianino, who gives the scene an explicitly sexual interpretation, was an exceptional draftsman, as shown by the vibrancy of the lines, the energy emanating from the nervous change of direction of the pen, the clever suggestion of light and shade, and even the unfinished state of the figures. The Jabach mount suggests that either Le Brun was given the drawing directly by the collector or that he acquired it in some other way. *VF*

BIBLIOGRAPHY

Popham, A. E. *Catalogue of the Drawings of Parmigianino.* New Haven and London, 1971, no. 304.

Parmigianino e il manierismo europeo, exhibition catalogue, entry by Catherine Loisel. Parma: Galleria Nazionale, 2003, cat. 2.3.54.

61

Ludovico Carracci

(Bologna 1555–Bologna 1619)

*Woman Seated on the Ground with
Two Children*

Pen and brown ink, brown wash, on traces of
black chalk

10⅞ × 8¼ inches

Inv. 7844

Denver

After an apprenticeship in the workshop of Prospero Fontana (1512–1597) in Bologna, Ludovico Carracci traveled to Florence, Parma, and Venice to further his artistic education. He then established an atelier with his cousins Annibale and Agostino in his native city. His first works are marked by an originality that sets him apart from his Bolognese contemporaries. Using drawing and study from the live model as a point of departure, he created a new approach to religious and secular scenes that abandoned traditional iconography and stressed the expression of feelings. Under the influence of his cousin and pupil Annibale, his style evolved in the 1590s toward a naturalism that was both stylized and emphatic.

This sheet is the only drawing by Ludovico in the collection of Charles Le Brun. It is a study for a figure of Charity, and it evokes the artist's taste for scenes of daily life, which he always depicts with humor and animation. *CL*

BIBLIOGRAPHY

Loisel, Catherine. *Musée du Louvre, département des Arts graphiques, Inventaire général des dessins italiens: Ludovico, Agostino, Annibale Carracci, VII*, Paris, 2004, cat. 38.

62

Agostino Carracci
(Bologna 1557–Parma 1602)

Head of a Bearded Man

Black chalk
10⅞ × 8³⁄₁₆ inches
Inv. 33437
Atlanta

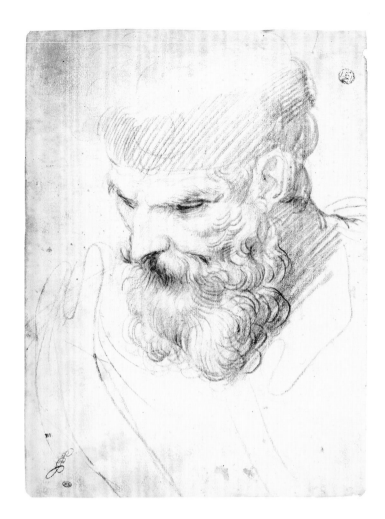

The older brother of Annibale Carracci, Agostino remains a more shadowy figure. Due to his activity as an engraver, he played a very important role in spreading knowledge of the works of Correggio, Titian, Veronese, and Tintoretto. He worked on all the projects of the Carracci atelier—notably, the fresco decorations of Palazzo Fava (1584) and of Palazzo Magnani (1590–1592) in Bologna. His participation in the decoration of the vault of the Galleria Farnese in Rome, where he worked in 1599 at the request of his brother, was very significant. He painted two important frescoes there, *Aurora and Cephalus* and *Venus and Triton.*

His painting *The Last Communion of Saint Jerome* (fig. 25), done in 1594 for the Church of the Certosa in Bologna (now in the Pinacoteca Nazionale), can be considered revolutionary in its search for monumentality and naturalism. The artist explores the repertory of emotions caused by the approaching death of the saint. This drawing, for a long time attributed to an artist of the sixteenth-century French school, is a study for one of the characters on the right side of the painting. The forceful use of line and the elegance of the figure are typical of Agostino's drawings. For this bearded old man, the artist was probably influenced by Paolo Veronese's *Astronomer Holding a Flat Astrolabe,* today in the Los Angeles County Museum. *CL*

BIBLIOGRAPHY

Loisel, Catherine. *Musée du Louvre, département des Arts graphiques, Inventaire général des dessins italiens: Ludovico, Agostino, Annibale Carracci, VII,* Paris, 2004, cat. 272, ill. 64, p. 51.

Fig. 25. Agostino Carracci, *The Last Communion of Saint Jerome,* 1594, oil on canvas, Pinacoteca Nazionale, Bologna, Italy.

63

Agostino Carracci
(Bologna 1557–Parma 1602)

Portrait of a Man (possibly Annibale Carracci)

Black chalk
10⅞ × 8¼ inches
Inv. 7845
Atlanta

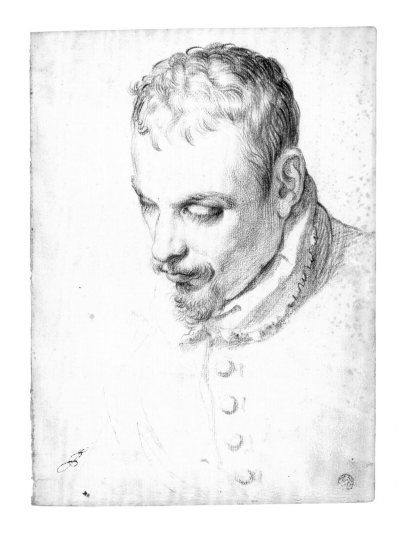

The recent attribution of this drawing to Agostino is based on a careful study of his style as well as the analysis of the paper, which shares many qualities with that used for the previous drawing (cat. 62). The portrait representation was one of the most frequent exercises done in the Academy of the Carracci, as Carlo Cesare Malvasia, the historian of Bolognese painting, wrote in his *Felsina Pittrice. Vite de' Pittori Bolognesi* of 1678. It would be very tempting to see in this careful study of a man lost in deep thought the features of Annibale Carracci, as he portrayed himself in his *Self-Portrait* dated 1593, in the Galleria Nazionale of Parma. *CL*

BIBLIOGRAPHY

Loisel, Catherine. *Musée du Louvre, département des Arts graphiques, Inventaire général des dessins italiens: Ludovico, Agostino, Annibale Carracci, VII*, Paris, 2004, cat. 273, ill. 65.

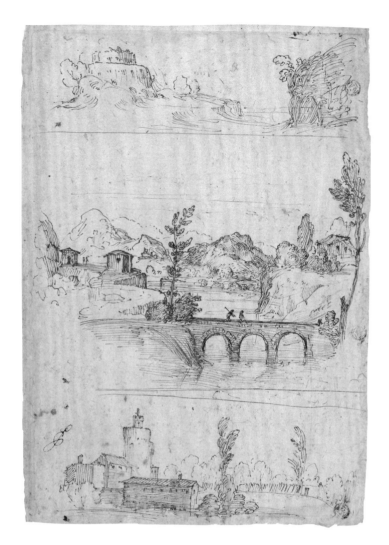

64

Agostino Carracci
(Bologna 1557–Parma 1602)

Three Landscape Studies (recto)
Group of Figures in Front of a Palace
(verso)

Pen and brown ink
11¾ × 8⁵⁄₁₆ inches
Inv. 8078
Denver

The role of the Carracci workshop in the development of a distinctively Bolognese style of landscape, both drawn and painted, is fundamentally important. Malvasia noted that the members of the atelier used to draw in the countryside outside Bologna. Agostino and Annibale also studied the landscapes of Titian, and the assimilation of that influence is evident in their paintings of the 1590s. To our knowledge, all the landscape drawings by Agostino that have survived are in pen and ink. This sheet has the calligraphic and naturalistic character typical of the landscape drawings by Agostino. *CL*

BIBLIOGRAPHY

Loisel, Catherine. *Musée du Louvre, département des Arts graphiques, Inventaire général des dessins italiens: Ludovico, Agostino, Annibale Carracci, VII,* Paris, 2004, cat. 337.

65

Willem Pietersz. Buytewech

(Rotterdam 1591/1592–Rotterdam 1624)

Standing Man with Two Dogs

Brush and brown ink, brown wash
7³⁄₁₆ × 5⅜ inches
Inv. 7512
Denver

66

Willem Pietersz. Buytewech

(Rotterdam 1591/1592–Rotterdam 1624)

Standing Man Holding a Sword,
with a Dog

Brush and brown ink, brown wash; area in front of
the soldier has been cut out and the sheet glued onto
secondary support; later retouched with black ink,
gray wash, and white gouache
7¼ × 4¹¹⁄₁₆ inches
Inv. 7512.bis
Denver

The little-known draftsman, etcher, and painter Willem Buytewech was a northern Netherlandish artist nicknamed "Geestive Willem" ("witty" or "inventive" Willem) by his contemporaries, because of the great range of subjects he treated and the liveliness of his observation. He entered the Painters Guild of Saint Luke in Haarlem in 1612, moving back to Rotterdam around 1617 and remaining there until his early death.

The two sheets presented here, dated around 1616–1617, had been previously attributed to the Carracci school, due to the comical rendering of the scene. In 1959, E. Haverkamp Begemann recognized the hand of Buytewech on account of the similarity to two other sheets in the Boymans-van Beuningen Museum in Rotterdam. In one image, the man wearing baggy, loose-fitting clothes is watching one of his dogs relieving himself. The other sheet, showing a stiffly upright man holding a sword, has a cut-out area where a codpiece presumably was, drawn over with what appears to be a cluster of ribbons. *VF*

BIBLIOGRAPHY

Dawn of the Golden Age. Northern Netherlandish Art 1580–1620, exhibition catalogue, entry by Maria van Berge. Amsterdam: Rijksmuseum, 1993–1994, cat. 295, no. 259.

67

Agostino Carracci
(Bologna 1557–Parma 1602)

The Annunciation

Pen and brown ink over traces of black chalk; corners
have been repaired; mount of Charles-Antoine Coypel
10¼ × 13⅛ inches
Inv. 7903
Denver

Fig. 26. Agostino Carracci, *The Annunciation,* ca. 1600,
oil on canvas, Musee du Louvre, Inv. 182.

Originally larger, this sheet is a good example of Agostino
Carracci's working method, as it shows two studies with
variants for an *Annunciation*. Other drawings for the same project
are in the royal collection at Windsor Castle. Some scholars believe
that they are preparatory for the painting now in the Louvre (fig. 26),
which is generally attributed to Agostino. It is also possible that this
group of sketches—probably executed during his last stay in Rome
in 1599, while he was working on the vault of the Farnese Gallery—
could have been conceived for a different composition, which, though
it has not survived, is known through a drawn copy in the Louvre
(Inv. 7904). The search for elegance and the refined elongation of
the figures, recalling the style of Parmigianino, seem to be charac-
teristic elements in Agostino's late works. *CL*

BIBLIOGRAPHY

Loisel, Catherine. *Musée du Louvre, département des Arts graphiques, Inventaire général des
dessins italiens: Ludovico, Agostino, Annibale Carracci, VII,* Paris, 2004, cat. 293.

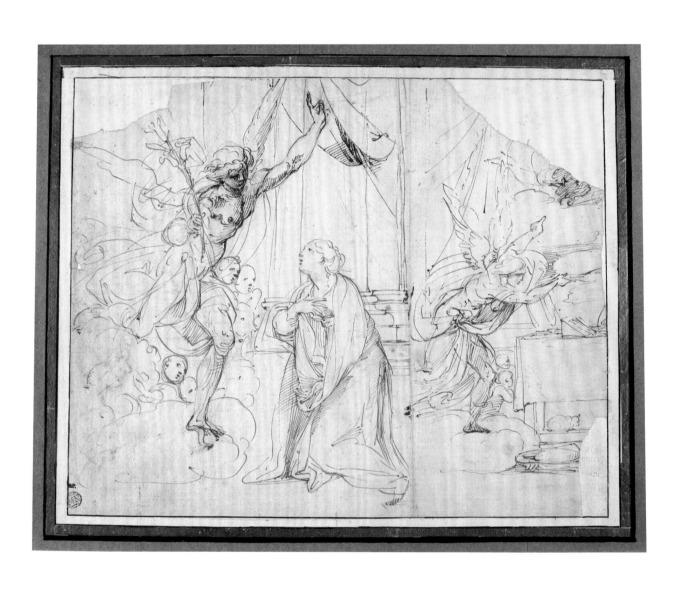

68

Annibale Carracci
(Bologna 1560–Rome 1609)

Study for Medusa

Black and white chalk on blue paper;
mount of Charles-Antoine Coypel
10³⁄₁₆ × 15¾ inches
Inv. 7371
Denver

A long with his cousin Ludovico and his brother Agostino, Annibale Carracci set in motion the "pictorial revolution" that transformed Italian art in Bologna around 1580. Reacting against Mannerism, the three artists studied the real world intently through the art of drawing, the privileged instrument of preparation for paintings. Their frescoed cycles, executed in close collaboration, show a return to naturalistic representation and spontaneity. Strongly marked by the influence of Correggio and the great Venetian painters, the Carraccis created a synthesis that laid the foundation for European Classical art.

Between 1595 and 1597, working for Cardinal Odoardo Farnese in Rome, Annibale created the decoration for the Cardinal's private bedchamber, called the *Camerino*. The main theme was Virtue, as personified by heroes of Antiquity such as Ulysses, Perseus, and Hercules. The figure of Medusa, one of the three terrible sisters, the Gorgons, is depicted here as Perseus prepares to behead her. The severed head was an instrument of terror as she turned those who looked at her into stone. The fight between the hero, protected by Minerva, and Medusa is painted in fresco on one of the lunettes on the ceiling of the *Camerino*. Here, the figure's desperate gesture is perfectly rendered through the skillful modeling and energetic use of the black chalk. *CL*

BIBLIOGRAPHY

Loisel, Catherine. *Musée du Louvre, département des Arts graphiques, Inventaire général des dessins italiens: Ludovico, Agostino, Annibale Carracci, VII*, Paris, 2004, cat. 474.

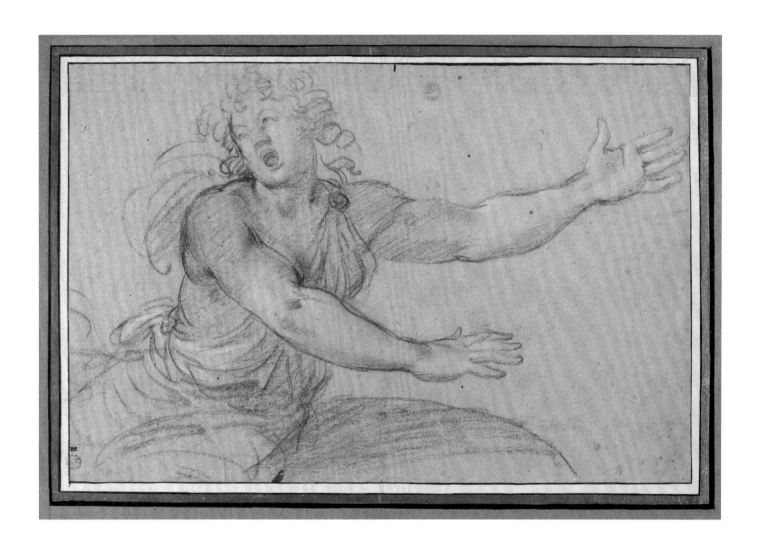

109

69

Annibale Carracci
(Bologna 1560–Rome 1609)

Hercules Carrying the Terrestrial Globe

Black and white chalk on blue paper; mount of
Charles-Antoine Coypel
15 × 9¾ inches
Inv. 7206
Atlanta

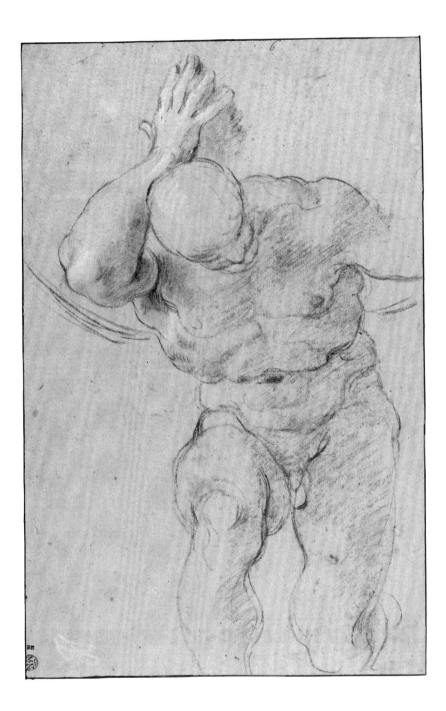

The man seen here is the central figure in one of the frescoes in the *Camerino*, the private bedchamber of Cardinal Odoardo Farnese in his palazzo in Rome, representing Hercules carrying the terrestrial globe between two astronomers. When he was living and working in the Palazzo Farnese, Annibale was fascinated by the extraordinary collection of antiquities. Under the guidance of Fulvio Orsini, the librarian in charge of the Farnese collections, the artist studied the ancient works that might serve as inspiration for his compositions. Scholars have underlined the resemblance of the figure of Hercules to the *Belvedere Torso*, at the time installed in the Statues Courtyard of the Vatican's Belvedere villa. When Annibale was executing the *Camerino* frescoes, his attention to Hellenistic sculpture led his aesthetic vision toward a stronger idealization of forms. *CL*

BIBLIOGRAPHY

Loisel, Catherine. *Musée du Louvre, département des Arts graphiques, Inventaire général des dessins italiens: Ludovico, Agostino, Annibale Carracci, VII*, Paris, 2004, cat. 482.

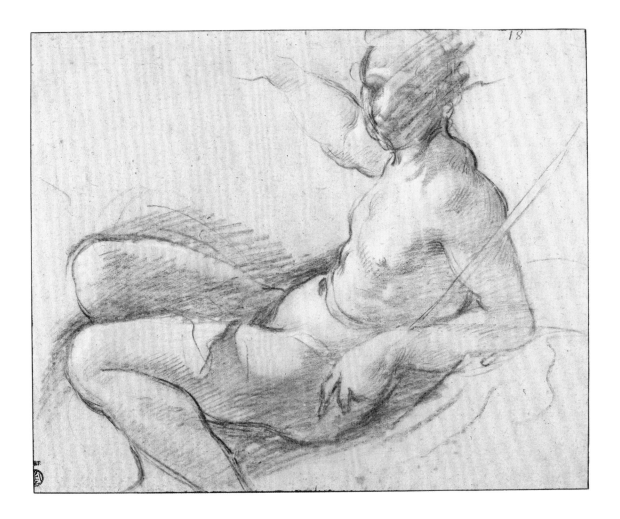

70

Annibale Carracci
(Bologna 1560–Rome 1609)

Study for Diana (after a Male
Model)

Black and white chalk on faded blue paper; mount
of Charles-Antoine Coypel
10½ × 13 inches
Inv. 7328
Atlanta

In his numerous studies from the live model, especially those executed while he was working in the Palazzo Farnese, Annibale Carracci used male models to work out the pose and the modeling of the figures, which he had already organized into a composition. Here a male model poses for the figure of the goddess Diana, placed at the right of the painting *Diana and Callisto,* in the collection of the Duke of Sutherland. The numerous *pentimenti* (corrections and alternative ideas) in the tracing of the legs testify to the search for the right balance of the figure. The strange hatching covering the model's face might be an effort to obscure its masculine characteristics. The drawing is contemporary with those for the vault of the Farnese Gallery, made around 1600. *CL*

BIBLIOGRAPHY
Loisel, Catherine. *Musée du Louvre, département des Arts graphiques, Inventaire général des dessins italiens: Ludovico, Agostino, Annibale Carracci, VII*, Paris, 2004, cat. 540.

71

Annibale Carracci
(Bologna 1560–Rome 1609)

Study for Christ in the *Coronation of the Virgin*
Black chalk on blue paper; mount of Charles-Antoine Coypel
9¹¹⁄₁₆ × 12 inches
Inv. 7169
Atlanta

In 1601 the banker Tiberio Cerasi commissioned Annibale Carracci and Caravaggio to decorate his funerary chapel in the Roman church of Santa Maria del Popolo. The commission instigated an interesting confrontation between the two most innovative artists of the time working in Rome. Annibale, with his assistant Innocenzo Tacconi, executed the frescoes on the vault and the painting on panel of the *Assumption of the Virgin* above the altar. Caravaggio executed the two paintings on the side walls of the chapel, the *Crucifixion of Peter* and the *Conversion of Paul.*

The figure represented here is that of Christ raising his arm to hold the crown above the Virgin's head. The image is placed in the central medallion of the vault. A recent restoration has revealed the important role that Annibale played in the execution of the frescoes. The pose of Christ repeats that painted in fresco three-quarters of a century earlier by Correggio in Parma. The perfect modeling and the monumentality of the figure are typical of the late works of Annibale.
CL

BIBLIOGRAPHY
Loisel, Catherine. *Musée du Louvre, département des Arts graphiques, Inventaire général des dessins italiens: Ludovico, Agostino, Annibale Carracci, VII*, Paris, 2004, cat. 544.

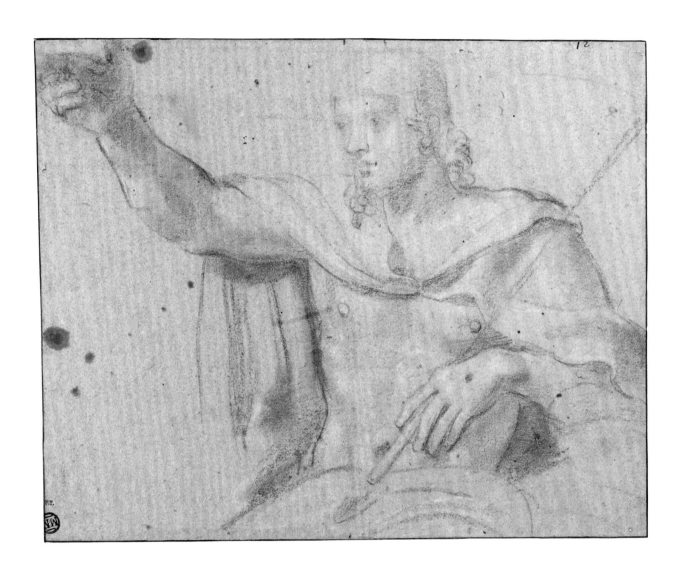

72

Annibale Carracci
(Bologna 1560–Rome 1609)

Study of Two Women for *The Birth of the Virgin*

Black and red chalk; upper right corner repaired;
mount of Charles-Antoine Coypel
9¹⁄₁₆ × 13⅛ inches
Inv. 7313
Atlanta

In March 1605, the Duke of Modena Cesare d'Este commissioned Annibale to produce a painting of the *Birth of the Virgin*. The correspondence between the Duke and Cardinal Odoardo Farnese on the subject of the painting is a moving testimony to the artist's sickness at that time. As he began work on the decoration of the Cappella Herrera in the Church of San Giacomo degli Spagnoli (no longer extant), the artist fell very sick and had to turn the work over to his assistants. After the Duke had repeatedly asked for the painting, Annibale started to work again in June 1605. The painting was almost finished in July 1606, when Cesare d'Este cancelled the commission. At the death of the artist on 15 July 1609, the inventory of his possessions included this painting in his workshop. It was subsequently finished by a pupil and is now in the Louvre (fig. 27).

The two figures on the sheet are detailed studies for the two female figures in the foreground of the painting. The use of red chalk, rare in the late drawings of the artist while preferred in his early ones, brings a special richness to the image. *CL*

BIBLIOGRAPHY
Loisel, Catherine. *Musée du Louvre, département des Arts graphiques, Inventaire général des dessins italiens: Ludovico, Agostino, Annibale Carracci, VII*, Paris, 2004, cat. 571.

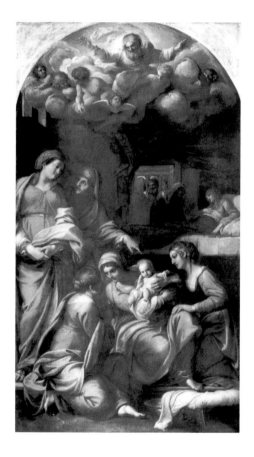

Fig. 27. Annibale Carracci and studio, *The Birth of the Virgin,* ca. 1606, oil on canvas, Musée du Louvre, Inv. 190.

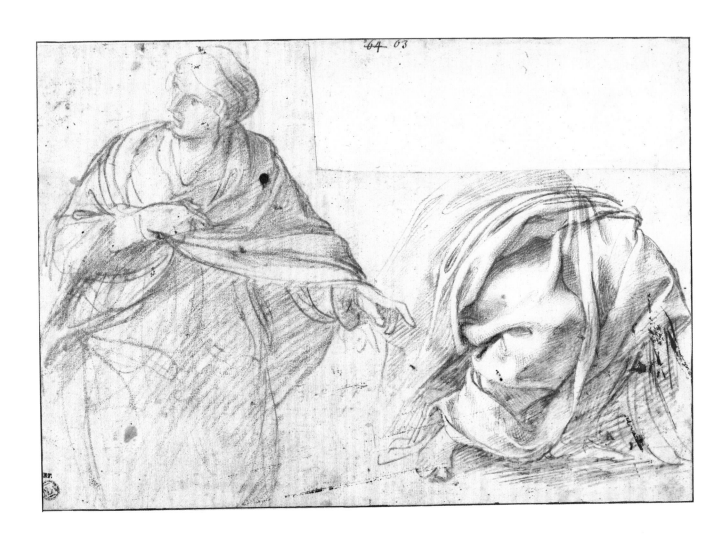

73
Zampieri Domenico, called Domenichino
(Bologna 1581–Naples 1641)

Daphne Turned into a Laurel Tree

Black chalk on gray-beige paper; mount of
Charles-Antoine Coypel
13¹⁵⁄₁₆ × 9¾ inches
Inv. 9087
Atlanta

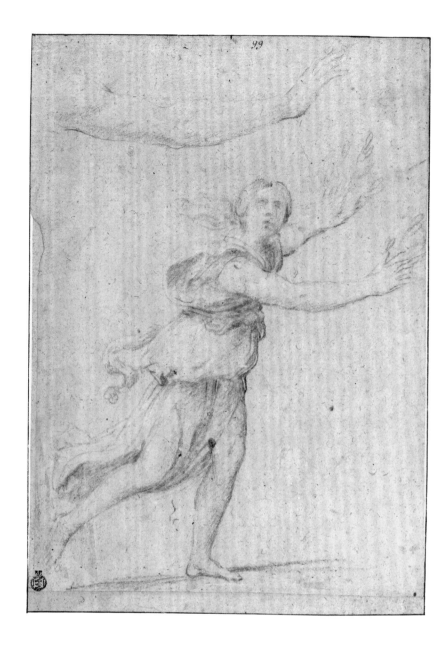

The favorite pupil of Annibale Carracci, Domenichino was the most important representative of the Classical style in Roman painting in the first two decades of the seventeenth century. He subsequently moved to Naples, where he painted the Cappella del Tesoro in the Cathedral of San Gennaro. After painting the celebrated fresco *The Flagellation of Saint Andrew* in the Church of San Gregorio al Celio for Cardinal Scipione Borghese, the artist became the protégé of the leading families of Rome. He was commissioned to execute the decoration of the Villa Aldobrandini at Frascati between 1616 and 1618. (Most of the fresco decoration has been detached and is now in the National Gallery, London.) It illustrates various episodes in the life of the god Apollo. The scenes are placed in a panoramic landscape setting, and the whole is framed by a trompe l'oeil illusion of tapestries hanging on the walls. A dwarf, a familiar figure at the Aldobrandini court, lifts the corner of one of the fake tapestries.

In this sheet, the unwilling nymph Daphne, trying to escape the pursuing Apollo, is changed into a laurel tree. The fluttering of her drapery while she is fleeing is rendered by the very skilled use of the black chalk. *CL*

BIBLIOGRAPHY

Spear, Richard E. *Domenichino*. Vol. 1. New Haven and London: Yale University Press, 1982, p. 199, no. 55v.; p. 201, note 61.

74

Zampieri Domenico, called Domenichino
(Bologna 1581–Naples 1641)

Man Leaning on a Long Stick (recto)
Study of Children (verso)
Black chalk on blue paper; surrounded by a strip of white paper
that is a remnant of the mount of Charles-Antoine Coypel for
recto-verso drawings
15⁷⁄₁₆ × 9³⁄₁₆ inches
Inv. 7333
Atlanta

The sheet is a precise study for the figure of a boatman straining to maneuver his boat, placed in the foreground of the painting *Landscape with Fortifications* in the collection of Sir Denis Mahon. Executed around 1634, and with the representation of the Flight into Egypt in the middle distance, the work is a reconstruction by Domenichino of the prototype of Classical landscapes, the *Flight into Egypt* by Annibale Carracci, now in the Galleria Doria Pamphilij in Rome. The painting by Annibale was executed in 1604–1608 for the chapel in the Palazzo Aldobrandini in Rome. Domenichino adds to the composition some naturalistic elements that give it a persuasive and direct quality, as can be seen in this drawing. In a lower corner is a separate study of the hat that the boatman will be wearing in the painted version. The very fluid modeling with black chalk underlines the unbalanced position and tense muscles of the figure. *CL*

BIBLIOGRAPHY
Domenichino 1581–1641, exhibition catalogue, entry by Richard E. Spear. Rome: Palazzo Venezia, 1996–1997, in cat. 49.

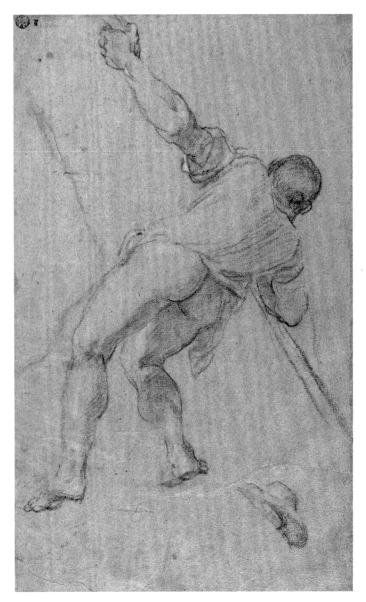

Recto

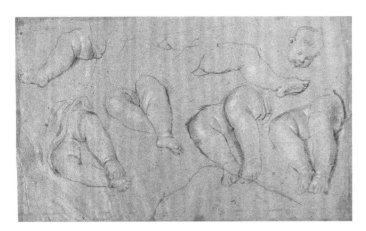

Verso

IV *The Collection of Pierre-Jean Mariette*

The collector Pierre-Jean Mariette himself was in the habit of drawing, and he put his talent to use in "restoring" his drawings in a particularly invasive way. It is not known when he invented the mount that became characteristic of his collection—the most elegant mount ever devised. He glued drawings onto a luminous blue cardboard backing or sometimes placed fragments of works by the same artist together onto a hand-colored paper. He then surrounded them with a line traced in Chinese ink. The width of the line gives the illusion of a shadow cast by a frame upon which light shines from the upper left. For some of these drawings, it is not unusual to see that the original sheet was re-cut or enlarged by adding one or more bands of paper, and careful examination can sometimes reveal evidence of Mariette's own hand in some retouched areas of a drawing (for example, cat. 75). Mariette's dexterity was such that, according to F. Basan, author of the Mariette sale catalogue, he was

Charles-Nicolas Cochin (French, 1715–1790), *Portrait of P. J. Mariette,* pencil, Collection Frits Luyt, Institut Néerlandais, Paris.

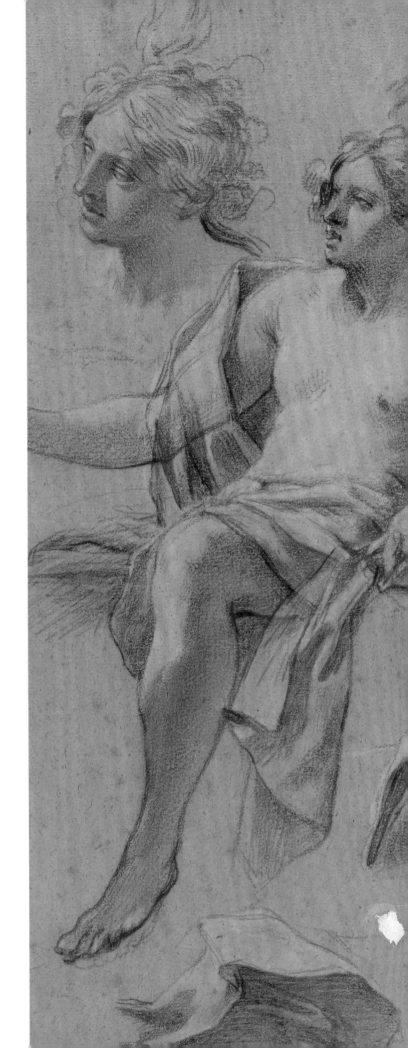

even able to execute the exceptional operation of separating a sheet drawn recto and verso into two separate pieces. This he did for *The Allegory of Night,* probably by Francesco Albani, now at Dresden's Kupferstichkabinett (Inv. C. 4555).

The collector's inventiveness can be appreciated in the variety of cartouches placed under the mounted drawings; each is elegant and imaginative and provides essential information about the artist and the work's subject and provenance. At the time of the 1775 Mariette sale, each drawing was stamped on the recto with the now-famous tiny ink mark, an *M* inside a circle.

In the last third of the eighteenth century, the Mariette mount was imitated but never matched. The tradition of gluing drawings onto specific mounts or backings was begun in the sixteenth century. In addition to assuring long-term conservation of sheets that could have been damaged or destroyed due to excessive handling, the practice constitutes an invaluable element in reconstructing the history of a work. *CL*

75

Raffaello Sanzio, called Raphael
(Urbino 1483–Rome 1520)

Head of the Angel in the *Expulsion of Heliodorus*

Charcoal, black chalk, gray and red wash; squared and pricked for transfer; original sheet regularized by the integration of paper on right and lower edges; Mariette mount with cartouche: *RAPHAEL URBINAS,* and on either side of the cartouche: *Unius ex Angelis ultoribus Heliodorum è Templo eijcientibus caput, in Palatio Vaticano* (Head of one of the avenging angels expelling Heliodorus from the Temple, in the Vatican Palace)
10½ × 12¹⁵⁄₁₆ inches
Inv. 3853
Atlanta

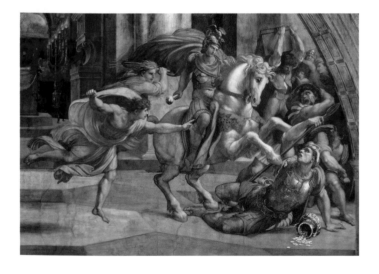

Fig. 28. Raphael, *The Expulsion of Heliodorus* (detail), fresco, Stanza d'Eliodoro, Stanze di Raffaello, Vatican Palace.

Although Raphael lived to be only thirty-seven, he is considered one of the greatest artists of the Italian Renaissance, along with Leonardo da Vinci and Michelangelo. Born in Urbino to a father who was a painter at the humanist court of the Montefeltro, he collaborated with Pinturicchio in Siena and was a pupil of Perugino's in Perugia. In 1508, his presence is recorded in Florence, where he had seized the opportunity to study the works of Leonardo and Michelangelo directly, as well as earlier Florentine masters. Later that year he was called to Rome by Pope Julius II. He was active there both as a painter and later as an architect, serving Julius's successor, Leo X, as well. He came to full mastery of his creative powers during the Roman period, when he frescoed the Vatican *Stanze* and *Logge* in the papal residence, designed cartoons for tapestries, and executed altarpieces. Raphael was also employed by privileged private patrons; the first among these was the pope's banker, Agostino Chigi, whose villa he decorated in fresco. In his brief life, Raphael achieved an expressive ability and a total mastery of techniques that are emblematic of the Italian Renaissance.

The work exhibited is a cartoon for the head of one of the two avenging angels in the *Expulsion of Heliodorus* (fig. 28), a fresco on the east wall of the *Stanza d'Eliodoro* in the Vatican. The decoration of the room was begun in 1511, at the end of the pontificate of Julius II, and completed three years later under Leo X. The Louvre also possesses the cartoon for the head of the second angel (Inv. 3852). The two cartoons were acquired by Mariette at the Crozat sale. They may have been among the cartoons by Raphael seen by Giorgio Vasari (see cat. 20) later in the sixteenth century in the house of Francesco Masini at Cesena, along with the cartoon for the head of a horse from the same fresco, now in the Ashmolean Museum, Oxford (Parker, 1956, no. 556). The episode depicted here, taken from the Second Book of Maccabees in the Old Testament, describes the expulsion of Heliodorus from the Temple of Jerusalem by three divine messengers, one on horseback, after trying to steal its treasure. On the other walls of the *Stanza d'Eliodoro* are represented the Liberation of Saint Peter, the Miracle of the Mass at Bolsena, the Meeting of Leo I and Attila— other illustrations of the intervention of Divine Providence. *VF*

BIBLIOGRAPHY

Cordellier, Dominique, and Bernadette Py. *Musée du Louvre, Musée d'Orsay, Département des Arts Graphiques. Inventaire général des dessins Italiens, V., Raphaël, son atelier, ses copistes.* Paris, 1992, no. 316.

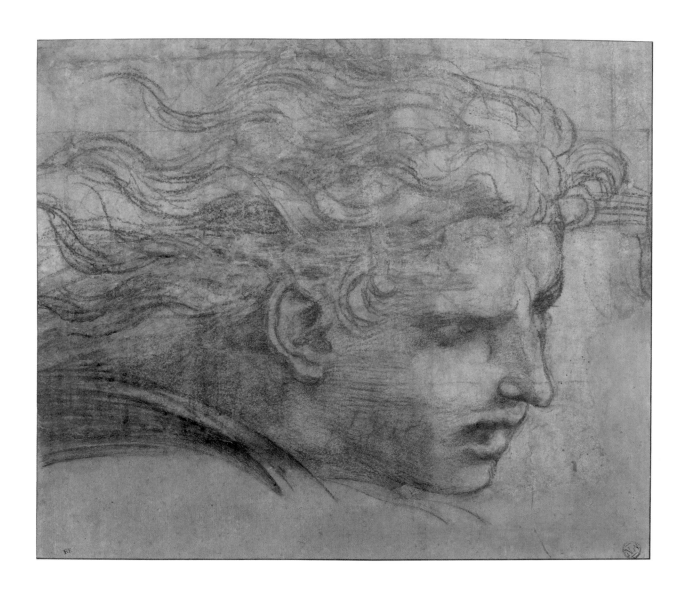

76

Albrecht Dürer
(Nuremberg 1471–Nuremberg 1528)

The Virgin Nursing the Christ Child with Saints and Angels

Pen with brown and black inks; signed on lower center with the monogram of the artist and dated: *1519;* framing lines in brown ink; number *24* in pen and brown ink on lower right corner

11 × 8⅜ inches

Inv. 18582

Denver

The cult of the Virgin was fervently celebrated in Dürer's native city of Nuremberg, particularly until the Reformation. Dürer depicted the Virgin and Child seated in a landscape several times in paintings, drawings, woodcuts, and engravings. In this sheet, signed with the artist's monogram and dated 1519, two angels hold a crown above the Virgin, while next to her are Joseph, Elizabeth, and Zacharias with the infant Saint John in the foreground. It has also been suggested that the older couple could be Mary's parents, Anna and Joachim. The older woman (Anna or Elizabeth), drawn in brown ink, could be a later addition by the artist. The balanced classical composition centered around the Virgin and the sheet's formal beauty show the influence of Italian art.

This drawing has a very interesting provenance and history of movement through several of the great collections that are specifically examined in the present exhibition. It was owned by Everhard Jabach, who continued to collect after his drawings were sold to King Louis XIV in 1671. The sheet is described in the 1695 inventory, drawn up after the collector's death. It was acquired by Pierre Crozat, possibly around 1720 (see the number *24* on lower right corner, which indicates the Crozat provenance; see also fig. 8). After Crozat's death, it came into the possession of Pierre-Jean Mariette in 1741 and, finally, after Mariette's death, it was acquired in 1775 for the royal collections. *VF*

BIBLIOGRAPHY

Dessins de Dürer et de la Renaissance germanique dans les collections publiques parisiennes, exhibition catalogue, entry by Pierrette Jean-Richard. Paris: Musée du Louvre, 1991–1992, cat. 62.

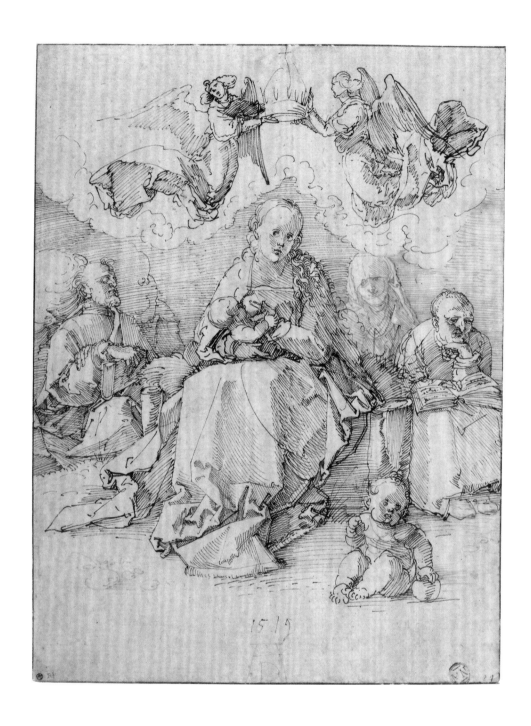

77

Hieronymus Bosch van Aeken ?

('s Hertogenbosch ca. 1450–'s Hertogenbosch 1516)

Witches, Monsters, and Fantastic Figures

Pen and brown ink; annotated by a later hand in brown ink
on lower edge on a piece of paper inserted onto the original
sheet: *Bruegel / manu / propria;* Mariette mount with cartouche:
PETRUS BREUGHEL SEN
8 × 10⅜ inches
Inv. 19721
Denver

Bosch was born in 's Hertogenbosch—hence his name (in French,
Bois-le-Duc)—one of the major cities of the Duchy of Brabant.
He worked in the family's workshop all his life. His surviving paint-
ings of secular and religious subjects present an iconography that
ranges from the realistic to the fantastically imaginative. His world
can seem to be almost a representation of the unconscious—replete
with bizarre figures, monsters, composite characters half human and
half beast, here ludicrous and absurd, there monstrous and terrifying.
The underlying themes are of sin, wickedness, the inevitability of fate,
folly, temptation, and the difficulty of obtaining redemption.

Mariette attributed the sheet to Pieter Bruegel, accepting the
validity of the inscription at the lower edge. In the early twentieth
century, it was attributed to Bosch, who did exercise great influence
on Bruegel, probably through drawings and also by means of prints
engraved after Bosch's death. The latest literature on Bosch calls into
question the attribution of the Louvre sheet. Bruegel's 1559 painting
Joust between Carnival and Lent, in Vienna, shows characters very similar
to some depicted here. The cowled figures riding on barrels and mill-
stones would fit right into Bruegel's *Joust.* The fantastic hybrid bird
at the bottom looks as though it could find its place in Bosch's *Garden
of Earthly Delights,* in the Prado, Madrid, but again it could also fit into
certain works of Bruegel's. Both artists drew upon the same Nether-
landish proverbs and moralizing literature. *VF*

BIBLIOGRAPHY

Lugt, Frits. *Inventaire Général des Dessins des Ecoles du Nord. Maîtres des Anciens Pays Bas nés
avant 1550.* Paris: Musées Nationaux, 1968, no. 69.
Jheronymus Bosch, exhibition catalogue, entry by Matthijs Ilsink, Jos Koldeweij, and
Bernard Vermet. Rotterdam: Museum Boymans-van Beuningen, 2001, cat. 7.28, fig. 138.

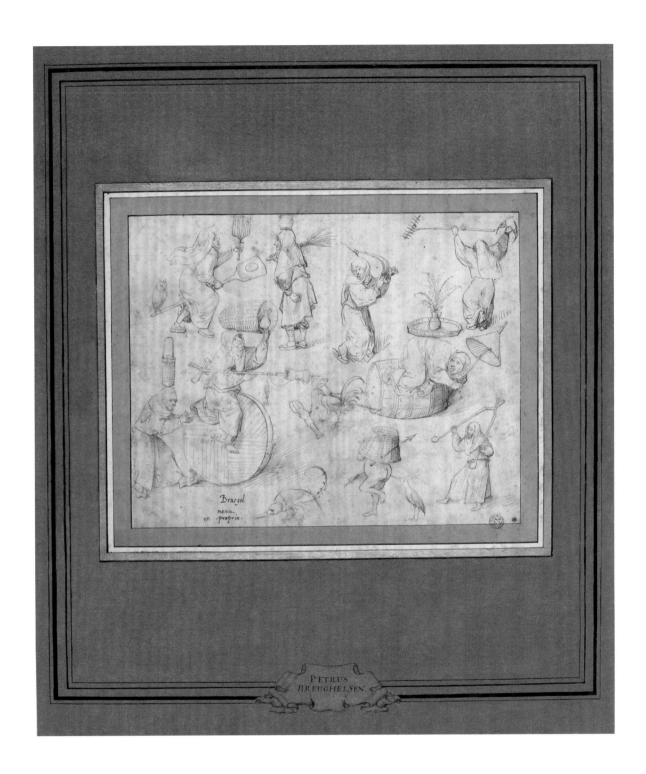

78

Bernard van Orley
(Brussels ca. 1488–Brussels 1541)

Landscape with a Horseman

Pen and brown ink, brown wash, and white gouache on paper tinted light brown, over traces of black chalk; number *4* in pen and brown ink on lower right corner; Mariette mount with cartouche: *BERN. VAN ORLEY BRUXELLENSIS*

12 × 18 inches
Inv. 20149
Denver

In 1515 van Orley became court painter to Margaret of Austria, governor of the Netherlands and aunt of Emperor Charles V. He later was in the service of her niece, Mary of Hungary, who also served as governor of the Netherlands. He was very popular and was considered the Raphael of the Netherlands. In his role of court artist, he was kept busy with the production of numerous works of various types, including tapestry designs, religious paintings, allegories, and portraits. He executed many drawings in preparation for the tapestry cycle *Hunts of the Emperor Maximilian* (some of the drawings and the tapestries are in the Louvre). The *Landscape with a Horseman* is a secular subject, probably from a literary source, belonging to another tapestry cycle. Van Orley employs the landscape setting that could be turned to so many different purposes by Netherlandish artists. There are many of van Orley's typical devices and details, including the strong

repoussoir of the tree overgrown with foliage and the use of the space like a well-appointed stage setting with various actors and actions. Also characteristic of the artist is the manner in which he develops the effect of depth by means of a receding landscape and progressively smaller figures. Some specialists have suggested that the fortifications of the large town seen in the distance are those of Brussels. In the Mariette sale catalogue, the view is said to be "of Flanders." The suggested date is 1521–1525.

This sheet, like Dürer's *The Virgin Nursing the Christ Child with Saints and Angels* (cat. 76), was owned by Jabach and is described in the 1695 inventory, drawn up after the collector's death. It was acquired by Pierre Crozat, possibly around 1720 (see the number *4* on lower right corner). After Crozat's death, it came into the possession of Pierre-Jean Mariette in 1741, and finally, after Mariette's death, it was acquired in 1775 for the royal collections. *VF*

BIBLIOGRAPHY
Lugt, Frits. *Inventaire Général des Dessins des Ecoles du Nord. Maîtres des Anciens Pays Bas nés avant 1550.* Paris: Musées Nationaux, 1968, no. 177.

79

Pieter Bruegel the Elder
(Bruegel? 1525/1530–Brussels 1569)

Alpine Landscape

Pen and brown ink; annotated and dated by a later hand on
lower center: *1553 Brueghel;* Mariette mount with cartouche:
PETRUS BREUGHEL SENIOR
9¼ × 13⁷⁄₁₆ inches
Inv. 19728
Denver

It is a paradox that our knowledge of Pieter Bruegel—whose friend
Abraham Ortelius, the famous cartographer, called him "the most
perfect painter of his century"—is so limited. He was admitted to the
Antwerp guild of painters in 1551. The following year, he traveled to
Italy and was back in the Netherlands by 1554. It is possible that Brue-
gel was urged to make this trip to Italy by the Antwerp printmaker-
entrepreneur Hieronymus Cock, who would translate the drawings
Bruegel brought back into prints. Karel van Mander, writing half a
century later in his *Het Schilder Boeck (The Book of Painting)* of 1604,
told of Bruegel's fascination with the Alpine landscape and said that
the artist "swallowed the mountains and the rocks to spit them up,
upon his return, on his canvases and panels."

This sheet and the impressive group to which it belongs are very
important in the development of the mountainous landscape and the

conveying of the sense of nature's power and majesty. Bruegel makes
clear the presence of man—the tiny travelers moving through the
vast space, the sinuous road man has made, the buildings stuck on the
crags, the cultivation on the plain beneath the heights. These expan-
sive landscapes show the influence of landscape prints and drawings
of Venetian artists such as Titian and Domenico Campagnola. The
same feeling of vastness will be found fifty years later in the moun-
tainous landscapes of Roelandt Savery (see cat. 7). Although scholars
now believe that the name and date on the lower edge of the sheet
were added later, the dating has been accepted because of the similar-
ity with another sheet by the artist, *Mountain Landscape with River and
Travelers* of 1553, in the British Museum.

Mariette praised the Alpine views by Bruegel, which he found
"superbly beautiful." When he drafted the 1741 Crozat sale catalogue,
where this sheet probably was bought, he wrote that "these landscapes
drawn with a pen are worthy of Titian." *VF*

BIBLIOGRAPHY
Lugt, Frits. *Inventaire Général des Dessins des Ecoles du Nord. Maîtres des Anciens Pays Bas
nés avant 1550.* Paris: Musées Nationaux, 1968, no. 329.
Orenstein, Nadine M. *Pieter Bruegel the Elder: Drawings and Prints,* exhibition catalogue.
New York: The Metropolitan Museum of Art, 2001, cat. 12.

80

Rembrandt Harmensz. van Rijn
(Leiden 1606–Amsterdam 1669)

Jacob's Dream

Pen and brown ink with brown wash, retouched with white gouache;
annotated in black chalk on lower right: *R 13;*
Mariette mount with cartouche: *REMBRANDT*
9 × 8¼ inches
Inv. 22881
Atlanta

Rembrandt is the most important painter and printmaker of seventeenth-century Holland. He is also celebrated for his large production of drawings in a wide variety of techniques. His masterly use of ink and wash and of black and red chalk enabled him to depict a multiplicity of subjects, from scenes of everyday life to portraits and religious or mythological compositions, as well as landscape views of the villages, rivers, and canals around Amsterdam. His art is unusual in seventeenth-century Holland for its focus on Christian subjects, many of which, such as this, are taken from the Old Testament. This may well be linked to a renewed focus on the Old Testament in a religious environment dominated by Calvinism.

The story of Jacob's dream is told in Genesis. Jacob, on his way to find a wife among the daughters of Laban, stopped to pass the night and fell asleep, using a stone as a pillow. He dreamt of a very long ladder set up on the earth and reaching to the sky. "Angels of God" were ascending and descending upon it. He heard the voice of Jehovah telling him that the earth upon which he was lying would belong henceforth to him and to his descendants, who would be as numerous as the specks of dust of the earth. Rembrandt has not depicted the ladder, which is usually pictured, but rather two benevolent angels standing above and stretching protective hands toward the sleeping Jacob. The intensity of the spiritual and divine event is represented in very human terms, an approach typical of the artist. A date between 1641 and 1645 has been proposed for the sheet.

The attribution to Rembrandt has been questioned in the past, and even recently, because many of the artist's pupils repeated and emulated his compositions. Mariette owned eleven drawings and 420 prints by Rembrandt, although the collector expressed the opinion that the artist did not demonstrate mastery either of "the correctness of proportions or the nobility of expressions," elements that were, in his eyes, the basis of great art. *VF*

BIBLIOGRAPHY
Rembrandt et son école, dessins du Musée du Louvre, exhibition catalogue, entry by Emmanuel Starcky. Paris: Musée du Louvre, 1988–1989, cat. 30.

81

Meindert Hobbema
(Amsterdam 1638–Amsterdam 1709)

Water Mill near the Bergpoort at Deventer

Pen and brown and black ink, gray wash over traces of black chalk;
annotated in pen and ink on lower right: *Ruisdael;* Mariette mount
with cartouche: *JACOB RUYSDAEL*

5 × 8 inches
Inv. 23014
Denver

Until recently accepted as a drawing by Jacob Ruisdael, and
described as such in Mariette's sale catalogue, this sheet
was re-attributed to his pupil Meindert Hobbema by Seymor Slive
in his recent catalogue raisonné of Ruisdael. Three drawings thus
argued to be by Hobbema and a painting signed and dated by him
in the National Gallery of Scotland at Edinburgh represent the same
water mill at Deventer, a town where the artist is known to have
traveled in the 1660s. The basis for the new attribution of the three
drawings—the Louvre sheet exhibited here, the second at the British
Museum in London (Inv. 00 11-242), and the third at the Petit Palais
in Paris (Inv. 996)—emerges from an analysis of style, including the
"sometimes spotty application of the wash in passages of the three

drawings, the rather schematic handling of shrubs and trees that shows
no indication of Jacob's dense, detailed treatment of foliage" (Slive,
cat. dubD46). The suggestion that the three works could be by Hob-
bema had been made in the past: Lugt, while retaining the Ruisdael
authorship, had mentioned Hobbema in relationship to the related
drawing in the Petit Palais; J. Giltay, in 1980, had claimed to see the
same hand in the three drawings discussed above.

Ruisdael was born in Haarlem in 1628 or 1629 and died in Amster-
dam in 1682. He is arguably the greatest Dutch landscape painter of
the seventeenth century. His father Isaack and his uncle Salomon were
also painters. Hobbema is Ruisdael's only documented pupil. The
representation of familiar landscapes was given great emphasis in
Dutch art of the period. This can be tied to a long-established North-
ern tradition of the representation of the real world, but it could also
be seen as a manifestation of patriotism in a country that had newly
emerged as a nation on the European scene.

The drawing was first exhibited in 1797 in the Galerie d'Apollon
of the Louvre (then called the Muséum central des Arts). It remained
on display, astonishingly, until about 1900. *VF*

BIBLIOGRAPHY

Lugt, Frits. *Inventaire Général des Dessins des Ecoles du Nord. Ecole Hollandaise.* Paris:
Musées Nationaux, 1931, no. 671.
Slive, Seymour. *Jacob van Ruisdael: A Complete Catalogue of His Paintings, Drawings,
and Etchings.* New Haven and London: Yale University Press, 2001, cat. dubD35.

82

Jacques Fouquier
(Antwerp 1590/1591–Paris 1656)

Wooded Landscape with Figures by a Sandy Road

Brush, pen and brown ink, watercolor, and gouache; Mariette
mount with cartouche: *JACOBUS FOUCQUIER*
8 × 12¼ inches
Inv. 19969
Denver

Fouquier (also called Fouquières) was a master of the Antwerp guild of painters in 1614. He worked in Brussels and Heidelberg before settling permanently in France in 1621. He was employed by King Louis XIII and was among the artists considered for the decoration of the Grande Galerie of the Louvre.

This timeless view of nature was highly appreciated by Mariette. He owned nine drawings by Fouquier, of whom he said "one does not know of another Flemish painter who put in his landscapes more freshness than Fouquier, who expressed with more precision and intelligence the diversity of objects found in the countryside." The appeal of the drawing clearly continued into the next century, as it was put on view in 1797 in the Galerie d'Apollon of the Louvre (then called the Muséum central des Arts). It remained on display at the Louvre until 1866, when Frédéric Reiset changed the selection of exhibited works.

Writing in 1949, Lugt underlined the similarity of style of Fouquier's landscapes and those of his Flemish contemporary Lodewijck de Vadder. Mariette's attribution of this sheet to Foucquier was maintained by Lugt, and it is still considered most likely. *VF*

BIBLIOGRAPHY

Royalton-Kisch, Martin. *The Light of Nature: Landscape Drawings and Watercolours by Van Dyck and His Contemporaries,* exhibition catalogue. London: British Museum, 1999, cat. 40.

83

Pieter Bout

(Brussels 1658–Brussels 1719)

Travelers on Horses Stopping at a Farrier

Pen and brown ink with gray and brown wash;
Mariette mount with cartouche: *PETRUS BAUT*
7¾ × 11⅝ inches
Inv. 19595
Denver

Pieter Bout spent most of his life in his native city of Brussels, although from 1671 to 1677 he was working in Paris. Mariette wrote about him that Bout liked to represent "fairs and subjects susceptible of having numerous figures" and that Adriaen Frans Boudewyns often executed the landscape backgrounds of his paintings. Bout had in fact worked in collaboration with several contemporary landscape painters, contributing figures and animals. His own landscapes are inspired by earlier Dutch and Flemish sources.

The exhibited sheet was the only work by the artist Mariette owned. The genre scene is in the Northern tradition of representing daily life. One horse is being shod, other travelers on horseback are waiting their turns, dogs are milling about; one tired character is sitting on the ground next to his dog. Through the open door of the thatched cottage, one sees a woman cooking on an open hearth. *VF*

BIBLIOGRAPHY
Le Cabinet d'un Grand Amateur, P.-J. Mariette, exhibition catalogue, entry by Arlette Calvet Sérullaz. Paris: Musée du Louvre, 1967, cat. 154.

84

Nicolas Poussin
(Les Andelys 1594–Rome 1665)

View through a Wood

Brush, brown ink, and brown wash; Mariette
mount with cartouche: *NIC. POUSSIN*
10 × 7¼ inches
Inv. 32465
Atlanta

BIBLIOGRAPHY

Inventaire Général des Dessins, Ecole Français, XIII. De Pagnest à Puvis de Chavannes. Directed
by Catherine Legrant, entry by Jean-François Méjanès. Paris: Musée du Louvre, 1997,
no. 1679.

Rosenberg, Pierre, and Louis-Antoine Prat. *Nicolas Poussin 1594–1665, Catalogue des
dessins.* Milan: Mondadori, 1994, no. R 744.

85

Nicolas Poussin
(Les Andelys 1594–Rome 1665)

Study of Two Trees

Pen, brush, and brown ink with brown wash
over traces of black chalk
9½ × 7 inches
Inv. 32466
Atlanta

BIBLIOGRAPHY

Inventaire Général des Dessins, Ecole Français, XIII. De Pagnest à Puvis de Chavannes. Directed
by Catherine Legrant, entry by Jean-François Méjanès. Paris: Musée du Louvre, 1997,
no. 1678.

Rosenberg, Pierre, and Louis-Antoine Prat. *Nicolas Poussin 1594–1665, Catalogue des
dessins.* Milan: Mondadori, 1994, no. R 745.

86

Nicolas Poussin

(Les Andelys 1594–Rome 1665)

Study of Five Trees

Pen, brush, and brown ink with brown
wash over black chalk; framing lines
9⅜ × 7 inches
Inv. 32467
Denver

Born in Normandy, Poussin received his formal training in France. By the time he was thirty, he had settled permanently in Rome, with one brief unsuccessful interlude in Paris between 1640 and 1642. He is one of the greatest French painters of the seventeenth century. He worked mostly for private patrons, men of letters, and art patrons who shared his love for erudition and Antiquity and his focus on the fragility of happiness and the significance of human life. His most important patron was Cassiano dal Pozzo, secretary of Cardinal Francesco Barberini.

Mariette acquired eight drawings by Poussin at the 1741 sale of the Crozat collection, all in the same technique and of similar dimensions. They were subsequently bought for the royal collections at his sale in 1775. The three exhibited sheets are among them. Mariette inscribed on the cartouche of cat. 84 the attribution to Nicolas Poussin. The mounts of cats. 85 and 86 have been subsequently cut down, so the cartouches no longer survive. The authorship of Poussin has been contested in the last forty years and the alternative name of Gaspard Dughet, Poussin's brother-in-law, has been suggested. Roseline Bacou, in the catalogue of the Mariette exhibition at the

Louvre in 1967, maintained the attribution to Poussin, as still does Jean-François Méjanès (personal communication, 2005). A date of 1625–1629, in the first years of the artist's Roman period, has been proposed. Mariette wrote in the Crozat sale catalogue that Poussin drew the major part of his landscape studies from nature in the vineyards of Rome and in the countryside surrounding the city, where he observed forms and, particularly, the effects of light. While cat. 84 has been described as a study of light and its transparency through leaves in a wood, cats. 85 and 86, considered pendants, are more explorations of form and structure. The brushwork is masterly, with variations in the application of briefer or fuller touches according to the thickness of the foliage on the trees, while leaving the white of the paper to suggest spots of light. *VF*

BIBLIOGRAPHY

Inventaire Général des Dessins, Ecole Français, XIII. De Pagnest à Puvis de Chavannes. Directed by Catherine Legrant, entry by Jean-François Méjanès. Paris: Musée du Louvre, 1997, no. 1677.

Rosenberg, Pierre, and Louis-Antoine Prat. *Nicolas Poussin 1594–1665, Catalogue des dessins.* Milan: Mondadori, 1994, no. 746.

87

Claude Gellée, called Le Lorrain
(Chamagne 1600–Rome 1682)

Pastoral Scene along the Banks of the Tiber with the "Ponte Molle"

Pen and brown ink with brown wash over traces
of black chalk; number *2* in pen and brown ink on
lower right corner; Mariette mount with cartouche:
CLAUDII GELÉE LOTHARINGI
8¾ × 11¹³⁄₁₆ inches
Inv. 26684
Denver

This drawing has been related to a painting in the Art Gallery of Birmingham, signed and dated 1645, as well as to the drawing number 90 in the *Liber Veritatis* (see cat. 33), which bears an annotation indicating that the corresponding painting had been executed for a French *amateur.* The imaginary scene focuses on the beauty of the landscape, which is animated by small figures and into which are set details like the bridge, transforming the whole into an ideal poetic space bathed in light. Joachim von Sandrart, artist and historian of German art who spent several years in Italy and was Claude's friend, described how Claude would go to the countryside from dawn until dusk to learn how to represent the birth of the day, the rising and setting of the sun, and the hours of dusk. Mariette wrote that "of all landscape artists, Claude le Lorrain is the one who put most air and freshness into his landscapes."

The drawing was first exhibited in 1797 in the Galerie d'Apollon of the Louvre (then called the Muséum Central des Arts). It remained on display until about 1900. *VF*

BIBLIOGRAPHY
Bacou, Roseline, and Jacob Bean. *Le dessin à Rome au XVIIè siècle*, exhibition catalogue. Paris: Musée du Louvre, 1988, cat. 72.

88

Simon Vouet

(Paris 1590–Paris 1649)

Study for *The Allegory of Intellect*

Charcoal, black and white chalk on beige paper
15⁹⁄₁₆ × 10½ inches
Inv. 33309
Atlanta

Simon Vouet is another foreign artist who spent a long part of his career in Italy. The precocious son of a minor painter, he traveled extensively in his formative years. From 1614 until 1627, he settled in Rome. In 1624 Vouet was elected president (*Principe*) of the Accademia di San Luca in Rome. His Roman years were very productive, as he executed works still *in situ* in churches and several smaller paintings and portraits. He was influenced by the various movements of Italian painting, from the art of the Carraccis to that of Caravaggio to contemporary figures such as Lanfranco, Reni, and Guercino. Upon his return to Paris, Vouet became First Painter to King Louis XIII, for whom he executed several commissions. Many decorative cycles were executed by Vouet and his assistants, both in Paris and in the surrounding area. Vouet was active in the 1648 founding of the Académie de Peinture et de Sculpture—the French equivalent of the Italian Accademia. Among the artists trained in his workshop were two of the most important painters of the next generation, Le Sueur and Le Brun.

The two drawings exhibited here are both related to works of Vouet's French period. This study is a preparatory design for a painting probably done for the Château Neuf de Saint-Germain, which is now in the Salon de Mars at Versailles. Recognizable because of the flame placed above his head, the figure of Intellect is described in a 1645 contract for a commission in the apartment of Queen Anne of Austria, in the Palais Royal as: "a young man dressed in gold with a flame above his head. . . . He will be placed on or above an eagle to show that Intellect always moves upwards toward the highest and noblest things." The body's sculptural fullness and the rendering of the head are typical of Vouet's figure style. *VF*

BIBLIOGRAPHY

Vouet, exhibition catalogue, entry by Barbara Brejon de Lavergnée. Paris: Galeries nationales du Grand Palais, 1990–1991, cat. 132.

89

Simon Vouet
(Paris 1590–Paris 1649)

The Swooning Mary Magdalen Supported by Angels

Black and white chalk on beige paper; enlarged along top margin
12⅜₆ × 9¼ inches
Inv. 33310
Denver

Fig. 29. Simon Vouet, *Magdalen Supported by Angels,* oil on canvas, Musée des Beaux-Arts et d'Archéologie, Besançon, France.

Several painted versions of *Magdalen Supported by Angels* are mentioned in archival sources; Vouet even kept one in his lodgings. Two specific references date to 1640 and 1649. The work most often related to this drawing is in the Musée des Beaux-Arts et d'Archéologie, Besançon (fig. 29). In 1666, François Tortebat engraved the composition in a print that bears a Latin inscription commenting on the position of Magdalen: "one is uncertain whether the Magdalen is dying or languishing for love; what does it matter whether she is dying or languishing? —she loves." The three figures are beautifully arranged in a harmonious and balanced decorative group, described realistically through the play of dark chalk and white heightening.

The sheet was very much appreciated by the public and put on view at the Louvre from 1797 until about 1900. *VF*

BIBLIOGRAPHY
Vouet, exhibition catalogue, entry by Barbara Brejon de Lavergnée. Paris: Galeries nationales du Grand Palais, 1990–1991, cat. 117.

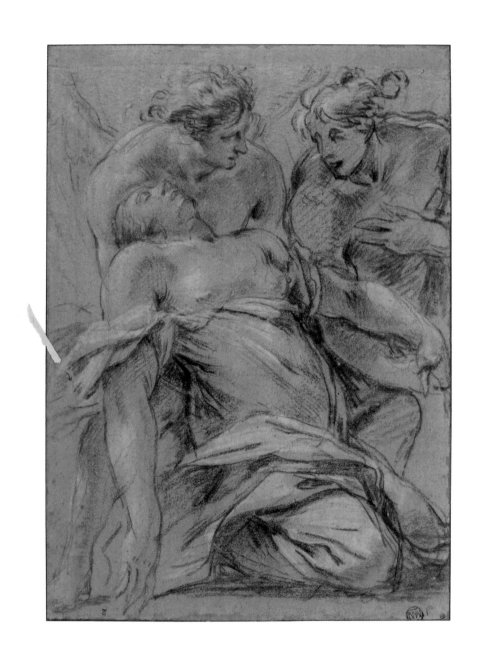

90

Eustache Le Sueur
(Paris 1616–Paris 1655)

Study of a Draped Man, Seen from Behind

Black and white chalk on beige-gray paper;
Mariette mount with cartouche: *Eustachii Le Sueur*
16¹³⁄₁₆ × 10¹³⁄₁₆ inches
Inv. 30682
Atlanta

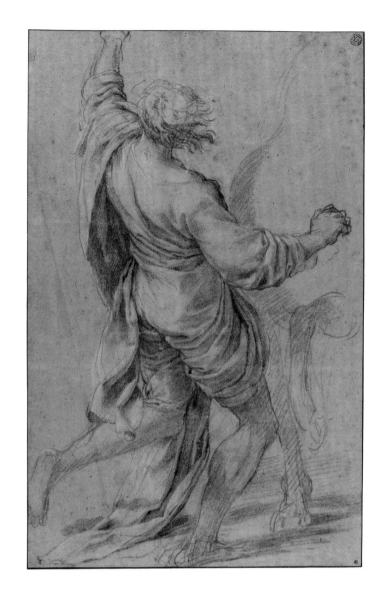

Unlike his teacher, Simon Vouet, Le Sueur never left France and executed his main works for prominent patrons living in the center of Paris, particularly on the Ile St.-Louis. He focused on history paintings and commissions for domestic decoration, his principal characteristics being elegance, sensuality, and harmony of rich, refined colors. He was extremely popular in his own time, as well as in the following century, when Mariette compared him to Raphael. The collector wrote that Le Sueur's manner was so close to Raphael's that one could mistake him for one of his disciples rather than Vouet's: "Both respected the taste for the Antique and took it as their model; they had the same idea of the Beautiful, the same simplicity, the same noble elegance in the arrangement of the draperies." Le Sueur was called the "French Raphael" and helped to establish what came to be defined as the French Classical style.

This drawing is preparatory for a painting of 1647, no longer surviving but known through contemporary descriptions and several other drawings, commissioned by Treasurer Claude de Guénégaud (*Trésorier de l'Epargne*) for his house in the Marais section of Paris. The subject of the painting was *Lucius Albinus fleeing Rome with his family, giving up his chariot to the Vestal Virgins.* The figure depicted in this drawing is that of a man trying to halt a horse. The influence of Raphael is clearly visible in the beautifully positioned figure, turning in space and seen from behind, with a sophisticated play of draperies following the man's movement. The black chalk technique, skillfully modulated with white heightening on beige or gray paper, is typical of the artist. *VF*

BIBLIOGRAPHY

Mérot, Alain. *Eustache Le Sueur (1616–1655).* Paris: Arthena, 1987, cat. 78, fig. 272.

91

Eustache Le Sueur
(Paris 1616–Paris 1655)

Study of Two Women for *The Finding of Moses*

Black and white chalk on gray-beige paper; annotation
in black chalk on lower center: *vert laque* (?) *dessous vert* (?);
Mariette mount with cartouche: *Eustachii Le Sueur.*
16⅛ × 11⁹⁄₁₆ inches
Inv. 30683
Denver

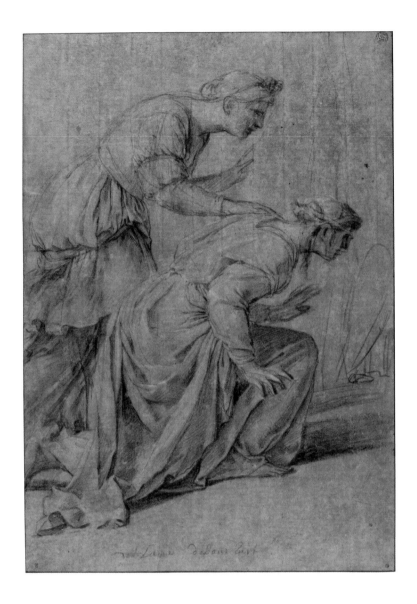

The two figures are studies for the servants on the left of the
painting *The Finding of Moses* in the Goulburn Estates at Betch-
worth, England, dated circa 1652 by Alain Mérot on stylistic grounds.
The painting was executed for Jérôme de Nouveau, Postal Controller
General (*Contrôleur général des Postes*), who lived in one of the build-
ings on the Place Royale in Paris (the present Place des Vosges). The
sheet is remarkable for its monumentality and the Classical nobility of
the figures, seen in profile, recalling ancient sculpture. The particular
kind of Classicism typical of Le Sueur has been called "Parisian Atti-
cism" for its elegance and a certain chilly preciosity. *VF*

BIBLIOGRAPHY
Mérot, Alain. *Eustache Le Sueur (1616–1655)*. Paris: Arthena, 1987, cat. 294, no. 160.

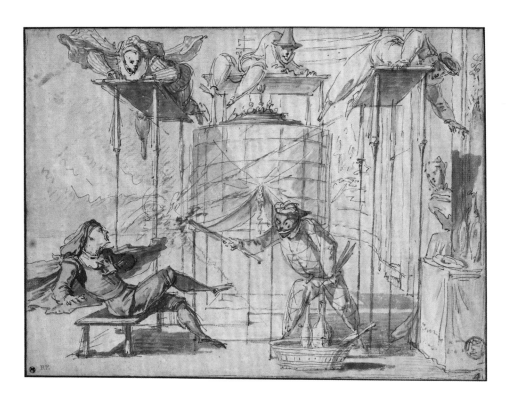

92

Claude Gillot
(Langres 1673–Paris 1722)

Scene from the Comédie Italienne:
*Harlequin, a Playful Wit: "Friends, let's not
exclude a clever guest . . ."*
Pen and black ink with red chalk wash; annotation in pen on lower
right: *4*; Mariette mount with cartouche: *CLAUDII GILLOT*
6⁵⁄₁₆ × 8⅝ inches
Inv. 26748
Atlanta

At the beginning of the eighteenth century, subjects drawn from
the theatre began to appear in French art. Italian actors of the
Commedia dell'Arte performed for the Parisian public, catering to
a new bourgeois taste—different from that of the court at Versailles—
with many *lazzi* (jokes) and burlesque situations. When the actors
were evicted from Paris in 1697, the repertory of Italian comedies and
pantomimes was played at the Théâtre de la Foire de Saint Germain
and the Foire de Saint Laurent.

Claude Gillot's body of work is dominated by his interest in the
world of actors and comedy. He drew mostly from live performances,
using a distinctive technique of pen and red chalk wash to create a
dramatic atmosphere. These theatrical scenes have been dated between
1704 and 1716. Usually, the point of view is that of the spectator
seated below the actors. Here, Gillot illustrates a scene from the
play *Harlequin, a Playful Wit (Arlequin esprit folet)*. During a banquet,

Mezzetin on the upper left, Polichinelle in the middle, and Pierrot
on the right, are frightened by the sudden rising of the benches and
the table at which they are sitting. At the left, Scaramouche is falling
off his bench as Harlequin threatens him with a lighted torch, causing
the turmoil. The composition was engraved in reverse by Gabriel
Hucquier, with the following lines:

> *N'excluons point amis un habile convive,*
> *qui dans les tours d'esprit est maître déclaré:*
> *Arlequin nous apprend que souvent il arrive*
> *qu'on mange le festin pour d'autres préparé*

> Friends, let's not exclude a clever guest,
> who is master of playful wit:
> Harlequin teaches us that often it happens
> that one eats the feast prepared for someone else.

VF

BIBLIOGRAPHY

Varnier, Eric. "Spectacles & caractères." *Claude Gillot, 1673–1722, comédies, sabbats et autres
sujets bizarres,* exhibition catalogue. Langres: Musée d'art et d'histoire de Langres, 1999,
p. 32 (fig.) and p. 121, note 21.

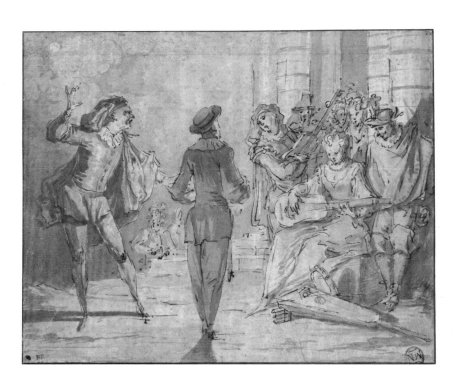

93

Claude Gillot
(Langres 1673–Paris 1722)

Scene from the Comédie Italienne:

*Jupiter Curious and Impertinent:
"Here is the character of a faithful
valet"*

Pen and black ink with red chalk wash; Mariette
mount with cartouche: *CLAUDIUS GILLOT.*
6¹⁵⁄₁₆ × 8⁷⁄₁₆ inches
Inv. 26749
Denver

Louis Fuzelier's pantomime of *Jupiter curieux impertinent* was played at the Foire de Saint Germain in 1711. The night scene represented here seems to come from the third act, where Colombine plays the guitar, with Mezzetin at her right and Polichinelle at her left. Several instruments are at her feet, perhaps put there by Pierrot, who is turning his back to the spectator. Scaramouche is gesticulating on the left. The composition was engraved in reverse by Gabriel Hucquier and bears the lines:

> *D'un fidelle valet voilà le caractère
> s'il découvre un concert à son maître fatal
> il se livre aux transport d'une juste colère
> voyant fièrement triomphe son rival*

> Here is the character of a faithful valet,
> if he discovers a plot fatal to his master,
> he lets a just anger seize him,
> seeing the victory of his rival.

As the actors of the Comédie Italienne were given to improvisations, it is not easy to identify the exact passage in the pantomime.

Gillot, Watteau's teacher, is a precursor of the artists of the *Fêtes Galantes,* a distinctively French artistic invention, in which elegantly dressed figures are set in an imaginary landscape, marked by a languishing, melancholic feeling. *VF*

BIBLIOGRAPHY

Varnier, Eric. "Spectacles & caractères." *Claude Gillot, 1673–1722, comédies, sabbats et autres sujets bizarres,* exhibition catalogue. Langres: Musée d'art et d'histoire de Langres, 1999, p. 24, note 49.

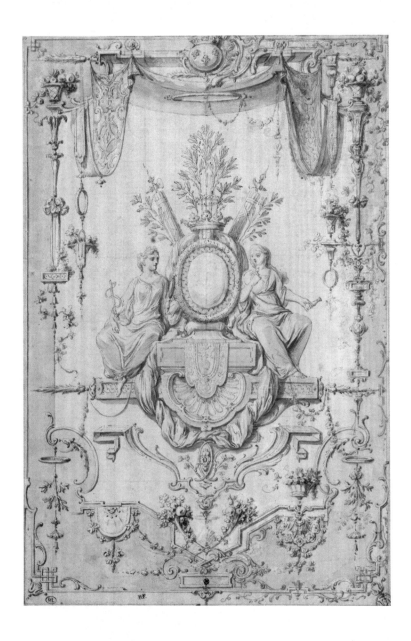

94

Claude Gillot

(Langres 1673–Paris 1722)

Study for a Heraldic Tapestry with the Allegorical Figures of Prudence and Secrecy

Pen, brown and black ink, brown wash, and red chalk wash corrected in white pigment over traces of black chalk; paper tinted beige; squared for transfer; Mariette mount with cartouche: *CL. GILLOT.*

11⅜ × 7⅝ inches

Inv. 26759

Denver

This study for a *portière,* a tapestry covering a door, was etched by the Comte de Caylus. The two allegorical figures, placed at either side of an oval medallion, carry their attributes: Prudence holds a stick, around which is coiled a snake, and a mirror. The snake symbolizes wisdom; the mirror allows the wise man to see himself as he really is. The figure of Secrecy brings a ring to her lips to seal them and holds a sealed bottle. The symmetrical use of the arabesques and foliated scrolls is typical of the Regency period (1715–1723) and derives from the grotesque decorations that had been adopted by the Renaissance after the discoveries of ancient fresco paintings. *VF*

BIBLIOGRAPHY

Varnier, Eric. "L'ornement." *Claude Gillot, 1673–1722, comédies, sabbats et autres sujets bizarres,* exhibition catalogue. Langres: Musée d'art et d'histoire de Langres, 1999, pp. 108–119 (fig.).

95

Jean Antoine Watteau
(Valenciennes 1684–Paris 1721)

Study of a Seated Woman

Black, white, and red chalk with stumping; sheet has been enlarged
at top and on left; lines of the original drawing have been extended
onto the enlarged section
9¾ × 7³⁄₁₆ inches
Inv. 33357
Atlanta

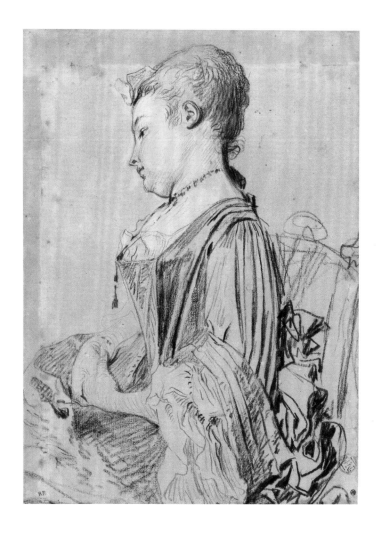

Watteau was born in Valenciennes, a town in northern France that was still part of the Spanish Netherlands just a few years before his birth. His artistic career developed mostly in Paris, where he was part of the circle of artists that gathered in the residence of the collector Pierre Crozat. For a time, he lived in Crozat's house and was allowed to copy the drawings in his large collection. The Comte de Caylus, who was also a frequent visitor at the Crozat residence, writes that Watteau executed "an infinite number" of copies after the work of the best Flemish painters and the great landscape artists. Watteau is a figure of innovation, a refreshing new current in French painting following the deaths of Le Brun and the official art of the time of Louis XIV. His art shows a radical shift in taste toward the representation of a new kind of subject. He was interested in the worlds of theater and masquerade, as was his teacher, Claude Gillot, and represented life as if it were a theater scene. His characters are wistful, longing for a lost time. His art has a realistic Northern streak, an interest in minute details, which can be connected back to seventeenth-century Flanders. His rich yet delicate color scheme is influenced by Rubens, whose art he came to know well through the Marie de Medici cycle at the Luxembourg Palace. Another strong influence came from Venetian art's colors and rich costumes. Watteau was the creator of a new genre, the *fêtes galantes,* or "gallant gatherings," in which small, costumed figures are assembled in a poetic setting—usually a sylvan garden or wood—sometimes playing music, sometimes acting, sometimes dancing.

The drawing exhibited here was engraved by Benoît Audran in *Figures de différents caractères,* a collection of prints after Watteau's drawings published in 1726. The print is in the same direction as the drawing and shows more of the woman's dress on the lower part and on the left. The use of the black chalk, with variations on the pressure of the hand applying it so as to obtain darker, thicker lines, is typical of Watteau's technique, as is the use of *les trois crayons* (the three chalk crayons), playing off the difference between the black, red, and white colors. For stylistic reasons, the sheet has been dated circa 1717. *VF*

BIBLIOGRAPHY

Rosenberg, Pierre, and Louis-Antoine Prat. *Antoine Watteau, 1684–1721: Catalogue raisonné des dessins*. Milan: Art Books Intl., 1996, no. 565.

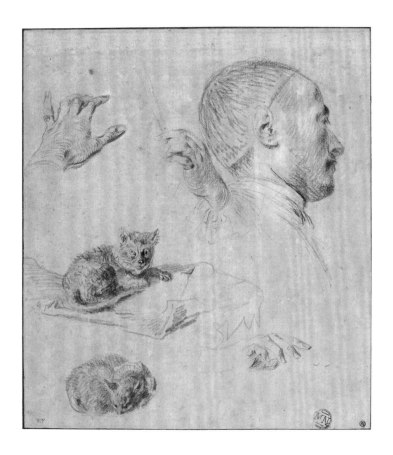

96

Jean Antoine Watteau
(Valenciennes 1684–Paris 1721)

*Study of a Man's Head with a Cap;
Three Studies of Hands; Two Studies
of Kittens*

Black, white, and red chalk and lead pencil; sheet
has been enlarged at the top; Mariette mount with
cartouche: *ANT. WATTEAU.*
7¹³⁄₁₆ × 7¹⁄₁₆ inches
Inv. 33358
Atlanta

This sheet has been dated around 1718 and its various studies linked to specific painted compositions. The details examined here, which are unrelated and even done in diverse techniques, show how the artist prepared his subjects, how he put onto paper a succession of images in a free manner, even changing the medium as he went along. One can see here the artist in dialogue with the sheet, trying to fix his thoughts onto paper. *VF*

BIBLIOGRAPHY

Rosenberg, Pierre, and Louis-Antoine Prat. *Antoine Watteau 1684–1721. Catalogue raisonné des dessins.* Milan: Art Books Intl., 1996, no. 614.

97

Jean-Baptiste Oudry
(Paris 1686–Beauvais 1755)

View in the Gardens of Arcueil

Black and white chalk with stumping on beige paper (formerly
blue); inscribed in brown ink on lower left, on an added strip of
paper: *J.B. Oudry 1747 à Arcueil,* glued onto secondary support
12½ × 18⅞₆ inches, including another added strip of paper above
Inv. 31488
Atlanta

Jean-Baptiste Oudry was the son of the painter and art dealer
Jacques Oudry. After his early training with his father, he entered
the studio of the portraitist Nicolas de Largillière (1656–1746), who
taught him to draw directly from nature and had a lasting influence
on his work. During this time Oudry came to know Flemish and
Dutch art, equally important influences on his later compositions. He
is best known for still-lifes, landscapes, and representations of animals
(particularly the portrayals of King Louis XV's favorite dogs), as well

as the cartoons for the series of tapestries representing the king's
hunts. He was director of the Manufacture de Beauvais and also
inspector of the Manufacture des Gobelins, two of the most impor-
tant production centers for tapestries in France.

Around 1745 Oudry visited the gardens of the Château of Anne-
Marie-Joseph de Lorraine, Prince de Guise, at Arcueil, just outside
Paris, to draw several highly finished views, mostly in black and white
chalk on colored paper; of these, about thirty survive in public collec-
tions. Other artists also visited the site to draw—among them Fran-
çois Boucher, Charles-Joseph Natoire, and Jean-Baptiste Pierre—but
Oudry was the most prolific. The gardens had been formally laid out
with terraces, ramps, and basins on a large hilly area crossed by a river.
At the time Oudry visited them, they were abandoned and overgrown,
soon to be demolished in 1752. The artist chose to show nature left to
itself in picturesque decay, creating a charming and poetic landscape
where humans are rarely present. *VF*

BIBLIOGRAPHY
Opperman, Hal. *J.-B. Oudry, 1686–1755,* exhibition catalogue. Paris: Galeries nationales
du Grand Palais, 1982–1983, 232–244, fig. 129/138f.

98

Jean-Baptiste Oudry
(Paris 1686–Beauvais 1755)

View in the Gardens of Arcueil

Black and white chalk with stumping on gray-beige paper
(formerly blue); glued onto secondary support
12¾ × 18⅞₆ inches, including two added strips of paper
above and below
Inv. 31489
Atlanta

BIBLIOGRAPHY

Opperman, Hal. *J.-B. Oudry, 1686–1755,* exhibition catalogue. Paris: Galeries nationales
du Grand Palais, 1982–1983, 232–244, fig. 129/138i.

99
Jean-Baptiste Oudry
(Paris 1686–Beauvais 1755)

View in the Gardens of Arcueil

Black and white chalk with stumping on gray-beige
paper (formerly blue); inscribed in brown ink on lower
left edge: *Oudry à Arcueil;* dated in black ink: *1749;* glued
onto secondary support
12¾ × 18½ inches, including an added strip of paper above
Inv. 31491
Denver

BIBLIOGRAPHY
Opperman, Hal. *J.-B. Oudry, 1686–1755,* exhibition catalogue. Paris: Galeries nationales
du Grand Palais, 1982–1983, 232–244, fig. 129/138g.

100

Edme Bouchardon
(Chaumont-en-Bassigny 1698–Paris 1762)

The Age of Gold

Red chalk; annotated on lower edge in red chalk: *L'age d'or;* enlarged along
the right and left edges; Mariette mount with cartouche: *AETAS AUREA
ED. BOUCHARDON DELIN. ROMAE* (The Age of Gold Drawn by
Ed. Bouchardon in Rome)
15¾ × 10½ inches
Inv. 23864
Atlanta

Edme Bouchardon, equally appreciated as sculptor and draftsman,
received his earliest training from his father, Jean-Baptiste, an
architect and sculptor. He moved to Paris in 1721 to continue study-
ing with the sculptor Guillaume Coustou (1677–1746). The follow-
ing year he won the Prix de Rome for sculpture, which entitled him
to move as a *pensionnaire* to the Académie de France in Rome. He
remained in Italy for nine years, rising to fame very quickly and
receiving many private and public commissions. While in Rome, he
copied ancient sculptures, executed busts influenced by the Roman
Baroque style, and produced works heralding the revival of ancient
art, which came to be called Neoclassical.

In 1732 King Louis XV called the artist back to Paris and com-
missioned three bronze sculptures for the Fountain of Neptune in
Versailles. From 1734, Bouchardon started working on ten stone
statues for Saint Sulpice in Paris, which are still standing against the
choir pillars of the church. The fountain on the Rue de Grenelle
(1739–1745) in Paris is one of Bouchardon's most important works,
where the poses and the draperies of the figures, inspired by ancient
statuary, develop the Neoclassical style. In 1750 Bouchardon finished
another royal commission destined for Versailles, a marble statue now
in the Louvre, *Cupid Carving His Bow from the Club of Hercules.* His
last work was the *Equestrian Monument to Louis XV,* which was to be
placed in the newest and grandest Parisian square, the Place Louis XV,
now the Place de la Concorde. Finished after his death, it remained
there from 1763 until it was destroyed during the French Revolution
in 1792.

Mariette and Bouchardon were close contemporaries and friends.
The collector considered the artist the most distinguished draftsman
of his time and wrote that "his drawings give him no less honor than

his sculptures; it was there that his genius shone brightest; he almost
constantly held a pencil in his hand. . . . Upon his death, his drawings
were sold at public auction for the price of gold—I mean the draw-
ings that were left because, while he was alive, he distributed them
among his friends, above all to me, as I have the greatest number of
them."[1] Mariette's 1775 sale lists 535 drawings by Bouchardon, among
them the two exhibited here. The Louvre has about 1300 sheets by
the artist, including copies of ancient statuary and works by Raphael
and Domenichino, studies of tombs, fountains, portraits, allegories,
and so forth.

The two sheets presented here are in red chalk, Bouchardon's
favorite medium. They fit the description given by the Comte de
Caylus of the artist at work: "He drew with such assurance that the
line of an entire figure was uninterrupted from the neck to the heels."[2]
The subjects are two of the four Ages of the World as imagined by
the Roman writer Ovid: gold, silver, bronze, and iron. The age of
gold was an earthly paradise; the following ages would bring increas-
ing trouble, war, and misery. The Louvre has four drawings by Bou-
chardon representing the ages (Inv. 23864–23868), all bought at the
Mariette sale. The iconography adopted by the artist follows Cesare
Ripa's *Iconologia,* a 1593 dictionary describing the representation of
mythological or allegorical figures and their attributes.

The Age of Gold, executed in Rome as indicated by the inscrip-
tion on the mount, is represented by a smiling female figure sitting
on a beehive, holding an olive branch and accompanied by a *putto.*
During the Age of Gold, men lived in a state of innocence, without
toil or trouble, fed by the fruits of Nature, such as honey. The Louvre
possesses a copy of the present drawing (Inv. 24704) executed by Pierre-
Charles Trémolières (1703–1739), a painter who was at the Académie
de France in Rome in 1728, while Bouchardon was still residing
there. This drawing and the following have never been exhibited. *VF*

NOTES
1. Philippe de Chennevières and Anatole de Montaiglon, *Abecedario de P.J. Mariette,*
in *Archives de l'Art Français,* vol. I, 1851–1853, p. 164.
2. Comte de Caylus, *Vie d'Edme Bouchardon, sculpteur du roi* (Paris, 1762), pp. 12–13.

BIBLIOGRAPHY
Guiffrey, Jean, and Pierre Marcel. *Musée du Louvre et Musée de Versailles. Inventaire Général
des Dessins de l'Ecole Française. Tome I. Adam à Bouchardon.* Paris, 1933, no. 764.

101

Edme Bouchardon
(Chaumont-en-Bassigny 1698–Paris 1762)

The Age of Bronze

Red chalk; annotated on lower edge in red chalk: *L'age d'airain;*
Mariette mount with cartouche: *AETAS AEREA. ED.
BOUCHARDON DELIN. PARISIIS* (The Age of Bronze,
drawn by Ed. Bouchardon in Paris)
15⅝ × 10⅝ inches
Inv. 23867
Denver

The Age of Bronze, during which men became violent and warlike, is shown here as a frowning female figure wearing a lion's head helmet and holding a spear. She is accompanied by a putto holding a lighted torch. According to the mount's inscription, the sheet was executed in Paris. *VF*

BIBLIOGRAPHY

Guiffrey, Jean, and Pierre Marcel. *Musée du Louvre et Musée de Versailles. Inventaire Général des Dessins de l'Ecole Française. Tome I. Adam à Bouchardon.* Paris, 1933, no. 768.

L'age d'airain

ÆTAS ÆREA
ED.BOUCHARDON
DELIN. PARISII

102

Charles-Joseph Natoire
(Nîmes 1700–Castel Gandolfo 1777)

The Signing of the Peace Treaty at Taranto between Augustus and Mark Antony on the Urging of Octavia

Pen and brown ink over traces of black and red chalk, gray and
brown wash, and white gouache on gray-blue paper; signed on
lower right in brown ink: *C. Natoire f.;* Mariette mount with
inscription: *Pax Tarentina Augustum inter ac Marcum Antonium, suadente
Octaviâ in Plutar,* cartouche has been cut down: *CAR. NATOIRE*
11½ × 16⅝ inches
Inv. 31380
Atlanta

Charles-Joseph Natoire was born in the southern French town of
Nîmes. His father, Florent, had studied painting and architecture
and sent the boy to Paris at the age of seventeen to be trained first in
the workshop of Louis Galloche (1670–1761) and subsequently in that
of François Lemoyne (1688–1737), both well-known members of the
Académie de Peinture. In 1721 he won the Prix de Rome for paint-
ing and two years later went to Rome to further his studies at the
Académie de France, where he stayed until returning to Paris in 1728.
In the 1730s and 1740s, Natoire was very busy with important royal,
public, and private commissions. In 1751 he was named director of
the Académie de France in Rome, where he remained for the rest of
his life. Natoire and Mariette were friends and corresponded on artis-
tic matters when Natoire was director of the Académie. The painter
had also been allowed to copy drawings in Mariette's collection, thus
probably being influenced by the collector's taste.

In true academic tradition, drawing was for Natoire a fundamental
element in the genesis of his works. Through copying works by other
artists, as well as making direct studies of models and multiple sketches,
he arrived at a final composition. This drawing is a preparatory study
for the fourth cartoon in a series of tapestries dedicated to the *History
of Mark Antony,* of which only three were executed by the Manufac-
ture des Gobelins. *The Signing of the Peace* is mentioned in a letter
dated 1757 sent by Natoire to the Marquis de Marigny. A painted
sketch after the drawing is in the Musée des Beaux-Arts of Nîmes. The
subject is taken from the section on Antony in Plutarch's *Lives,* where
the account is given of the struggle for power between Augustus and
Antony after the assassination of Julius Caesar. In the southern Italian
city of Taranto, Octavia, half-sister of Augustus and wife of Antony, is
shown pleading for peace between the two, arguing that whoever the
winner would be, she would be the loser. *VF*

BIBLIOGRAPHY

Duclaux, Lise. *Musée du Louvre. Cabinet des Dessins. Inventaire Général des Dessins. Ecole
Française. XII. Nadar-Ozanne.* Paris, 1975, no. 50.

Pax Tarentina Augustum inter ac Marcum Antonium, suadente Octaviâ, *in Plutar.*

153

103

Charles-Joseph Natoire
(Nîmes 1700–Castel Gandolfo 1777)

View of the Roman Emperors' Palace on the Palatine Hill in Rome

Pen and brown ink; red, yellow, and black chalk; brown, gray, blue, and red wash with white gouache on gray-blue paper; signed and dated on lower right in brown ink: *C. Natoire f. 1759;* Mariette mount with inscription: *Regiae Augg. Domus Vestigia in Hortis Farnesianis sub monte Palatino, Romae delineabat* (Charles Natoire drew the ruins of the Roman Emperors' palace in the Orti Farnesiani on the Palatine Hill in Rome); cartouche has been cut down: *CAROLUS NATOIRE*
11½ × 18⁹⁄₁₆ inches
Inv. 31383
Atlanta

This signed and dated drawing was part of a group of four landscapes sent by Natoire to the Marquis de Marigny, asking him to choose two and give the other two to Mariette. It shows the Palatine Hill in Rome with the ancient ruins of the Roman Emperors' residence overgrown with vegetation and inhabited by peasants with their animals. It is a new view of Antiquity, mixing a pastoral scene with decaying monuments, which would be developed slightly later by artists like Jean-Honoré Fragonard and Hubert Robert. *VF*

BIBLIOGRAPHY
Duclaux, Lise. *Musée du Louvre. Cabinet des Dessins. Inventaire Général des Dessins. Ecole Française. XII. Nadar-Ozanne.* Paris, 1975, no. 57.

Regiæ Augg. Domus Vestigia in Hortis Farnesianis, sub monte Palatino, Romæ delineabat.

CAROLUS
NATOIRE

155

Index

Boldface page references indicate illustrations.

Published on the occasion of the exhibition *The King's Drawings from the Musée du Louvre,* organized by the High Museum of Art, Atlanta, and the Musée du Louvre, Paris

LOUVRE ATLANTA

High Museum of Art Denver Art Museum
October 14, 2006–January 28, 2007

Library of Congress Cataloging-in-Publication Data
Loisel, Catherine.
 The king's drawings from the Musée du Louvre / Catherine Loisel, Varena Forcione ; with the assistance of George A. Wanklyn.
 p. cm.
 Issued in connection with an exhibition held Oct. 14, 2006–Jan. 28, 2007, High Museum of Art, Atlanta, Georgia.
 Includes bibliographical references and index.
 ISBN 13: 978-1-932543-09-4
 ISBN 10: 1-932543-09-0 (hardcover : alk. paper)
 1. Drawing, European—Exhibitions. 2. Drawing—Collectors and collecting—France—Paris—Exhibitions. 3. France—Kings and rulers—Art collections—Exhibitions. 4. Drawing—France—Paris—Exhibitions. 5. Musée du Louvre—Exhibitions. I. Forcione, Varena. II. High Museum of Art. III. Title.
NC225.L65 2006
741.9'407444361—dc22 2006014179

For the High Museum of Art
Kelly Morris, Editor
Heather Medlock, Assistant Editor
Rachel Bohan, Editorial Assistant
Nora Poling Bergman, Consulting Editor
Translation by Meghan Clune Ducey
Photography by Peter Harholdt

Designed by Jeff Wincapaw
Proofread by Barbara McGill
Color separations by iocolor, Seattle
Produced by Marquand Books, Inc., Seattle
 www.marquand.com
Printed in the United Kingdom by Butler and Tanner